THE SECOND HALF

THE SECOND HALF

FORTY WOMEN REVEAL LIFE AFTER FIFTY

ELLEN WARNER

BRANDEIS UNIVERSITY PRESS

Waltham, Massachusetts

Brandeis University Press
Text and photographs © 2022 by Ellen Warner
Foreword by Erica Jong © 2022 Erica Mann Jong
Afterword by Sarah Lamb © 2022 Sarah Lamb

For permission to reproduce any of the material in this book, contact Brandeis University Press, 415 South Street, Waltham MA 02453, or visit brandeisuniversitypress.com.

Library of Congress Cataloging-in-Publication Data
Warner, Ellen, 1948– author.
The second half: forty women reveal life after fifty / Ellen Warner.
Waltham: Brandeis University Press, [2022]
Summary: "The Second Half explores, in portraits and interviews, how the second half of life is experienced by women from many cultures" —Provided by publisher.
LCCN 2021031956 (print) | LCCN 2021031957 (ebook)
ISBN 9781684580866 (cloth) | ISBN 9781684580873 (ebook)
LCSH: Older women—Interviews. | Older women—Social conditions.
LCC HQ1063.7 .W37 2022 (print) | LCC HQ1063.7 (ebook) |
DDC 305.26/2—dc23
LC record available at https://lccn.loc.gov/2021031956
LC ebook record available at https://lccn.loc.gov/2021031957

Designed by Lisa Diercks / Endpaper Studio
Typeset in Mixta Pro, Larken, and Folio Medium by Lisa Diercks / Endpaper Studio

Printed in Singapore
10 9 8 7 6 5 4 3 2 1

for Alix and Lily

CONTENTS

ERICA JONG

I've often thought that portraiture was kinder to women than the photography that replaced it. Photography flatters the bony, not the fleshy. Photography can be cruel. But paradoxically, these photographs and interviews by Ellen Warner show that women can be handsome and arresting at every stage of life. When we see their expressions as they become marked by time, we experience wisdom that is inspiring. We read their faces as if they were stories. Photography usually shows us the magic of youth, which is no challenge. We are surrounded by photographs of the young and beautiful. Here, we are asked to find beauty in experience. Everybody has a story to tell. What makes this book unique is the empathy the reader feels after learning what these women have overcome and what they look forward to in their second half of life. Ellen Warner has found women with stories so moving that they teach us. The common link between these very different women is their strength.

I grew up in a family of portrait painters and almost became one

myself, so I am in love with the way the faces of aging women change and grow. Studying expressions leads us to admire them. Faces reflect the struggles and joys of lives—the subtle turn of a lip, the gentle slope of a brow, the confidence of direct eye contact. Acceptance of how time changes us is, after all, the ultimate wisdom. To live is to change—though change is never easy. These faces hint at the stories that the women have lived through. Warner's interviews cut straight to the heart of what makes these women so special.

The bravery and resilience of Odette Walling, surviving a traumatic childhood only to face war, imprisonment, and torture, and her ability to still find love and motherhood. Jean Angell's ambitious career choice in studying law as a woman at a time when women were expected to stay home, and how the isolation she dealt with prepared her, perhaps, for her future struggles with ALS and the enormity of choosing whether to live or die. Women from the Middle East pursuing education, or women from Europe and Australia embracing and creating jobs for themselves that no one was giving out. Each story defines how choices lead to consequences that reap both reward and heartache. Each woman shows how she survived both and shares advice.

When I was growing up with a grandfather who was a portrait painter, I became aware of light and shadow and what facial expressions tell us about a person. I remain fascinated by the revelation an artist is able to make that showcases the personality of his or her model, knowing the exact expression or pose that makes the person unique or compelling. Isolating the way that the light emphasizes certain features and understanding the way a person's expression transforms them. That Ellen Warner chose to use black and white photography for this book is in itself an art form. She admits that choosing the women for this book was not about beauty, but about finding faces and stories that were captivating.

As a writer, I create character through action, description, and dialogue. For the photographer, the challenge is to show personality in a moment. Who are these women, and what questions should be asked to get them to reveal their stories? How do the details of each background give insight to the life of the woman posing in it? What Ellen Warner has done is observe the beauty of older women and give a whole person in a moment's flash. The interviews that accompany each photograph further enrich the pictures as you put a face to the protagonist of each struggle and success. You come to know these women by imagining what they are thinking. You are given not only words but also light and shadow, composition, and form. How do you catch the personality of a woman wearing a hijab? By the way she stands, the way she positions her head and hands, her attention to the camera. Her confident gaze tells you everything.

My mother, like my grandfather, also painted portraits and took pleasure in painting her children—and later, grandchildren—as they were sleeping. Perhaps because children can't sit still to pose, or perhaps because all sleeping children look angelic—regardless, I admire these paintings because they captured a moment and allow these moments to live forever. Much like these photographs—beautifully composed, Warner is gifting us and these women with a moment that showcases strength and beauty that transcends time.

When I am photographed, I have to force myself to relax and remember that I can't control the outcome. I think the fear of being photographed is the fear of losing control. The more you can forget the outcome, the better the photo will be. I love photographs where you feel that the subject is completely free and unconscious of the photographer. I rarely like photographs of myself, but I try to give up control because I know we don't see ourselves clearly. There is no doubt that photography has changed the way we see women. From magazine covers and advertisements, commercial photography has

made it rare to see women as they truly are growing older. Women past the age of fifty don't live in pajamas and water plants in their slippers—well, maybe sometimes—but the reality is that women past the age of fifty have usually shifted their responsibilities from finding partners, forging careers, and raising children to reaping the rewards of reciprocated love, friendships, hard work, and, eventually, grandchildren.

The second half of life that Ellen Warner refers to is seen in the portraits of these women who understand what life encompasses. No longer fresh-faced beauties waiting to discover what lies ahead, their beauty lies in grace and understanding. These women know of pain from labor, be it childbirth or long hours at work. They also need the sweetness of a hand to hold and the warmth of a hug. Looking at these images, you think that these women aren't worried about hair-dos or shades of lipstick. These are women who know how to run their fingers through the earth to plant tomatoes; women who taught their children how to knead dough and bake, how to watch clouds passing by, and how to appreciate the colors of sunset. These women take pride in their heritage and cultures, showing backdrops of their environments sometimes scattered with sculptures or rustic farm fences and apple trees. They share experiences of love and loss and learning.

We need to celebrate women not for wrinkles, but for laugh lines. We need to see ourselves changing and growing. If that means looking older, celebrate it. Experience is as beautiful as youth. These pictures are meant to teach us that every stage of life has its own enchantment.

THE SECOND HALF

INTRODUCTION
ELLEN WARNER

In 2003, I first went to Patmos, a Greek island that I fell in love with and now return to every year. The way I get to know a place is to take portraits of the people who live there. Fifteen years ago, I asked Jacqueline Délia Brémond, a beautiful French woman who had been coming to Patmos for thirty-five years, if I could photograph her. She had just turned seventy, and while I was taking her portrait, I asked her what it felt like to be seventy. I found myself listening attentively, not in the abstract way I usually do when talking to a subject while really focusing on the composition of the picture. I had been thinking about aging, myself. "This is what I want to know," I thought. What does it feel like to be seventy, eighty, or one hundred years old? How will I feel when I lose my looks or my ability to be independent, to travel alone to remote parts of the world? What is it like to know that the end of life is approaching? And that was the birth of *The Second Half*.

I've spent my career taking pictures. Interviewing was new to

me. I had to decide what questions to ask. What did I really want to know? I narrowed my questions to the following:

- *How would you describe the second half, i.e., life after fifty?*
- *What did you learn in the first half that's been helpful in the second?*
- *How do you feel you've changed, including your interests, values, and your sense of who you are?*
- *What used to give you the greatest pleasure? What gives you the greatest pleasure now?*
- *What was your happiest time? Your saddest time?*
- *How do you look to the future?*
- *How would you like to be remembered?*
- *What advice would you give younger women?*

After several interviews, I decided that the reader needed to know more about the women. What kind of family were they born into? What had their childhood been like? So I began to start each interview by asking the woman to tell me her life story, starting from the beginning.

People often ask me how I found the women in the book. The answer is: usually through other women. Shortly after that trip to Patmos, my husband and I were invited to visit friends in Paris. I was chatting with our next-door neighbor across our garden wall, wondering how I would find women. "You must photograph the woman who was married to my husband's uncle!" my friend said. That was Odette Walling. Our hosts in Paris recommended a few women, and Jacqueline Délia recommended others. On another trip, walking down a little street in village of Ubud in Bali, I saw a beautiful woman. "Who is she?" I asked my companion. "She's my Auntie," was the response. That was Ni Ketut Takil. (I was later told that in local villages, it's customary to call every older woman an Auntie.) In southern Algeria, I was crossing the desert with five friends to visit the

prehistoric paintings of the Tassili. I asked our Berber guides if they could keep their eyes open for a nomadic woman—which is how I met Fatma Doufen.

In general, I had two criteria for the women I photographed and interviewed. They had to be interesting looking—not necessarily beautiful, but interesting looking. And they had to be willing to open up and be honest in the interview. And, with a couple of exceptions, I didn't want to photograph friends—I wanted to approach each person with fresh eyes and ears. I looked for diversity, both geographic and socioeconomic, within the limits of how much of the world I could cover.

When the women couldn't speak English, they had friends—and, in one case, a granddaughter—translate. I asked very personal questions during each interview, and I wondered if the granddaughter learned intimate things about her grandmother that she might never have known.

While everyone told me her age at the time of our interview, I've used "circa" (abbreviated as "ca.") when I don't know for certain the specific year when someone was born. Some interviews were very long, and then I had to edit a great deal—an agonizing process, as I found everything about each woman's life story compelling.

Each woman has taught me something. I've learned about running a pub in London, arranged marriages in Saudi Arabia, shoeing racehorses, raising a son to become a world-famous cellist, and much, much more.

The women have been inspirational. I will never forget the courage of Jean Angell, who could move only her eyeballs and depended on others for care. Her ability to adapt and still lead a vibrant life—attending ballet performances and art exhibits, using her legal mind to help her wide circle of friends and family—made me forget she had a disability. Or Lali Al Balushi, whose husband divorced her in Oman

and moved with her three small children, the youngest two months old, to Pakistan. Now, small annoyances aren't so important to me.

Because this project took fifteen years to complete, circumstances for some of the women in the book have changed since they were interviewed. Tamasin Day–Lewis, whom I interviewed early in the project shortly after she was divorced, is now happily remarried. And a few of the women, including Olivia de Havilland, have died. Each woman's interview and photograph is a moment in time, how they felt then, as honestly as they could relate it. Their lives span a century, and their attitudes express their time and culture.

One of the things I found interesting is that the nomad in the Sahara and the cook in South Carolina often come to the same conclusion as the Marquesa in Seville. There is a definite consensus, which was surprising to me at first, that the second half is better than the first. "This sounds like turning lemons into lemonade," said an American friend of mine in her forties, but I found it voiced with real conviction. In the second half, you know who you are, and you are liberated by not caring about what others think of you. In the second half, wisdom kicks in, intuition takes over, and you can accept yourself, flaws and all, with greater ease and clarity. That very positive message became the underlying theme of *The Second Half*.

I would like to express my gratitude to the women in the book, who have taken the time to be included and in many cases have reflected upon unpleasant memories. I trust their stories will be as helpful to readers, as they ponder difficult decisions or moments in their own lives, as they have been to me.

ODETTE WALLING

Born 1920, interviewed at age 86 • Resistance leader, Ravensbrück prisoner #47321, Kings Medal for Courage, and Médaille de la Résistance • Paris, France

Each day and each moment changes your feeling about the second half. You get a nice phone call; the sun is there. You get a nasty phone call, and you are all alone.

I haven't changed at all as I've gotten older. I've always been extremely faithful to friends, but very intolerant if they behave badly, and I do not easily forget.

My father died when I was very young. His lungs had been burned by the German gas at the Marne. He had become a socialist and was antiarmy. I had been very close to my father. I adored him. When I had whooping cough, he was the only one who could give me the medicine. It smelled like ether. Even if he came back at 10 P.M., I was not asleep. I took that horrible medicine only if he gave it to me.

The saddest time of my life was when no one told me my father was dead. I saw a box they couldn't fit into the house. I thought it was very funny. Then we went into the cemetery and the box was there. The box went into the ground and I was given a purple bouquet, and

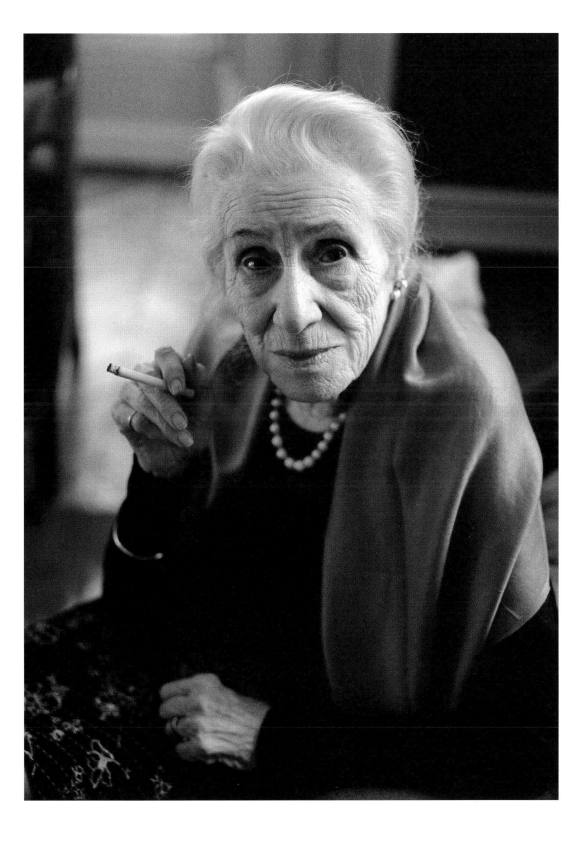

there was a nun who smelled of bad soap. She hated me as much as I hated her. The nun said, "You are a very bad girl. You don't want to throw your flower to your father." I then realized my father was dead. I ran from that nun, jumping from tombstone to tombstone. I was four years old.

I had a lonely childhood, as my father was dead and my mother remarried. My stepfather was a total bore. I grew up alone with a small dog. We had a Black maid and a deaf gardener. I was totally different from the other children in school, with good English shoes, which I threw away one day into the sewer. My mother didn't understand. I don't think my mother was made to be a mother. At eighteen, I legally became an adult and got a small apartment on the Quai Voltaire. I had a little pension from my father. I went to medical school, but on Saturday nights and Sunday mornings, I answered telephones for a company.

The war started when I was nineteen. When I was twenty-one, Hitler came to Paris. I was stuck at the hospital where I was working. For two and a half days, I couldn't get home. You couldn't cross the street. I spoke to some Jewish people who had no money to run away. I managed to take the little boy to the non-occupied zone. Then I went to see a British friend of my father's, who was head of the resistance. I went by myself to Switzerland.

I became chief of the area from the Belgian border to the tip of Brittany. I had another name. I cannot tell it because I was responsible for the death of some Germans. I could be in danger still. We followed the Germans everywhere and I told my men what was happening. I had fake papers, and I pretended to be a social worker going to big cities to see how children and pregnant women were doing with no food. François, my childhood friend, was caught. He was tortured and he collapsed. He spoke, so they came to arrest me. I was in Amiens. That was in 1944.

In Amiens, they woke me practically every night. They had mock executions all the time. They would put a gun to my head and tell me that if I didn't talk, they would shoot. I didn't talk; they didn't shoot. I wanted them to shoot me, but they did not. They put me underwater to make me talk. I've never again put my head under water.

I was interrogated by that German friend of Hitler's. I came back after being tortured and lay flat on my pallet. I was lying on my stomach because my back was so sore. There was an old German who had been in World War I, and he would sneak in to see me. He gave me cigarettes and patted me, and he said in German, "Oh my God, kinder. Oh, my God. You are so brave." He would have gotten into terrible trouble if they discovered that he came to me. His name was Gideon. He was a farmer, growing apples.

There were two to three weeks when we were in quarantine, then we went east. We stopped in camps where they were torturing men, making them jump on nails. Then we arrived at Ravensbrück.

During my time in Ravensbrück, I spent five days in a coma in the snow, thirty below zero, nude in some rotten bamboo thing full of people who were dying. I was left for dead. It made me lose my kidney. I was punished to walk for a month in shit up to my knees and to shovel it. We had no soap, little water, not even a towel. Then in August, it was so hot. I thought of throwing myself on the electric wire. We were up at 3 A.M. to a bowl of dirty water. You go out without a coat in all weather and stand until sunrise. You could hear the women falling—puff, puff, puff. Then you carried, without food, a fifty-kilo bag with the dogs after you. I loved dogs. They could sense it. I was never attacked by one.

We saw train after train of women and children arriving from Poland and further east. Little girls in the snow. I was beaten terribly because I gave them my bread. I still have the smell of the incineration. My mother didn't know where I was.

I don't wear any of my decorations, and I don't want to have the big pension I should have. I didn't do it for that.

Two years or so after the war, I met my husband, who was working in Paris. We got married in Rome, three times in one day: once in Italian, once at the French Embassy, and once at the American Embassy because he was American. The Americans were shocked that I didn't want to take American citizenship. I was twenty-nine or thirty when I got married, and Christopher was born a little over a year later. He was premature because I had one kidney not working. When Christopher was five years old, we moved to Cape Cod and lived in Wellfleet.

We had a few years of happiness, and then it was over. His father left us when Christopher was thirteen. He said to me, "If you ever remarry, I will kill myself. If you take a lover, I will kill myself." When Christopher was twenty-one, he allowed himself to be bought by his father and didn't see me for three years. All I knew of him were postcards.

I have very few friends but good friends, but now they are all dying. I am not afraid of dying. I am tired. I am not religious. I don't want to go to an old officer's place to die. Old people are so ugly when they are in a group.

I've always been a very lonely person. I read a lot—a bit of everything—in English and in French. I'm used to being alone.

Seeing my son Christopher gives me the greatest pleasure. I spend a lot of time in bed. I take care of people I hardly know with little money. Simone Weil's older sister by three years is my closest friend. I met her outside Paris. We were prisoners together, kept in an old fortress built by Vauban. She had been caught in Lyon. I met her when we were both naked in the showers, the first time I'd had a shower in a month. . . . We telephone every day. She is like my sister, though five years younger than I am. They didn't think she was Jewish. She has blond hair. She lost her whole family in Auschwitz.

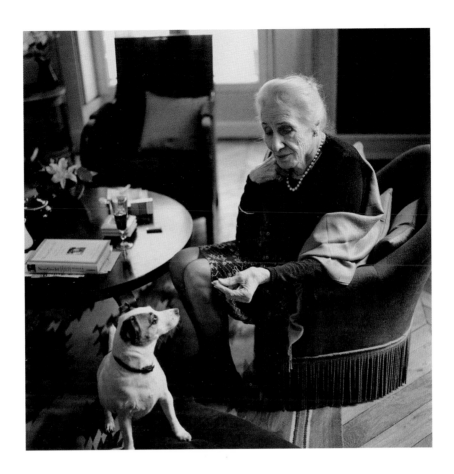

I hope I won't live too long.

My advice to younger women is to accept that you are getting older. Nothing is more annoying than women who want to play twenty years old when they are aging. One has to age gracefully. It isn't always easy.

JEAN ANGELL

Born 1944, interviewed at age 65 • Lawyer with Lou Gehrig's disease
Prouts Neck, Maine, U.S.A.

My second half is so different from the first that they seem to almost not belong together. My first half was busy in the extreme, and my second half has been limited to enforced tranquility. The first half was full of work, family, and so many activities. In the second half, most of that has been stripped away, leaving relationships with family and friends. But I have searched to understand the ways that what I learned through experience has informed my ability to deal with an extreme and debilitating illness.

I grew up in the suburbs of Chicago, but most of my close relatives lived in New York. I was drawn to the East Coast and went to Wellesley College. But the culture of the early 1960s, where job opportunities were extremely limited and women were not viewed as successful unless they landed a husband, was stultifying. I wanted more; I was passionate about civil rights and issues of the poor. I decided to go to law school immediately after college. What a change

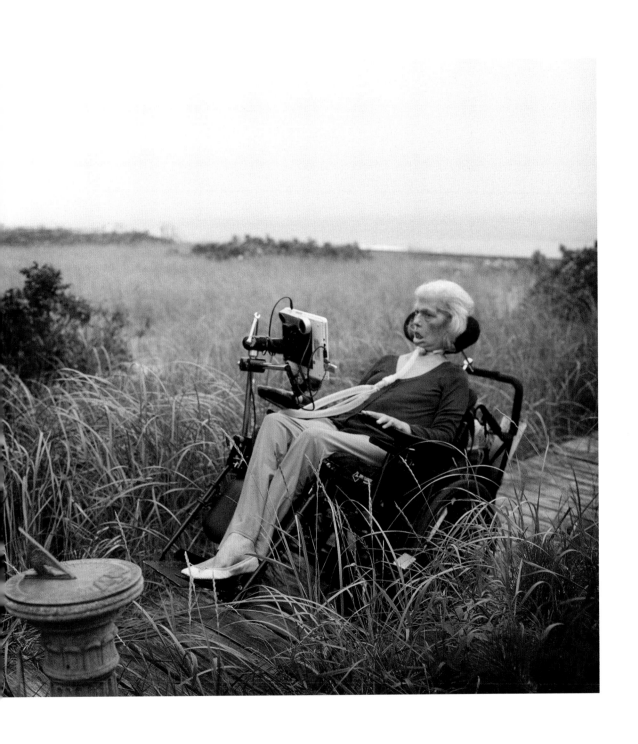

from Wellesley. The debate was lively, the issues fascinating. But it was a world that had not really changed. The often-asked question was: what were twenty-eight women doing in a class of five hundred and fifty men at Harvard Law School? It bred in us the desire to show that we belonged there—that we were not just taking men's rightful places, and that we would accomplish things.

After law school, I went to work at a large law firm. Although Harvard Law hadn't had many other women, there were some—but at my law firm, I was the only woman lawyer. Unlike other starting lawyers, I was given a closet of an office all to myself because the powers that be thought male associates would be uncomfortable sharing an office with a woman. None of the men's eating clubs permitted women in their dining rooms at lunch. I would often be the only woman in the room in large restaurants.

I came to Wall Street just before the Vietnam War and the social revolution of the 1960s opened the doors of law schools to women, and subsequently to the law firms, which had so resolutely resisted hiring them before. I went to work in the trusts and estates department, though I had reservations about being placed where women often were; even so, I enjoyed working with individual clients, helping them understand what problems they faced, and finding creative solutions to those problems that met their needs.

Managing a demanding career was not enough for me. Women of my generation wanted what their mothers had: a husband, children, a home. One was supposed to manage both complicated parts of life effortlessly without sacrificing either. Just trying to create that seamless impression was a task, and it left little room for personal space. But I wasn't willing to give up anything. I loved my work, adored my husband and children, relished my homes, planned interesting travel holidays, and joined not-for-profit boards. I couldn't think far ahead; I managed day by day.

Then suddenly, my world was turned upside down by a devastating diagnosis. When I was fifty-three, without warning, my body literally slowed down. I couldn't walk fast anymore, and when I tried, I fell down with increasing frequency. When I finally consulted a specialist, I was told I had ALS, Lou Gehrig's disease, which would progressively rob me of all muscle strength, eventually making me a helpless quadriplegic, unable to speak and, when my diaphragm ceased to move, unable to breathe. Death generally occurs within two to five years for those diagnosed with ALS. There is no effective treatment; there is no cure.

Knowing you are living on borrowed time is strange. First of all, you know you can end life at any time—how do you know when it is the right moment? And second, what will you do with this borrowed—indeed, stolen—time?

It was shocking. I didn't really feel sick. It was infuriating; I didn't feel ready to die. It was devastating for my family as my physical decline progressed. This disease is all about loss. We had to give up our home; someone in a wheelchair couldn't live in a narrow five-story house filled with stairs. The law practice I had loved and nurtured evaporated. I tried to focus on my husband and children, to be sure they understood that they were and always had been the most important parts of my life. But my frustration and sadness were hard for them to understand and to accept. I often seemed a different person.

Four years after my diagnosis, my breathing had become so compromised that it was clear the end was near. But unlike with cancer or heart disease, I had an alternative. My muscles didn't work, but I was otherwise healthy—this meant that if I chose to, I could go on a ventilator and be fed through a tube; I could continue to live. I wasn't ready to give up, so five years ago, I made the choice and began an artificially sustained life.

Knowing you are living on borrowed time is strange. First of all, you know you can end life at any time—how do you know when it is the right moment? And second, what will you do with this borrowed—indeed, stolen—time? The moment in which I had to decide whether to let the disease take me or to choose my alternative option was a life choice. I would have loved to still be able to walk and laugh and hug my family, but I could not. What could I do? I could still protect and make a life for my husband. I could nurture and support my children; I could lavish attention on my friends; I could do things now for which I never had time before; I could read and go to movies, theater, concerts, and museums. With the help of amazing technology, I could even speak and write when I ceased to be able to physically do so.

The loss of physical independence is very hard to get used to—never having any privacy and having to ask for everything isn't very nice. You resist each stage of physical loss, and there is terrible sadness when you inevitably lose. Some stages were harder than others. I hated losing the ability to speak, to eat and drink, to hold a book and turn the pages, to go out alone. But that is a long time ago now. There aren't many benchmarks now, and life is very much the same.

You wonder where my strength to fight this disease comes from? It's a combination of personality and experience. I'm not a very depressed person. I choose not to dwell on the losses that occur, but instead on what I can do. That said, it's hard to say what has been my happiest time. There go on being happy times, and there go on being sad and difficult times.

There were a lot of things throughout my life that gave me great pleasure—my husband, my children, doing something interesting or difficult intellectually, traveling, trying new things. Now I have to do a lot of that in my memory. I love watching my children grow up and do such interesting things with their lives. I'm not religious, but I have a highly developed sense of what is moral and ethical conduct. I guess

what sustains me is that my family still needs me, and my family and friends still value me.

The family was close before, but it got even closer. My kids grew up so much. I think they unconsciously took a great deal from me to replace what I could no longer do. It's funny sometimes to watch.

Figuring out what people needed and wanted was a huge part of my practice, and I still use this skill. It is very gratifying. People know when they have a problem, but they often don't know exactly what that problem is. Lawyers are trained to isolate exactly what the problem is, because only then can you see what your range of solutions and your possibilities are.

I am haunted by the many people we've known with ALS over the last ten years who have died. Why them and not me? Why didn't they fight harder to see their children grow, find satisfying careers, and fall in love? If they loved life, why did they let it slip away? I do not have a future that looks like everyone else's. But I can continue to love and be loved. I can make others understand that they do not have to accept defeat, that they can continue to make and enjoy life, however daunting the obstacles. I can help people understand that doing so is within their power, and that the struggle will bring its own rewards.

ROXY BEAUJOLAIS

Born ca. 1947, interviewed at age 60 • Publican of the Seven Stars
Carey Street, London, England

I'm Australian. I was born in Adelaide, but when I was young, the family moved to Sydney. I left when I was twenty-five. I got a free ride in a cargo boat and came to the Northern Hemisphere. I was the only passenger.

Perhaps I wouldn't have done it if I'd known how difficult it would be. To survive, I got temporary jobs. In the early 1970s, I worked at a famous jazz club called Ronnie Scott's. Sarah Vaughan, Stan Getz, Dizzy Gillespie— they all came there. These old guys played till they dropped dead. They toured. I made my connections.

When I left Ronnie Scott's, quite honestly, I didn't know what I was going to do. I did picture research. I cooked a bit. Then I was offered a job of managing a pub. I took it, and for the next fifteen years, I managed pubs for big brewing companies. Six years ago, when I was in my fifties, my mother died, and I had a bit of extra cash. I bought this pub. I also have a steak house.

I know I was a late developer. I floated for years, being totally

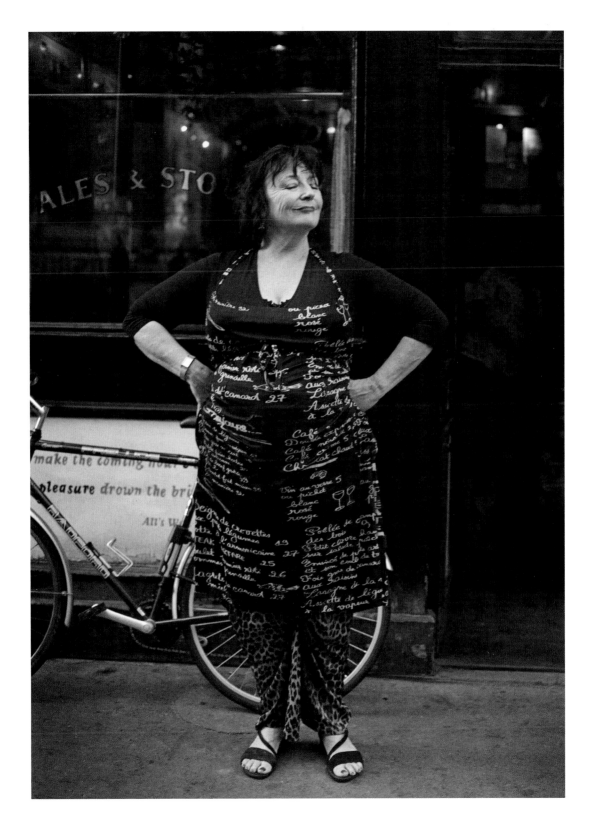

carefree and single until I was in my forties. I finally decided to put a stop to it because I worried that I'd end up a spinster, and I met the man who was going to be my husband a week later. We've been together for twenty years, married for twelve. I never had children, just by accident I suppose. Never tried and never got pregnant, and suddenly it was too late. I have cats and pubs.

I would imagine I'll be working forever. I enjoy it. It's very sociable. This pub is four hundred years old, so there's a tiny, winding staircase. It's a physically knackering job, but I had a revelation this year that has changed my life. I got hypnotized and gave up drinking. Perhaps I wasn't an alcoholic, but I was drinking too much. It's a professional hazard.

I guess the second half is about preparing for the end. I suppose my life isn't particularly conventional. People usually look forward to retiring. Men in offices must be yearning for it, but I think it must drive women mad. I began to think about my own mortality when I turned sixty—I think that's why I stopped drinking. I'd like to be composed and mobile as I age.

Being successful professionally gives me the greatest pleasure. It's a form of nurturing, being a publican—I cook for people, I listen to them. My pub draws a varied crowd—a lot of legal people come. A lot of Anglican church musicians, singers come. It's an educated crowd. I'm in all the guidebooks and people come for my cooking. I hope the pub will work out successfully and that I'll be doing it into my eighties. There's no reason why I couldn't.

As I age, I feel comfortable within myself. A certain knowingness takes over. One doesn't have that lack of confidence and unsureness anymore.

I don't think about myself so much now. When you're young, you are so self-absorbed. It's a natural thing. It's a matter of confidence. I looked like a confident woman because I was tall and I was loved, but I was riven with insecurity.

It all comes down to the big "E"—Experience. You get it by going out every day and facing people. I've become much more sure of myself. It's the process of maturing. One thing that young people are up against now is the cult of celebrity. Everything seems so second rate—Paris Hilton, or Kate Moss—it's poison. Teenage people have that to aspire to. Celebrity makes them compare themselves. When I was young, the cult of celebrity was less pronounced. It was long-distance celebrity. Now everyone wants a crack at fame.

I would tell young people not to be so self-absorbed. Young women worry too much about themselves—is my bum too big? And they have these dreadful models, who embody superficial values, as role models. In the end, you are your own worst critic, and it's indulgent to spend so much time thinking about yourself. Care for others. Stop all that self-interest—it's boring. And unbecoming. In the end, everyone just needs to be nurtured.

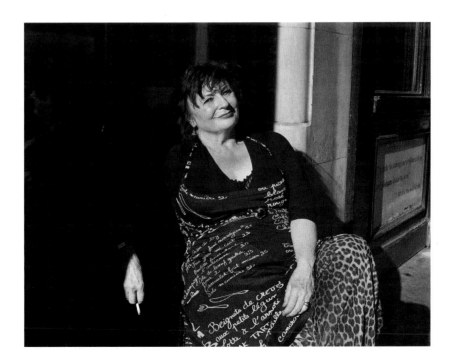

TERESA SAYWARD

Born 1945, interviewed at age 64 • State assemblywoman and retired farmer
Willsboro, New York, U.S.A.

I was born in Willsboro at home. My dad worked in the paper mill. He mixed all the chemicals at the mill. My mother was a stay-at-home mom. There were five of us. We were very poor. Dad died of cancer when he was thirty-seven. I was the youngest at six, my oldest sister was sixteen, and my mom was thirty-four. My mom raised us by scrubbing floors and taking in laundry. She never remarried. We always had food, we always had clothes, and we were always clean. I would not trade my childhood for anything. We learned sharing and we learned what it means to be a family.

I married right out of school and was a mother for the first time at seventeen. My husband's family were farmers, so we put our heart and soul into the farm and raised four children that way. We started our day at 3:30 A.M. and worked 365 days a year.

We had twelve foreign exchange children living with us at the farm. How do you expose your children to other cultures if you can't travel?

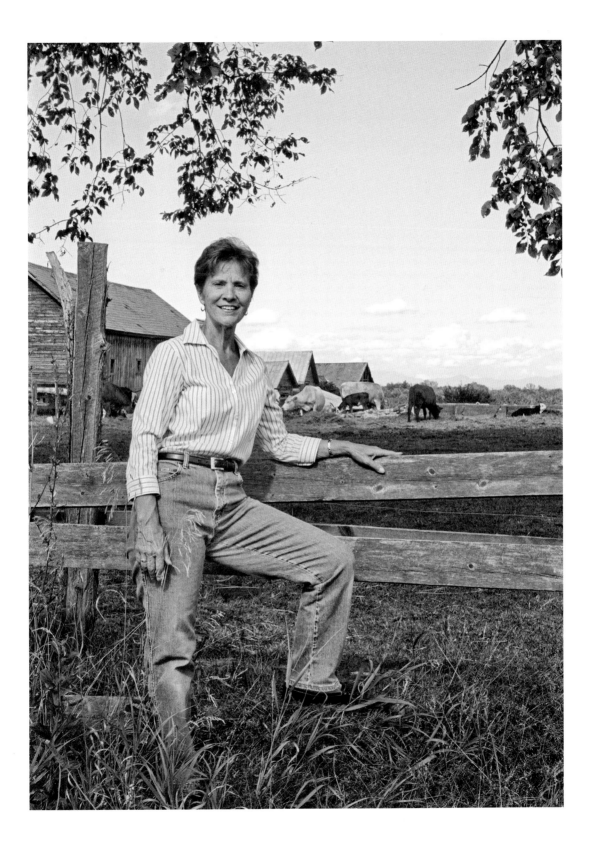

It was when we were farming that I got interested in politics. I read everything I could about farming and got very interested in the Farm Bureau, and became involved in the Bureau's meetings. When I went to my first Farm Bureau meeting, one of the gentlemen said, "The women are in the kitchen." I said, "I don't want to be in the kitchen—I came to the meeting." They welcomed me at the meeting, but it had never occurred to them that a woman would want to be part of the political process.

When the children grew up and went to college, Ken and I made a business decision to sell the cattle and the machinery. I picked the spot to keep for our house because when I chopped hay here, the views were wonderful. We built this little house, and I was working with a woman who sells antiques when I ran for town supervisor. I lost the first time I ran, but by very little. The second time, I won and served for eleven years. I served as chairman of the County Board of Supervisors and chaired the Legislative Committee, so I would go to Albany to lobby. I ran for assemblywoman when I was fifty-seven. Only 8 percent of assemblymen are women.

I would advise young women to be independent. You see so many things that happen to women when they are in situations they can't get out of. Strive for independence.

I wouldn't have made a commitment like that if I had children at home. When they were home, I wanted my children to know that they could find me at home or in the barn. And I think Ken would not have wanted me to be that involved with politics when we still had the farm, because he needed my help. When I decided to run for supervisor, he was very supportive. Now that he's retired, he accompanies me. My children were also supportive. They walked the streets for me when I was campaigning.

When we ran the farm, I was always very independent. I milked

cows, I birthed all the cows, I chopped hay—I did everything my husband did. When we built a new barn, they came to put up a big sign that said "Sayward and Sons." I looked at my daughters and said to the man, "If you put up that sign, he's just lost three of his best workers." The sign was changed to "Sayward and Family."

Life after fifty is the best part. When you focus on raising your children and, in our case, on owning a business, it's a lot of responsibility. Being a parent is hard work. I have no regrets, but this is an easier time. And it's a time when I feel totally and completely independent. My sense of who I am and my core values have not changed, and I think that makes me a better leader and a stronger person. Not having gone to college was always something that bothered me, but now I stand up on the floor and talk about issues. I write legislation. I have confidence in the fact that life lessons are sometimes the very best education one will ever get. Sometimes we don't take advantage of those and instead depend too much on formal education. I think both are very, very important.

I learned while growing up that hard work really pays off. I worked seventeen days in a row without having a day off just for myself. I move comfortably among seniors and among single moms. A little more difficult for me is to move around circles where people are more affluent.

Family is the most important thing to me. Stuff isn't important to me. If someone needs something I have, they can take it. I don't have a lot of clothes. I have what I need. What is important to me is watching the hollyhock come up every year and picking my own basil and making pesto. I never felt that we were poor. We always had love and understanding.

I think that, in government, if people will not stand up for what they think is right, no matter what side of the aisle that might put them on, they shouldn't be elected again. I believe our country is

headed in the wrong direction because we've become so partisan. Good government comes from many different thoughts, ideas, and cultures. When big issues need to be discussed, we need leaders who have the presence of mind to consider diverse ideas. Common sense is what we're lacking. I think it's important to have diversity, and with the partisanship at both the state and federal levels, we won't be able to.

Of course, the biggest sadness was losing a son. He was thirty-seven, the same age my dad had been when he died. He was doing what he loved to do, riding a motorcycle, in the way he wanted to do it—without a helmet. My children, the three of them, took care of everything. Ken and I did nothing, nor could we have.

But even in sadness, there are blessings. His son, who was twelve when his dad died, spends every other weekend with us. His grand-father is teaching him how to hunt, and he kayaks with us. Family always has to be my first pleasure.

I knew my second son was gay probably when he was in kinder-garten. I knew he was different. He was artistic. It wasn't until he was in college that we really knew. He was into drugs. Looking back, he was torn.

I said to him, "Glen, you have to be who you are. You can't be who someone else wants you to be." He told me, "I want to be normal. I want be successful, to have a house with a fence and a family." Well, Glen is successful now, and he has a house and a fence and a family.

The greatest compliment I ever had was posted on a blog. A woman spoke about my standing up on the floor of the assembly and speaking about gay rights. She said, "We will change society one mother at a time." The key is to never judge, but to understand. It's the key not just to raising your children, but to being a neighbor, a legisla-tor, a businessman, or whatever.

I never close a door that may need to be opened. I don't know

where I go from here. Do I decide to retire when I'm done with politics? I think in life you can and should plan for things, but you should always be prepared to embrace whatever opportunity presents itself. Then your plan might be altered, but how boring life would be without surprises.

One should never take oneself too seriously. I would advise young women to be independent. You see so many things that happen to women when they are in situations they can't get out of. Strive for independence. Even though my mother was not prepared for being left alone and single when my father died, she was independent enough to find her way. You must be able to stand on your own two feet, as you never know what life might bring.

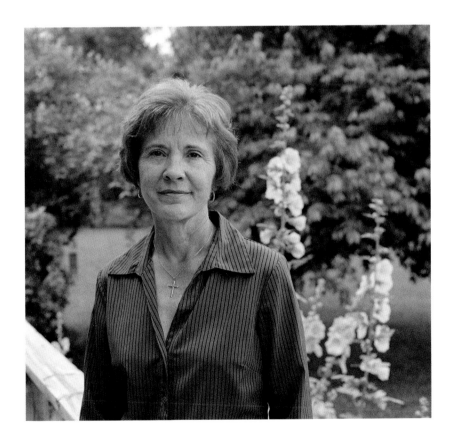

LESLIE CARON

Born 1931, interviewed at age 77 • Actress
Paris, France

When I was born, my family lived in a very large house built by my grandparents, and we were there until the Second World War. It was a different life then—a very grand life: chauffeurs, nannies, and so on. My mother was American. She had been on the stage. She came to Paris for a holiday and met my father and married into the Caron family, so she had different, American ideas about bringing up children. We were given a lot of physical freedom; whereas French children were taught to be neat, and not to climb trees, not to get up on chairs, my mother wanted us to swim before we could walk and to be physically fearless.

When the war started, everything changed. My grandparents lost their fortune, and we lived in an apartment in the Quartier Latin. Soon after that, my mother thought it was a good idea for me to have a profession, and I started learning dancing.

I started dancing when I was eleven, which, for dancing, is considered quite late. I adored it. First, I went to ballet three times a

week. But soon, my mother decided that if I was going to be a profes-sional dancer, I must give up going to school and dance every day. She was very American in that she was far ahead of French women in the notion of women working and being independent.

I went into *le conservatoire* of dance. My mother thought I should have a taste of the stage early on so I would never get stage fright. I joined a theater group and played a little boy. At sixteen, I joined Roland Petit's company, *Les Ballets des Champs-Élysées*. We started touring Europe. It was great fun.

My mother committed suicide when she was sixty-seven. She was convinced that, since she had lost her looks and youth, life was over, and she was so wrong. But it affected me for a long time. I was also convinced in my fifties and part of my sixties that I had become worthless.

Then one opening night, when I was the star of a ballet called *La Ronconte*, about Oedipus, and I was the "sphinx," Gene Kelly happened to be in the audi-ence. There was a big hoopla in the press because the sphinx was so young, and my costume was very tight. The look was new and sensational. The press made a fuss over me, and I was asked to do a lot of auditions and movie people contacted me. But finally, it was Gene Kelly who came to Paris and auditioned me for *An American in Paris*. He was very gentle, very polite, as if he was talking to something made of very fine, precious, china porcelain. He said, "Well, I know you can dance, but I'd like to know if you are photogenic, and I'd like to know if you can act." He had been sent to Paris to screen-test another girl, but he slipped in a test with me, unbeknownst to MGM, thinking that I was the one who would be right for the part.

I didn't know what to do in front of a camera, and I found it all very cold, this great big steel instrument of the camera. I was used to an audience, and I was used to the lights. Also, I was extremely shy,

and it was very difficult for me to speak, as I was used to performing in silence. Speech was really a torture to begin with—and I wasn't sure of myself since I couldn't really speak English, so I learned a lot of my lines phonetically.

I stayed in California for about four years before returning to Paris.

I had been asked by a producer, Donald Albrey, who owned the New Theatre in London, if I wanted to do a play there. I said I would do Gigi as a warm-up for the film I was planning to do. And Don said, "Who would you like as a director? And I said, "Tennessee Williams thinks that a young man called Peter Hall is the best thing England ever had, so why not Peter Hall?" Peter managed to free himself from all his obligations and directed the play. And there we were. We fell very much in love.

We were married for about eleven years. We parted for career reasons: he had a very important career, and I certainly wasn't about to give up my work.

My greatest happiness were the years when my children were born, when I was twenty-five to forty. I very, very much always wanted to have children. My fifties were the most difficult years for me. At forty, I still looked like a young girl. At fifty, I didn't, and during that period I had the discovery of middle age. I was hit with a real lull in my career because I didn't look like a kid anymore, and I didn't move easily into middle-age parts.

I lost heart there for a while. During my fifties, I thought I wasn't good for anything anymore. It took a long time for that feeling to change. I decided to do something else, and I started an auberge. I think I was sixty when I tackled the immense job of restoring the buildings and launching the hotel/restaurant. I knew absolutely nothing of business, and I didn't know anything of the French working laws.

How it began was that I had a weekend house, a very old mill house. I would drive to town to buy groceries and there were a bunch of little abandoned stone houses on the side of the road, and I kept thinking, "These little shacks would make a wonderful little hotel." And then one day I was crossing over the bridge with my son, and there was a "for sale" sign on one of the houses. I think we bought it on the spot and asked the *notaire* if we could have the others as well. I didn't know how to borrow money from the bank; I didn't know anything at all when I started.

Meanwhile, in my sixties, work started coming back. I was offered a wonderful part in Louis Malle's film *Damage*, playing Juliette Binoche's mother. And I was also offered *Grand Hotel* in Berlin, in German, which was quite a challenge because I don't speak it! To my great surprise, when I thought my acting career was over, things kept coming—and things of real quality.

My mother committed suicide when she was sixty-seven. She was convinced that, since she had lost her looks and youth, life was over, and she was so wrong. But it affected me for a long time. I was also convinced in my fifties and part of my sixties that I had become worthless. I think managing the restaurant gave me authority. I was called "Madame Caron" by the all the employees, and I gave them their checks at the end of the month and was personally responsible for them. That gave me a tremendous sense of worth, and I knew I had more to contribute than just being a pretty girl with nice legs. It gave me a sense of community, and I was providing a service that was very important for this town.

In my second half, I feel comfortable. I feel pleased with everything I've done. I know some of the films were duds, and sometimes I think, ten years later, "If I had that part now, I'd know what to do with it." What's more important to me is people—friends, relationships, and my grandchildren, and their success in different professions and

in their lives. I have two children—Christopher and Jennifer, both by Peter Hall—and three grandchildren.

The nice thing now is that I think there's a natural compensation in that you get to know who you are, and to appreciate yourself. That really is the compensation for losing your youth. Also, experience makes everything easier in that you don't let people walk all over you.

I learned to be disciplined in the first half, and that helped me in the second. Discipline throughout life is essential. An offshoot of discipline is to do whatever you are doing well—if it's a voice-over, if it's a leading part, if it's cooking a dinner, do it without cheating. I think ballet gave me that backbone of discipline.

Another thing I've learned is that the most precious thing is to maintain your health, and I think that's something you have to start working on very early. That's also what I mean by discipline. You have to be conscious of the food you eat, the drinks you don't drink, and the cigarettes you don't smoke. All that has to be prepared long in advance if one wants a pleasant old age.

Apart from a little work like dyeing your hair and wearing makeup, I think one shouldn't worry too much about aging. It is important to keep in shape and be slim. Don't let yourself get heavy—this is really unforgivable for both men and women, and very bad for health. I've never suffered from hunger. I find that it's possible to keep your weight down if you eat sensibly. Of course, there's the discipline of *never* eating anything between meals.

I would advise younger women to have an important focus of interest. So, creation, creation, creation—the world demands people to be creative. There's always something you can do that will be useful for society, and that's the secret—
to be useful.

DR. FATHIA AL SULIMANI

Born 1950, interviewed at age 60 • Nephrologist
Riyadh, Saudi Arabia

I was born in Mecca, a holy place. There were nine children in the family. My parents supported education. There were no schools here in the beginning, so my father took all of us to Egypt, where we spent nine years. We grew up with only my mother because my father was working in Saudi Arabia, so he went back and forth to Egypt and gave her the money for the flat, for schooling, the clothes—everything. She struggled a lot because of our education.

When we returned to Saudi Arabia, I was in ninth grade. We lived in Riyadh. I went to King Saud School. Most of the girls liked arts. Nine of us didn't like arts. We liked science.

We talked to our director in the school, and we said, "We are not interested in art, in geography, or things like that. We like mathematics and science." She said, "I cannot help you." She said, "I'm going to call for you the man in charge of all schools." We covered our faces and we wore the school uniform, and we went and met him. We told

him, "We'd like to have science." He said, "Listen, you can read, you know how to write. Go and get married." We felt really bad.

At that time, there was King Faisal. And we knew that King Faisal was a good man and supported education, and he had said, "Anybody who has a problem, come to my palace." So we decided to go to the king, but we didn't tell our parents. We wore our school uniform. It was a Friday, which is our holy day. It was the evening time before the sun set. We were fourteen years old. We knew we would be really nervous, so we wrote what we wanted on a piece of paper. We went to the palace, and when we got there, we were shivering. Everybody wanted to cry.

There was a big line. By the time we got close to the front of the line, he was supposed to go to his mosque to say his prayers. But he saw us girls, so he didn't go to his mosque—he went back and waited for us.

He shook hands with each one of us. "What is your name? What do you want?" We gave him the piece of paper. That day I will never forget in all my life. He opened the paper, and as he read it, he started to smile. He said, "You don't know how happy I am to see Saudi girls coming and asking for education." He said, "I promise you, within one week we will open science to you." We were so happy! Finally, somebody listened to us. He said, "If you have any problem, please come again. I will follow your career." We prayed for him and thanked him.

Within one week, the science classes started. We were the first batch of girls to graduate in science. The king followed our education and followed our grades. He said, "If anyone has grades above 90, give her a scholarship to study medicine outside the country." To where, it was asked—to England or to the United States? "No," he said, "to another Islamic country. Have them go to Pakistan."

When I was seventeen, we finished our secondary school, and I got a scholarship to Pakistan for seven years. I did six months working in OB-GYN and six months in medicine.

My friends were sent to Lahore, but they sent me to Karachi because my brother was stationed there with the navy, so he could be responsible for me. There were seventeen Saudi boys and me sent to Karachi. I was the only girl. I was very embarrassed.

I lived in a hostel, a safe place for girls. After 8 P.M., no one was allowed out. The first night, I was crying, missing my home and family. My brother said, "I will check on you after one week. If you are OK, you will stay here. If not, I will take you to Lahore." Slowly, slowly I got used to it.

I would tell younger women that you have to depend on yourself. Don't let others interfere. You have to be good in everything—in your studies, in your career. Listen to expert people. Take advice from them.

I came back here to Riyadh in the beginning of 1979 and applied to King Abdulaziz University Hospital. It is the best hospital in Saudi Arabia. I chose internal medicine. I worked for two years, then I got married when I was thirty. My mother said, "You have to get married. I am having heart problems and I want you to be settled before I die." I was the last child who was unmarried.

At the time, I had applied and had gotten a scholarship to work in Canada as a fellow. My father pushed me and said, "Never mind, leave your mother and go to Canada. I can convince her later." But I saw her crying one day, and she said, "Fathia, I won't live long, and I want to be happy." After that, I said I would forget about the scholarship and get married.

Four proposals had come to me, so I asked my mother who to choose. She said, "You have a mind. You have a brain. This is your life, not my life. You are the one who has to choose." Thank God I chose a good man, Ham d'Allah. My husband had finished biochemistry from Indiana University, and he came to Riyadh and told his best friend that he wanted to get married. His best friend said, "Your future wife,

she is here. She is a doctor, well educated, from a good family. Introduce yourself to her." His best friend was my brother-in-law, but he didn't tell him that.

My brother-in-law came to me and told me, "There is a man. I knew him when he was young. We grew up together. Meet him. Study him and give your opinion. Mind you, your mother wants you to get married." My brother-in-law invited him to his house. The first time I met my husband, I sat with him as if I knew him for a hundred years. He liked me a lot. We met only two times. I said to him, "I like education. I want to go to Canada." He said, "Let me settle for two years, and then you can work on your career." His father and mother came to see me in my house with my father and mother. They liked me and we got married. We were both thirty.

I continued to work. I took night duties. Medicine is not easy. I wanted to be a good wife, so I took no servants. I did all the cooking and cleaning, ironing—everything. I got pregnant. The first child was a daughter—a sweet daughter. It was difficult for me to leave her in the house. My brother found me a housemaid, a Filipino woman. She helped me raise the children and stayed for fifteen years.

Internal medicine was too hard for me with my daughter, so I switched to nephrology. I had four children—three boys and a girl. I wanted to be a good mother, a good doctor, a good wife. So, when I came home, the first thing I did was supervise their homework. Then I cooked.

In the second half, every woman has some changes because of menopause. My children are grown up, so my responsibility is less. I am very close to them. My daughter used to tell me, "You are supposed to bring me a sister." I said, "I am your mother and your sister." I don't have a social life. I don't have time, especially now that I have my grandchildren. You don't know how much I'm attached to my grandchildren!

My deepest sadness was when I lost my mother. My day of greatest happiness was when my daughter graduated from school with honors. While she was walking in, tears came because she was an educated woman. She was first in her class. I cannot tell you the feeling.

My family gives me the greatest pleasure now. We all meet in my father's house every Wednesday night—all my brothers and sisters and their children. If anyone has a problem, we help. My sisters-in-law are just like my sisters. Our children come too, they get together, and we are open—the girls are not covered—because we are educated. Communication is very important. Thursday evening is the time for my mother-in-law. I respect her very much, just like my mother.

I'm happy because I did my job in life. When I enter the hospital, I forget myself, and I forget my family. I am there concentrating on those people. When I come out, I care for others.

I would tell younger women that you have to depend on yourself. Don't let others interfere. You have to be good in everything—in your studies, in your career. Listen to expert people. Take advice from them. Be a good wife. Don't depend on a housemaid, or you'll face a lot of psychological problems with your children. You have to take the time to take care of your own child. You are the mother. The picture will be reflected in the child. It has to be a good relationship between the mother and the children. Before work, before anything, you must be good in the home.

Be close to your husband and take care of him. You know, here, they can go and marry a second or third wife. Sit with your husband. What are his problems? What does he need from you? Why does he want to get married to another lady? What is he not getting from you?

MARILYNN PRESTON

Born 1946, interviewed at age 60 • Journalist, playwright, and Emmy Award–winning TV producer • Santa Fe, New Mexico, U.S.A.

I write a nationally syndicated newspaper column about healthy lifestyles called *Energy Express*. It is the longest-running fitness column in the country and reaches two million readers a week.

I grew up on the south side of Chicago. I got my master's degree in journalism at Northwestern and went immediately into newspaper journalism for nineteen years.

I was married in 1969 to Barry, a banker. We were both living in New York at the time. Later we moved back to Chicago. I was a critic and feature writer at *Chicago Today*, which folded into the *Chicago Tribune*. I reviewed TV, film, and theater, but kept my hand in feature writing. I became a full-time TV critic. I found that this was a way for me to comment on the world.

I was married to Barry for thirty-five years. Barry and I were very different. We had different views of the world, but it was a wonderful relationship. As you get older, you realize there is limited time left, and

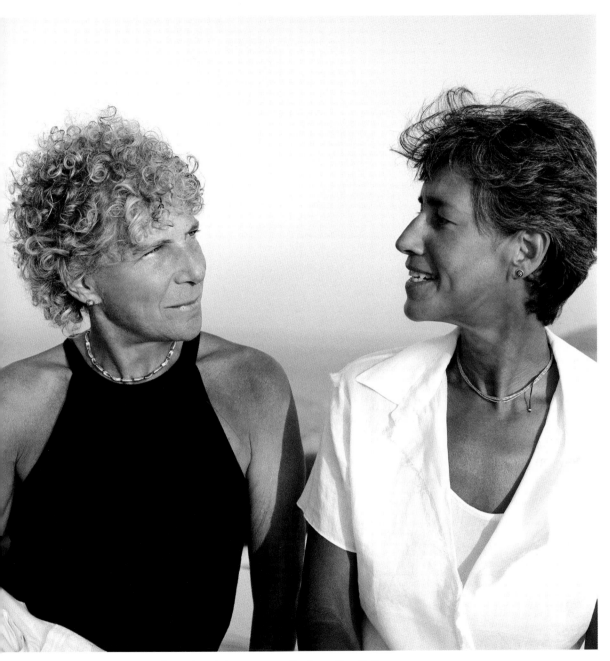

Marilynn Preston (right) with her partner Barbara Bonfigli

certain compromises that you have been making just don't seem good enough anymore. I knew that in order to be true to myself, I needed to change my life.

Barbara and Barry and I had been friends for many years. Then Barbara and I started working together on a television project. The more time I spent with her, the more I realized how lovely it was to spend time with someone who saw the world the same way I did, and who didn't undermine or ridicule my interests. I realized that if I was brave enough, I could change my life for the better in an important way. I'd been tracking the criteria for a happy, healthy life in my column, and I was suddenly faced with those choices in my own life. I knew that if I turned my back on the decision at hand, I could create real sickness for myself.

In the second half, I've learned the power of forgiveness. I needed to forgive myself for the pain I'd caused. I let go of anger and pain. I don't feel like anyone's victim, and I take responsibility for every choice I've made. I feel enormously grateful and energized about the unfolding of life in the future.

Leaving Barry and becoming Barbara's partner was the toughest and best decision I ever made. I think of myself as a kind person. I knew that on the other side of the pain I was causing, there would be a greater happiness for Barry and certainly for me. We have maintained a friendship that I'm certain will only get better. The number one goal for both of us in all of this was to maintain a loving relationship. From that place, the rest will follow. If there's one thing I've learned, it's that love is more important than money. Ending a thirty-five-year marriage was very difficult, but I already had begun to see how much happier life could be. I didn't love Barry any less during this time, and I think that made it easier. I was concerned about him, and I cared about how he'd get through it. I was confident he would—and he's getting remarried this fall.

I knew I had done the right thing as soon as I decided. I felt enormous compassion for the people who I loved who were hurting, and for the difficulties I had created. I had the support of family and friends. I feel sorry for people who don't have the courage to do what they need to do, who are trapped and shrivel up. I didn't want to shrivel. I was happy to live large.

Life is full of surprise. I've held to the belief that sexuality is just a spectrum. I don't feel I've signed up for the Lesbian Nation or for some cause. I just realized that it was OK to love a woman. True freedom is the internal acquiescence to the unfolding of life. I was surprised, but I accepted what is. I've been a student of many different religions, and all of them declare that you must "know thyself." I trusted that if I did, I would find true happiness.

For me, the second half has been better than the first half. I woke up along the way. I've read that at the end of life, what is most important is whom you loved and who loved you. And once you believe that you are obligated to open your heart and be open, that's the road to knowing yourself. You have to pay attention to that inner voice. Yoga, meditation, sitting in nature, slowing things down, and appreciating this moment are all ways to achieve this. You must check in with yourself. Most of the time that you are dwelling on the past or worried about something in the future is a waste of time. The practice of coming back to the present moment has made me calmer, less reactive, and more grateful. In my younger days, I had a much harder edge, and I used my humor in ways that were unkind. I know I've dropped that way of being, and it's wonderful to let it go. It's unnecessary and self-destructive. The second half is so much about being grateful. I've been very blessed.

The older I get, the more confident and calmer I get. Some people see aging as the funnel narrowing. I see it as expanding. I have more energy, more humor. My body hasn't been compromised. I feel

fortunate. I realize how important it is to stay active, eat well. Every week for thirty years, I have been writing about this, so I am constantly nurturing myself with information.

Now I know what's real. In the early years, I was more ambitious; I've flirted with a kind of fame in a small way, but I've managed to never get caught up in it. I've written two books. I've had three plays produced. I was on TV in Chicago for three years cohosting a morning talk show. All these tastes of "success" were tickets to ride, but I know that other things ultimately matter much, much more.

As you get older, you realize there is limited time left, and certain compromises that you have been making just don't seem good enough anymore. I knew that in order to be true to myself, I needed to change my life.

Now I let it go. I've redefined success in my second half. I have a lot of joy and love in my life, and I know I'm helping others to find balance and joy and strength in their lives as well, and that's very important to me. I'm still active as a TV producer. I have another play in me. If they happen, they happen. If they don't, that's OK too. I know how fortunate I am to be able to say that.

In the second half, I've learned the power of forgiveness. I needed to forgive myself for the pain I'd caused. I let go of anger and pain. I don't feel like anyone's victim, and I take responsibility for every choice I've made. I feel enormously grateful and energized about the unfolding of life in the future. I can't laugh enough. I still feel ambitious about certain things. I want to get this play done. I want to write more of them. Will we go through the same number of changes from sixty to ninety that we've had from thirty to sixty? Life is full of surprises, and I want to be awake and open to all of them—the good and the bad.

One of the things that continues to inform me is an interest in death and dying. It fascinates me. It's something that people shouldn't

be afraid of looking at, and I think the sooner the better. I want to go through aging and dying with humor and grace. I want to be awake and aware for my death—but not soon!

I believe that life is a story that we tell ourselves, so we might as well tell ourselves a good one. I like to envision an afterlife. Why not?

Be open to the experiences that will tell you who you are. You won't find that from a book, and no one else can tell you. Experience must be your teacher. Find those experiences that will reveal to you who you are, and that will be your path. And while you're on it, have as much fun as you can. If you sit quietly and listen to that inner voice, you'll know whether you've made the right choices. And if you haven't, be courageous enough to choose again.

JACQUELINE DÉLIA BRÉMOND

Born 1936, interviewed at age 70 • Publisher, co-founder and co-chair of Fondation Ensemble • Paris, France • Photographed in Patmos, Greece

I was born in Paris in the 5th Arrondissement and most likely I will die in the 6th—from one gate of the Luxembourg Garden to the other, this is my life journey! In the meantime, I have seen many places, done many things. I've had no plan for my life. I've been like a goat jumping from one rock to another, but I am very opportunistic. Like a cat, I have had several lives.

My parents lived in an apartment on Saint Germain, just in front of the Sorbonne. My father was a financial director for a big publishing company. My mother was a dream. I had no brother or sister. That's why I don't like noise; I like to be on my own.

When I was eighteen, I married a painter as young as me, whose father, a rich Romanian Jew, had died in a concentration camp. He was painting, I was studying at l'École du Louvre. Every month, money came in without any effort on our behalf. A poisoned gift. When he started drinking, that was the end. I left.

I met Stefan, who was first dancer at the Warsaw Opera. I was then working for a real estate company, living it up with jet-set society and not enjoying it so much. Stefan was different from the men I knew; he played chess and spoke six languages. When he defected from Poland and moved to Los Angeles, I followed him. I needed a change and, in the 1960s, the States was a dreamlike destination for any European. We lived in a transparent geodesic dome built on top of the Hollywood Hills by an engineer who was a great admirer of

> The second half is the period in life when the inside of a person starts to show outside. I have the same interests as I had before, but with the feeling, as time passes by, that my horizons have to widen to make sure the mind doesn't shrink together with the body.

Buckminster Fuller. It had three hundred and sixty steps to climb up to reach it, so it was very cheap. I had four years with Stefan. We were poor. I was an interpreter; I took any job. We were like two fish in a glass bowl. The two fish had a child, Nathalie, who was born in Los Angeles in 1966. When she was six months old, I left Stefan, and Nathalie and I returned to Paris. Later on, Stefan became successful and the best family friend.

So, I was thirty, I had a child and no money. The only thing I knew a little bit about was writing, so I got a copywriter job in an ad agency. After two years, I left and launched my own company.

In the meantime, I met Gérard, the Man of My Life. Now, after these forty years we've been together, Gérard has become a rich and powerful businessman, but when I first met him, he was just a young man in his thirties whose only dream was to become a great jazz musician. He played guitar and bass. One unhappy day, someone came and borrowed his guitar and started to play. The man was so good, Gérard said, "I'll never be a great musician." He stopped playing immediately and started working in his father's

real estate development company. The company he built, Pierre & Vacances–Center Parcs, is today a leader in the European tourism industry.

With Gérard, I gained two lovely children, and by now my agency was successful, which made me proud, as I came from a background where women were not encouraged to earn their own living. But I was interested in feminism and started to work as a photographer for a magazine called *F* for "femme." Yet words were still my universe, and when a publishing company asked me to create a collection of foreign literature, I jumped at the chance.

I was fifty, just beginning the second half of my life. At L'Etrangère, I published good novels, but I was questioning life, and trying to get answers to some fundamental problems. Assuming other people were sharing my search, I started a new collection of philosophical reflection, *Ose Savoir* (*Dare to Know*), from Kant's injunction.

Everything I did was always full of will. There was nothing that was impossible. My father was like that; he thought that if you have good judgment, there is no limit.

When my daughter was growing up, I couldn't let go. I had to be in charge, to be in control. My daughter did every stupidity just to prove to me that she was in charge. She needed and wanted to develop her own personality, but I was too controlling. I was always there, full of love, too present. This was very difficult for her. She had two fathers, neither of them with her, and an overpowering mother who was desperately trying to be right.

Our relationship became very tense. It started when she was fourteen and lasted until she was seventeen. A most difficult time. I was destroyed. She loved me deeply, but I was in the way. When she was seventeen, she moved in with her father in Los Angeles and went to Santa Monica College. After four years, she returned to Paris and started to create her own show. She acted, sometimes with others,

sometimes in her own one-woman show, for four years. Then she met some Buddhist people and started to meditate. She did a silent retreat for three years, three months, and three days. That was a long time not to see, not to hear, not to touch somebody you love; it was a great teacher to "let it go." Almost at the same moment, a serious accident jeopardized my life. The two events made a sort of a miracle: my relationship to the people around me changed drastically. It opened a path to freedom that I never could have imagined before. Now Nathalie and I have a fantastic relationship.

The second half is the period in life when the inside of a person starts to show outside. I have the same interests as I had before, but with the feeling, as time passes by, that my horizons have to widen to make sure the mind doesn't shrink together with the body. Gérard gave me the rare opportunity to set up a foundation and make it work, so it's my everyday task to look further than my private inner circle, and I strongly believe that widening one's horizon is one of the best ways to stay awake and young at heart. Our foundation, called "Ensemble," which means "together," is a wonderful asset for that exercise. At the same time, I try to cultivate an inside space where I can retreat and where life will remain intact when my body won't care so much for action.

The most important thing I learned in my life was to let go. I learned this in my second half thanks to my daughter. The thing that has always given me the greatest pleasure in life is to feel free. That hasn't changed.

I feel at ease most of the time. I try to live every moment as fully as I can, knowing that there are not so many left. I look to the future with expectation, as tomorrow is now. I want to be remembered as a tiny part of a magnificent whole.

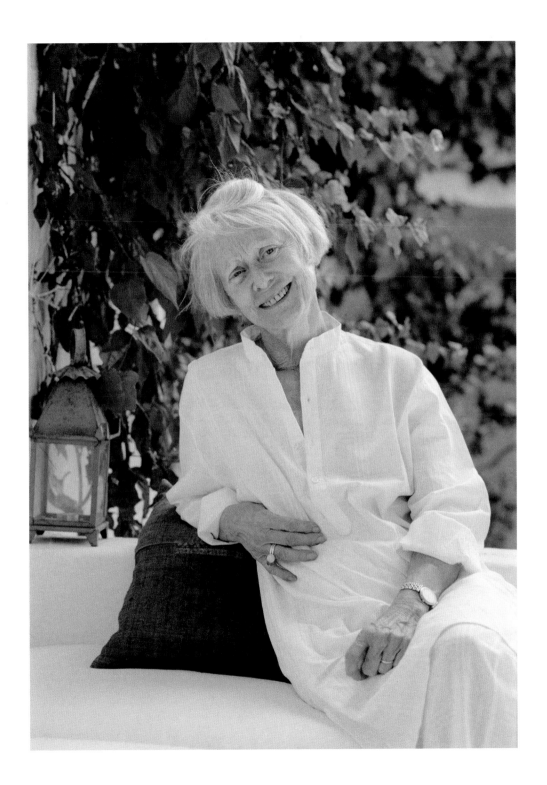

JACQUELINE DÉLIA BRÉMOND

FATMA DOUFEN

Born ca. 1945, interviewed at age 62 • Tuareg nomad
The Sahara, 36 kilometers from Tamanrasset, Algeria

I prefer life now in the second half because I have more time. I am free and I can do what I want. I can visit my friends in another village, or they can come here. When I was young, I had to go to the river to bring water, and I had to go to find wood and go out with the sheep. I used to have to milk the sheep in the morning and again in the afternoon. I had to grind the wheat. There was much work to do.

When I was younger, many families lived together, and when it was your turn to cook, you had to cook for everyone. I made the butter. I sewed the skin of the goat into a container for the milk. From goat hair, I made string. Now my daughter does that work. Now everyone comes to visit me. When you are old, you have an important position. You are respected.

Nothing is more or less important to me now than it was when I was young. I am not afraid of dying. Now the children are old and I worry less about them.

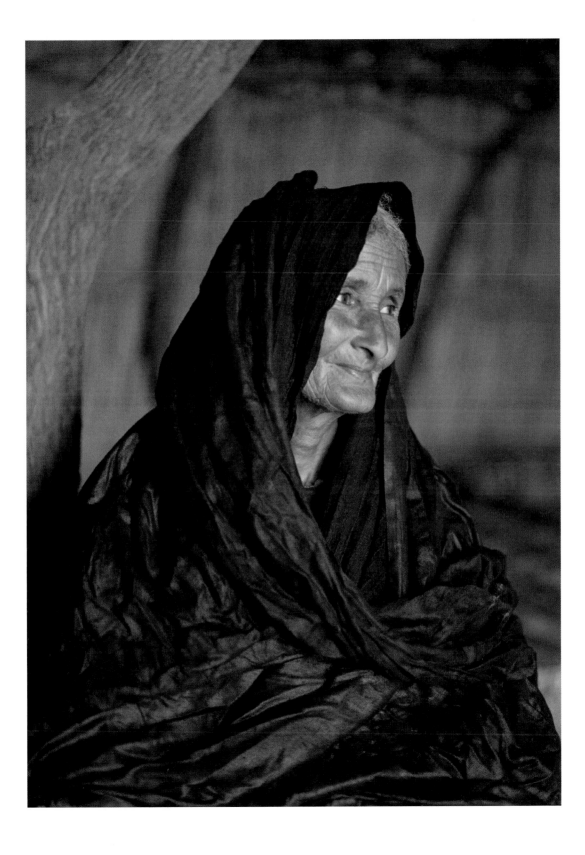

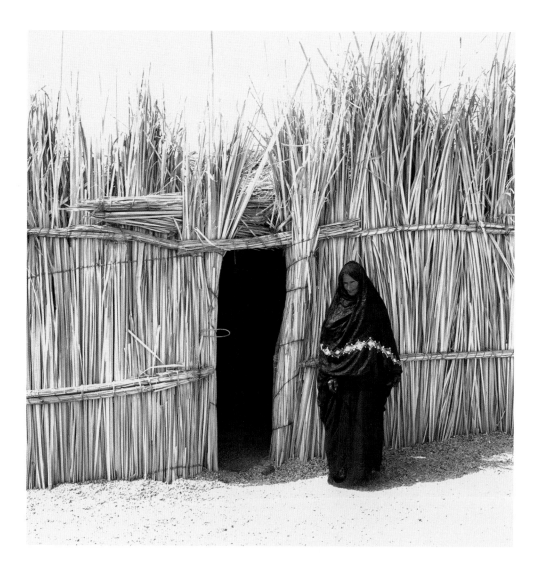

My happiest times were when I was married and when my daughter was married. And I am always happy now when I have guests and when it rains, because that means there will be water for us and grass for the sheep. I am usually happy, but I am afraid to learn that someone is ill or dead. I am afraid of sad news. My saddest times were when my mother died, and when my husband was ill before he died three years ago.

I can't think about tomorrow because I don't know if I will be alive or dead. You must live in the present moment. It's important to have guests because an empty house is not a good thing. You must stay in your home in the middle of your family and never make problems with others. It's better to shut your mouth.

If someone asks you for something, even if you only have one of this thing, you must give it to him. If you have some wood and your neighbor asks for it, you must give it to him. Even if you have nothing for your own dinner, give your neighbor what he asks for. Your house must always be open to other people. If your neighbor says, "My sheep have gone away," go with her to look for them. If she has guests and doesn't have a carpet, give her yours. If she has a baby, cook for her. Never say no, and always help others.

FRANÇOISE SIMON

Born 1931, interviewed at age 76 • Portrait painter
Paris, France

I was born in 1931 near Paris, in the Chateau de Villiers, an eighteenth-century family house. When I was eight, it was wartime, and we ran with my brother through France with the Germans chasing us to Biarritz. You know, as children, you think you are the most important thing on earth; if the Germans invaded France, they wanted to capture *us*. At that time, France fled in front of the Germans, but once the Germans occupied France, we were able to go back to the Chateau.

My parents started in the Resistance very early, and in order to get us out of danger, they took us to the center of France to our grand-father's place in the middle of the woods. We spent the rest of the war there. When it was over, I was thirteen or fourteen, and we went back to Paris.

I was sent to many convent boarding schools. I didn't do very well; I was kicked out of many. It wasn't easy for me to adapt to school. Then finally I was sent to St. Mary's Convent in Cambridge, England,

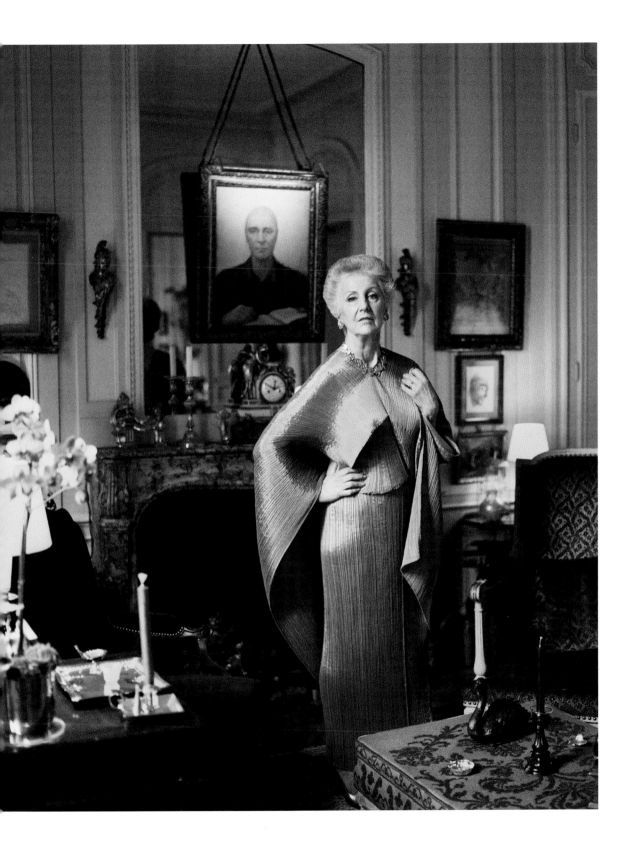

where I spent two wonderful years. I was seventeen when I left, and was sent to a finishing school in Florence. There I spent another year, and it was there that I started painting very seriously instead of just having fun with pencils and brushes.

I was constantly insulted every day by a painter who said I was no good at all. It was the opposite of art school today, when one has to encourage everyone. It was wonderful being in the beauty of Florence. Of course, there were no tourists right after the war, so Florence belonged to the Florentines and to people like me. It was like Florence in the nineteenth century.

Everything is a bit blurred when one is young, and then comes the second half—the time when you have to make clarity out of the blur. It's a time to make judgment on oneself—judgment about what one has done, and what one has not done—and to make the best of what is left. There is no escape.

The finishing school was ruled by a British lady who was the widow of a British Army officer, and she was stiff with gin at eight o'clock in the morning. We had some of the best Italian university professors. They were starving, and they would do anything for money, even teach stupid girls; it was shameful. I spent a year there and then I came back to France and married very classically to a famous French name. I had a wonderful daughter, and then I divorced at thirty-two after twelve years of marriage.

I remarried two years later to a scientist. We were married for thirty-one years before he died. He bought a big mansion in Gascony and there we had international scientific meetings. He was very handsome in a particular way. He was one of the fathers of artificial intelligence. There were a very small number of scientists who had the instinct that this sort of technology was going to be the big thing. He was one of the most brilliant people I've ever met.

I abandoned painting a little bit when I was married to my first husband. Then I started painting again when I was about twenty-five, and I never stopped. I always painted portraits. My first commission was when I was fourteen. A Danish diplomat commissioned me to paint portraits of his two sons. I have just finished painting the portrait of the archbishop of Paris. Thankfully or not, I have a way of understanding what a portrait can be. When I paint somebody, I isolate, I immobilize, and I keep the sitter quiet. These are the three conditions of meditation. People's real faces suddenly appear, the secret face they have when they are alone. We all are playing a part when we are in public. We are social beings, and the more we love someone, the more we want to please, so the more we lie. We want to be amiable.

I also paint still lifes. I paint everything and I show those in exhibitions. You cannot experiment on a commission. You can only find new techniques when you paint other subjects—then you can apply those new techniques to your portraits. When someone competes in the Olympic Games, it means that he has practiced a lot. With practice, the eye changes. You have to provoke a change of vision. Every painter of value has shown something no one else has seen. A painter has to establish a coherent, new way of seeing things that applies to everything. This is what the great painters have done: invented a new way of approaching reality.

Everything is a bit blurred when one is young, and then comes the second half—the time when you have to make clarity out of the blur. It's a time to make judgment on oneself—judgment about what one has done, and what one has not done—and to make the best of what is left. There is no escape.

As we get older, we must stop having the dreams we had when we were young. We must have aspirations, but not the romantic dreams. Life is not a romance anymore. It is something more serious.

We have to be scheduled about the small amount of time that is left, and therefore we mustn't lose time.

I've narrowed the field and concentrated on what is important. I want to concentrate on my painting, and also prepare for old age and death. It's a very interesting process. You have to train yourself to accept death in order to arrive at it honorably.

My sense of what I am for others has changed more than my sense of myself has changed. Others find me to be older than I feel inside. Not being ill, I forget that I am old. It's a dichotomy. I learned nothing in the first half. I am trying now. One has to learn something every day. Everything is a surprise.

My time of greatest happiness was when I was forty, because I was happy with a man who suited me perfectly. Life was fascinating, intellectually demanding—everything I really wanted it to be. Things became very interesting from when I was thirty-nine until sixty-nine, when he died. I had to face the death of one half of myself, so I really had to take care of the half that was left and make the best of what he had given to me.

There are different sorts of sadnesses—there is the negative sadness when life is not good; a halt in time. A real sadness for me was losing someone with whom I had been in great harmony. You once discussed everything with this person all the time, and suddenly it's silence. You read a book and there is no one to talk to about it. You have no one with whom you can share what happened at a dinner. You are never sure you are understood. Your vocabulary, which was perfectly clear to someone, is not necessarily clear to anyone else. You have to make your happiness within yourself. There's a great difference between happiness and joy.

Looking back on my life, I had pleasures on different levels. Being a painter, I have more satisfaction in looking at things than many people. The art of admiration belongs to me. Discipline is

important. Try to understand what it is you want to do, and make the best of it.

I feel well within myself. I feel engaged with life because there is no time to lose. When I think about the lives of other people less fortunate, I think that it would be shameful for me to be complaining. I want to be remembered for a few decent paintings. I have no idea how other people think of me now, so how can I think of how I want to be remembered? I really don't care. I won't be there to enjoy or regret their opinion.

There is no future. There is only the present moment, which is there to be lived. It has to be accepted as a permanent impermanency.

LUISAH TEISH

Born 1948, interviewed at age 60 • Shaman, teacher of Transformation, and spiritual anthropologist • San Francisco, California, U.S.A.

I was born in New Orleans in 1948. My mother says that she went into labor with me when she was sitting around with a group of friends cracking jokes.

I grew up in a family of nine children. Though I've walked in the world as an African American woman, my ancestry is mixed. My mother's father came from Haiti, and her mother was half Choctaw. My father's people have all the characteristics of being Congolese, but he grew up on a sugar plantation in Louisiana. My name is the name I received in 1968 when I was initiated into an Egyptian sun-worshipping temple.

I went to a Catholic elementary school in Louisiana. At the time of junior high school, I had to walk two miles to stand on the freeway and wait for the bus that took colored children two towns away. The boys in the Klan made a habit of shooting at colored children, so we had to know when to run and hide, and when to come back to the freeway to wait for the bus.

Then I left home with an aunt and went to Southern California.

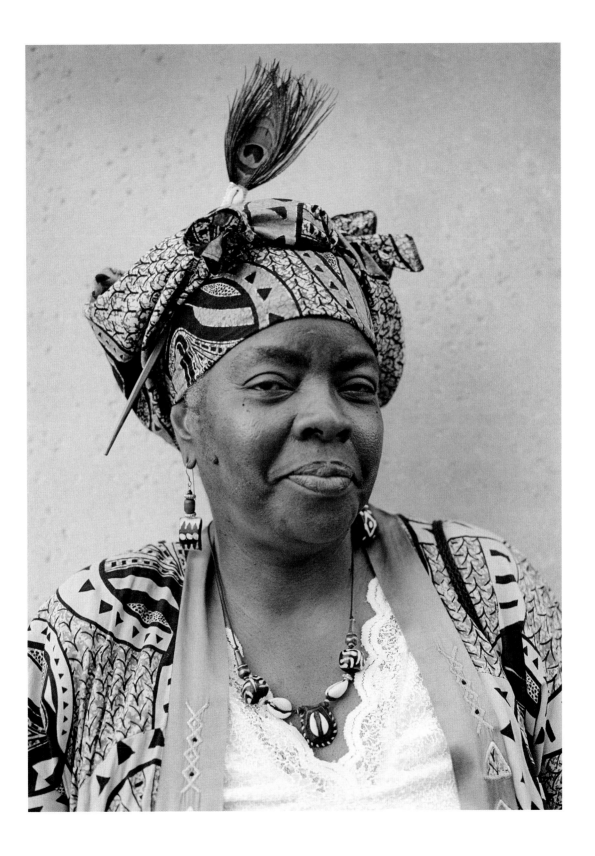

For a brief period of time, I belonged to a street gang in Los Angeles. Either you belonged to a gang or you got beat up by one. Gangs have territories, and me and my cousins were considered bold because we lived in our enemy's territory. You had to go through an initiation, which I still won't talk about in terms of what happened. You had to demonstrate loyalty, courage, and strength, and a sense of kinship to other people.

The fortunate thing for me was that at the same time, I had guid-ance from two teachers at high school to whom I'll always be grateful. One encouraged me to pursue a career in dance on a Friday, and when I got to school Monday, she was dead. That made me determined to be a real good dancer. The other teacher who really saved my life was my journalism teacher. She recognized that I had potential as a writer, and she put it to me point-blank. She said, "You can stick with me and be a writer, or you can keep going the way you've been going and end up either crazy or dead." It's with gratitude to these two women that I'm a writer and a performing artist today.

I got a job with the Neighborhood Youth Corps. I was elected to the position of editor in chief of the school newspaper, which put me in the student body government. I served on the Police Community Review Board for the school. My anger got rechanneled into working for justice.

I graduated from high school with honors and got a scholarship to Pacific University in Oregon. The student body was eleven hundred. There were thirty-five Black students.

I left Pacific University and went to Reed College. In 1968, there was an insurrection where the students took over the administration building and demanded that a Black studies program be initiated. We won that battle. I was a serious community activist not only for Black studies but I was also part of Operation Green Thumb and part of Albino Center Freedom Schools, which was set up in the ghetto to

offer culturally relevant educational materials. I was also a member of Volunteers in Vanguard Action, fighting for the rights of Mexican migrant workers.

From Reed, I got a scholarship to go to East St. Louis, Illinois, to a performing arts training center under the direction of Madame Katherine Dunham. She was considered the First Lady of Black dance. I was with Madame for a year and a half as a teacher trainee. The first month I was there, the other dancers laughed at me, but in six months I became the lead dancer. Being with her troupe brought me in contact with people from all over the world.

I broke away from her and went to the Black Artists Group in St. Louis in 1970. This remains in my mind as the most creative period in my life. I became the choreographer. When I arrived, there were two dancers and one piece of choreography. I opened it up to the community. We kept ourselves alive for three years doing classes for fifty cents a person. We were experimenting with spiritual practices. People would fast for thirty days; we would go into intense meditation. I had to go into a silent retreat for sixty days; that was completely psychedelic.

In the second half, my sense of who I am has changed. A lot of my earlier work feels as though it's become compost for what's growing in the second half.

Intensity like that cannot endure. My love life went to hell, I had a miscarriage, people ran out of money. I decided I had to leave if I wanted my career, and my life, to go anywhere. So I packed up my stuff and headed out to California with nothing but one suitcase, a box of macrobiotic food, and twelve dollars in my pocket. I stayed with a dancer I knew. There was a place on the corner of 51st and Broadway in Oakland called *Everybody's Dance Studio*. It was a multicultural dance studio, but she didn't have an African dancing teacher. She hired me to start a dance class.

I got pregnant and delivered a baby who died. Two dancers who I was close to died. I took a bunch of pills and tried to check out. Instead of dying, I had an out-of-body experience where my spirit sat up on the ceiling and told me that I had come here to do something important and that I couldn't run away. A friend sent me to see a Cuban priest. The priest said, "You are the daughter of the Love Goddess." I said, "Bullshit!" He said, "Not only are you a daughter—you are a favored daughter. The finest jewelry is tempered in the hottest fire, then plunged into the coldest water before it's polished. Now it's polishing time." I woke up.

Even as a child I'd had prophetic dreams, and I used to see spirits and knew things before they would happen. I had an interest in all the mystery that was going on around me. Where I grew up, it was taken for granted that dreams meant something, that the birds and animals talk to each other, and that the dead talk to you. I would see my mother and her friends do things like invoking the rain, interpreting dreams, and snake handling; all you could do was eavesdrop and wonder what they were doing. If I asked my mother what they were doing, she would say, "That's what the old folks say." Finally, one day you realize that the old folks are the ancestors.

I was initiated into the Orisha tradition in 1982. It qualified me to help others determine whether they're fulfilling their original contract with creation. I have been trained in certain medicines, rituals, and divinatory processes to help people transform their lives and get back in alignment with who they really came here to be.

In 1985, I published *Jambalaya: The Natural Woman's Book of Personal Charms and Practical Rituals*. *Jambalaya* became a women's spirituality classic. Since then, I have traveled all over the world performing the mythology and folklore of various cultures, highlighting the positive role of women in religion and culture. In 1993, my immediate elder gave me a chieftaincy on behalf of the elders of Ile-Ife,

Nigeria. Ile-Ife is our Mecca, our Rome in southwest Nigeria. I did a lot of work to end apartheid in South Africa. For twenty-three years, I've taught at the University of Creative Spirituality. I've taught holistic studies and transpersonal psychology, and I've taught ritual theater and spiritual autobiography. I am the founding mother of a temple called Ile Orunmila Oshun, which means "the house of love and destiny" in Yoruba, the language of southwestern Nigeria.

In the second half, my sense of who I am has changed. A lot of my earlier work feels as though it's become compost for what's growing in the second half. I educate differently. As I get older, material things are less important. I'm prouder now of having been a country woman, but as a teenager I was ridiculed for being from the South and doing gardening and making homemade stuff.

Seven years ago, I left a twenty-one-year marriage. What is kind of depressing is that the prospect of finding a man I can both talk to and sleep with seems hopeless. I'm a sensualist; I love bright colors, beautiful scents in the garden, the magic of the earth giving us beautiful flowers, well-seasoned food, interacting, and intimacy.

What I've found is a need to rearrange my talents in the second half because of diminished cooperation from my body. I want to adjust my sense of self to the physical downshift I'm experiencing without a loss of soul. I have to take a look at where I can have the most positive impact.

What I have to give to the coming generations has become very, very important because, actually, they seem even less empowered than my generation.

My advice is to be true to yourself. Know that you have power and use it. Enjoy your life, and let no man dominate you. Don't let him do it.

PERLA SERVAN-SCHREIBER

Born 1943, interviewed at age 62 • Publisher, writer, and founder of *Psychologie* magazine
Paris, France

I was born in Fes, to an old Moroccan Jewish family that had come to Morocco in 1492 from Spain. I went to a Jewish school, and after that I stayed in Fes for college and for one year of university studying law. Then I moved to Casablanca where one of my brothers lived. Because we were a very poor family, each sibling helped the next. I lived with my brother and continued my studies in law and political science for three years. Then I moved to Paris to continue my doctorate in French.

I adored Paris immediately, but the difference regarding education was so enormous. In Morocco, there were sixty students in a class. In Paris, there were eight hundred. You could never speak to the teacher. It was not so difficult in Casablanca to work part time and study part time, but in Paris, everything was so difficult that I gave up.

My wish had been to be a teacher of law at a university. When I stopped studying, I looked for a job in something else. My luck was to

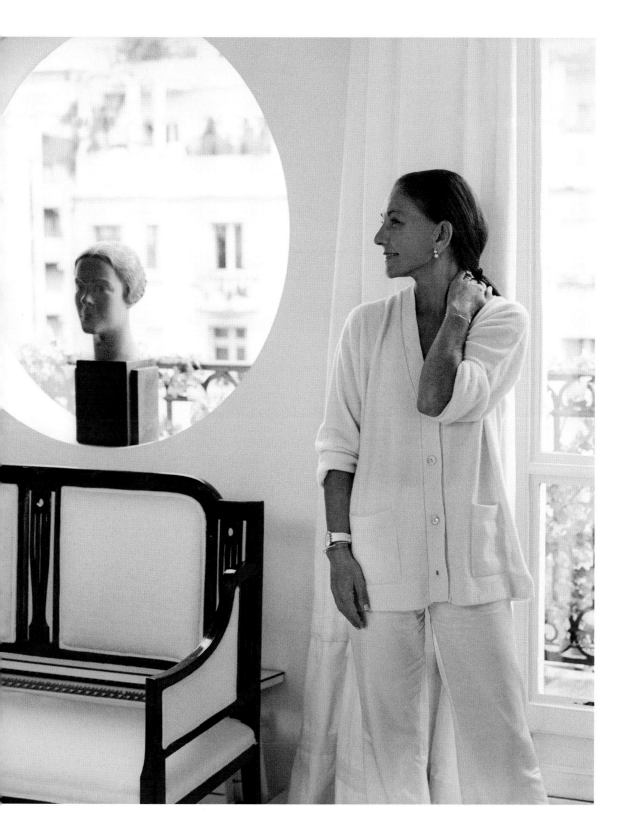

find a job in a fashion magazine called *Elle*. I was hired at age thirty-two to work in advertising and marketing, and I never stopped. I stayed at *Elle* for a year and a half, then immediately after I went to *Marie Claire*. I stayed there for seventeen years. I was the managing editor of marketing and advertising.

In October 1986, I met my husband, Jean-Louis. I had an idea for a new fashion magazine and was looking for money, and Jean-Louis was a famous editor, so I went to him to ask for backing. I never did publish my magazine, but I married. I found a husband—not a magazine! He was forty-nine and I was forty-two. I had been with one boyfriend for fifteen years when I met Jean-Louis, but I had never shared an apartment with anyone.

I never wanted to have children. My goal in life was to enjoy life as a couple. My mother was so exhausted and sad about her life because she was married when she was fourteen—in that society, it was like that. I'd always heard my mother say, "If I didn't have children, I'd be free." She was not very happy with my father, and having six children and being poor was difficult. In my body it was written, "Be free all your life." There is no place for children in that. Now I can't stop working because life has been very good for me. I'll continue until the last day of my life.

Until my husband, I never owned anything—not a bicycle, car, nothing. I want to be free and be able to prepare my bag and leave. I want to have my wings. That's the center of my life.

I've been married for twenty-two years of real happiness. After we got married in April 1987, it was ten years before we started *Psychologie* magazine. During the first ten years, I worked part time with Jean-Louis at *Expansion* and I wrote three books. I wrote my first book, *Le Métier de Patron* (*The Role of the Boss*), in collaboration with Jean-Louis. At university, you learn how to be a manager, but you don't learn how to be the boss. I wrote portraits of the most famous

bosses in France at that time. I wanted to understand how they became the boss, what was the psychology.

My second book is about femininity; the title is *Femininity: From Freedom to Happiness*. It was the story of my generation, when so many women said, "We are free, but what about happiness?"

In the first half of life, I learned what exactly I desired, what exactly I wanted, who exactly I am. You live many years trying to satisfy the desire of a mother, a boyfriend, a boss before you realize what you want for yourself. But it took me some time; life was difficult in my teens. We were poor. We had a very nice family, but they were very conservative. I felt very constrained; I was fifteen kilos heavier, and I didn't like my body. It was very strange. I wasn't depressed, I had a lot of friends, but I didn't like the life that was expected of me. I didn't know if one day it could change. It's very important to feel that you are in the right place in life, and when I was a teenager, I was looking for my place.

I hated my adolescent years, but since turning twenty-five, I have felt better each year. Now is the time of greatest happiness. I am quite sure about who I am, I live with a man who I love, and he loves me, but it's a question of confidence. I have it now. Confidence in myself and in my relationship with my husband. "Confidence" is the word most important to me.

You can tell me that I am old, that I have wrinkles. But I take care of myself a lot. I take good care of my body. I eat the best food, I sleep, I have no stress. That's an important part of freedom: when you stop trying to impress people. Just to be what I am is the best for me. It is something that I feel very deeply in my heart, in my body. Of course, there are some days when I'm not there with the best energy. Of course, some days inside it feels difficult, but it doesn't matter because I know that I will always be myself.

Once a year, I go to an ashram without my husband for five days. During those five days, it's completely silent. Even during meals. I also

do meditation every day at home immediately after I wake up. I take a coffee, and after I wash my face, I go to the same place in my office. I meditate for twenty minutes, sometimes thirty, and afterward, I do exercises. I wake up at 5:45 A.M. during the week, but not on weekends. Then I walk. That's also a kind of meditation.

The main difference in the second half is that we know better what we want, and after that, everything is simpler. You have to learn to choose, to renounce. It's very important to renounce. When we are young, we want to do everything. It's not this *or* that—it's this *and* that. But life is not like this. It's always *or*. To renounce is not something sad. It's a happy choice. You have to know who you are, what you want, and what your priorities are.

It's a kind of miracle to be able to work with my husband. The secret to this is space. We have our own areas in our apartment. We are lucky we can: it makes it easier to *reussir son couple*. The most difficult thing is to live as a couple and build a good relationship over a long time and to keep desire for each other. That's a job also. It's important to keep your appearance, to feel good in your body. It's the same for him. It's also important to share the same philosophy, to make your minds grow with each other.

Do you believe that in a couple, love just grows alone? Of course not. You must have thought, time, imagination. Love is not only a gift—you have to work on it. You have to be conscious. It's a job. You have to organize, you have to say, "Of course I have a lot of work, but I have to go and see my mother or my friend and bring them some happiness."

I am really very comfortable with what I see as the main rule of existence: that everything can stop at any moment. I feel that I'm lucky to have good health, to have energy, to have desire, to have curiosity to learn a lot of new things every day, and to have such nice people around too. My life is a love story because in the middle of my life, there is love. If I can help and bring some happiness, then that's a love story.

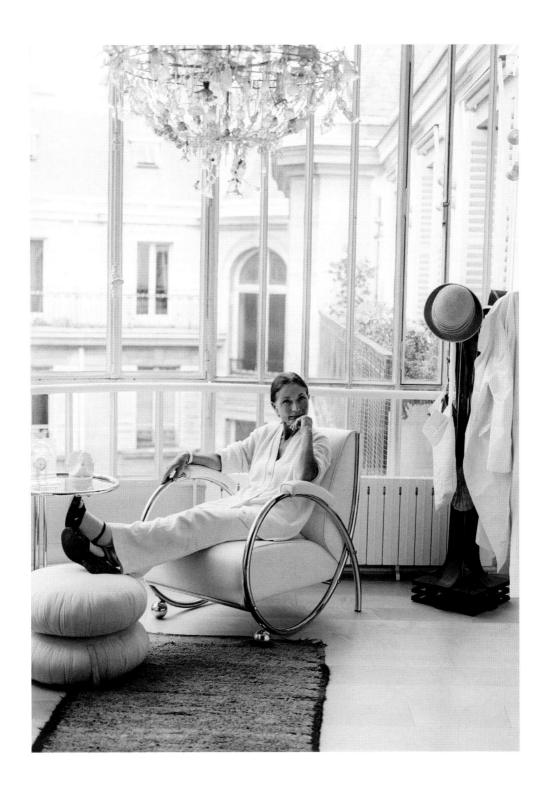

PERLA SERVAN-SCHREIBER

IRENE CARLOS

Born ca. 1900, interviewed at age 107 • Retired cook
Antigua, West Indies

I've always lived in Freetown. I was a domestic, hardworking from birth. I worked for a lot of people. I cooked. My mother was cooking, and she took sick. She asked if I could come and help. I delight in cooking.

I went to school and I tried to grab the little learning that I'm using today. My mother died, and I had to go out in life to find something to do to keep things together. I was bright, and God has helped me up to today. You can't fool me easily.

The first part of my life was more troublesome. But people were more sympathetic than recently. If I was short of money, people would help me. When my mother died, I went to my employer to get money to bury her. Life was harder when I was young, but people were nicer. My first half was happier than now. Things used to be cheaper; mackerel and herring were much cheaper. Sugar was a penny and a half a pound. Flour was six pence a pound. You could make a good living.

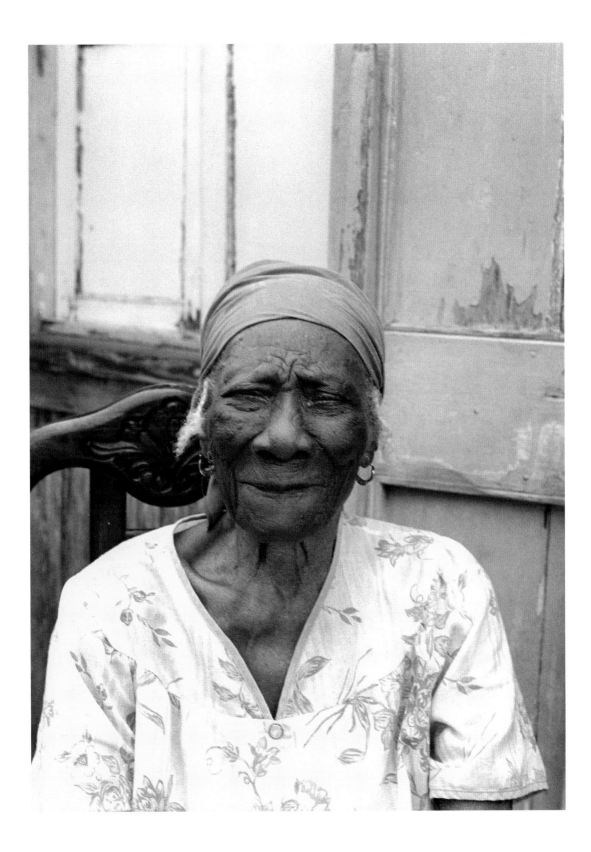

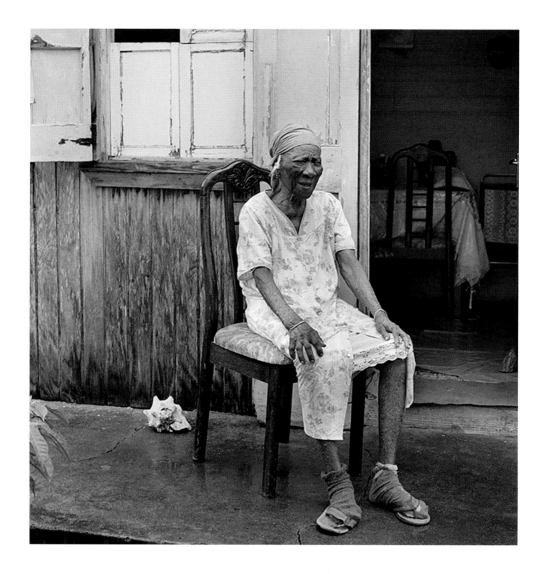

I have no children. I never married. I don't put up with foolishness. I intended to get married, and the man tried to fool me and had someone on the outside. I was engaged, but he deceived me. Men are so deceiving. You can't trust them. So I said, "Go." I didn't want to go to the police station with a man. I almost had a baby once, but the doctor took the baby to save me. I was close to fifty. I thanked him and told him I was glad that my life was spared.

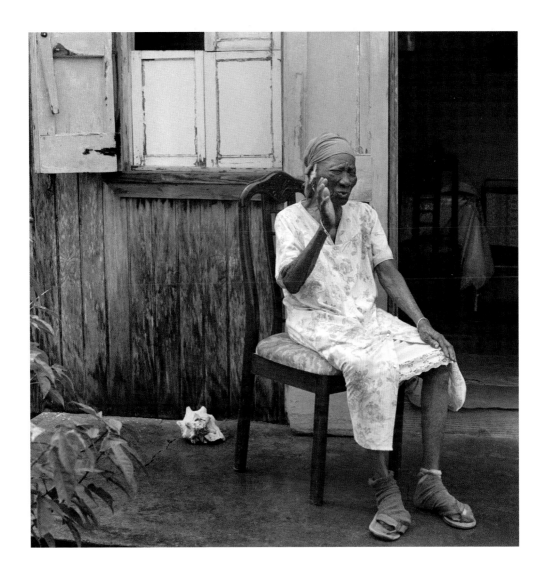

When you don't have people of your own, you have to make out the best you can. I have arthritis in my two legs. I can't do much walking. I have my stick. The government gave me a wheelchair, but I don't have anyone to push it. By the help of God's mercy, I've tried to take care of myself. I'm the oldest person in Antigua, you know.

I had one sister and she died. I have one brother, but I don't see him. My sister lived with me and we got along very much. Her name

was Doris Carlos. One day, she went to the doctor. I had a bad feeling. I asked my employer if I could leave early. She said, "Try and make up something for supper." I did and went home. I had the privilege to close my sister's eyes.

I love dancing and singing. I used to go to concerts and any-where there was dancing. I still dance and sing. As I hear the band, I'm ready. I still have that little shaking just to make me feel good. I like to recite things I knew when I was young. I used to act in plays. I had my broom and danced. "Here we go luby lu, here we go lubi li." I liked to be on the stage. I was a good stepper too. When they saw Irene at the door, all eyes were on Irene. Well, I can't do stepping now, but I still try. I like singing too. I like to go to church a little late so when the door opens, everyone looks back!

> **I never waste time. I liked to keep up with the elderly when I was growing up. They give good advice.**

When I was young, I was never afraid of anything. I'm not afraid of being alone—only if I should take ill when nobody is around. I like people to be around. When people visit me, I like to joke to tickle the brain. My nephew and his wife take care of me. He works at the airport. They come on Sundays. She comes and washes my skin and washes my clothes. Once a man, twice a child.

I'm not a lazy woman. I liked to be working. I carry a good name. Never out of a job. I'm not praising myself, but I have a good name. I always try to be friendly. I speak very politely and I'm respected in the community. For you to gain respect, you have to show respect. All that I work with, they always care for me. It must be what you do, the service you give. They had real confidence in me. I'm not boasting. I had a good time in service.

I never waste time. I liked to keep up with the elderly when I was growing up. They give good advice. People who are out of the world can tell you what to do and what not to do. Young people now come

and ask me for advice. I tell them: know the life you're living, and if it's not useful, cut it out. Some women go into life too soon. Wait until your time comes. Check out things before you rush into it.

It's God's mercy that I'm here. It's a privilege from God. Many have gone younger than I, and I am here to give God thanks for his protection of me. The word of the Lord becomes more important. Even when I wake up at night, I give Him thanks. I never leave Him out.

I have spent some good time in the world. I'm very happy—very happy, only sometimes people around me get agitated. I'm happy to know I've reached this age. I've never been to the police court.

When you are young, you take part in the activities that take part in the world. When you reach a certain age, you have to stop.

Life is sweet, you know.

NI KETUT TAKIL

Born ca. 1932, interviewed at age 75 • Jero Balian (sacred healer)
Banjar Baung Sayan, Ubud, Bali, Indonesia

I am from this village. I had eight brothers and no sisters. My father was a rice farmer, and my mother helped my father in the fields. We were a poor family, but there was a lot of love. We ate rice with corn, rice with sweet potatoes. In those days, we were very poor in Bali. We only had one rice crop a year. Now, with technology, we can have three rice crops a year.

During the war, when I was about ten or twelve years old, the Japanese came to Bali. They took me to work on Turtle Island and at Kuta, carrying stones for construction projects. The Japanese gave me money for food, just enough not to be hungry. I slept in the balai banjar (a public place in each village where people can go to rest). When the Japanese left, I walked home. It took two or three days.

I was about fifteen when I got married. I didn't want to be married but the family wanted it. I knew my husband, and I didn't love him, but my parents said I had to marry him. The first time he tried to have sex with me, I ran away, but I couldn't run away forever. Once

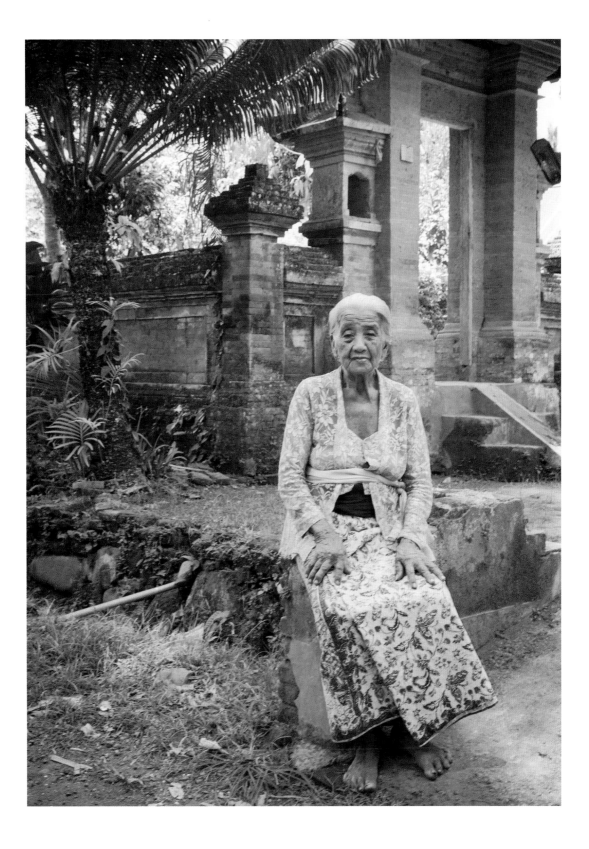

it was done, I felt OK about it. He is a good man. We always lived together and never fought, but we didn't have any children. In Bali, if a person doesn't have children, they can take a child from their brother or sister. I took a little girl, and when the girl was married, she left to live with her husband's family.

My husband, Made Togog, is a farmer. He's in the rice field right now. I used to help him digging and cleaning the rice fields. I wake up at five and cook rice and make him coffee before he leaves.

When I was twenty-five, I realized that I knew more than the other people, and so I started to help them. When someone loses money and he or she wants to know who the thief is, they come to me. I go to the family temple and I pray, and then I get an idea of who the thief might be.

Sick people and confused people come to me, and when people have an accident they come to me and ask why. I go to the temple and afterwards I have an idea of the answer. I give people holy water to cure them; it's water that falls with the rain. I am very happy when the advice I give people has a good result.

When a family has a ceremony, like a wedding, a birth, a tooth-filling, or a cremation, they come and bring me an offering. I pray on it to make sure that the ceremony is good and that there is no trouble.

When I was young, I used to think a lot about my brothers and their families. Now I'm thinking all the time about not having children. That is the most important thing to me now. I feel sad to be older because I don't have any children. In Bali, children are very important. No one will take care of me when I'm older and no one will handle my cremation. I will not go to another life if I'm not cremated. I have many nieces and nephews, but some are good and some are not. My husband comforts me and tells me that people in the village will take care of the cremation and that the dogs won't eat my body.

I only think of being alive and dying. I don't think about being young or old.

My advice to younger women would be that you must be on good terms with your family and neighbors. If you have more than they have, give them what they need. And don't talk badly of other people— don't gossip.

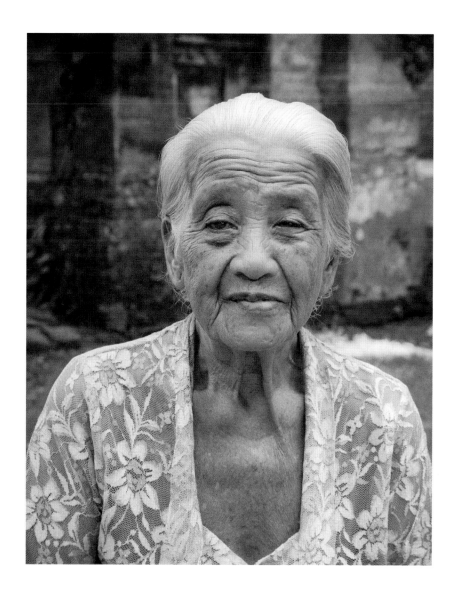

BOKARA LEGENDRE

Born 1940, interviewed at age 70 • Actress, writer, artist, and TV presenter
New York and South Carolina, U.S.A.

What I've spent my life doing is trying to prove to my mother and to myself that I'm worth something, but I've done it in my own way. Only recently have I come to realize that what I do might be worth something. It's taken me a long time.

When I was two weeks old, I was passed on to my nanny, whom I called Mamie. I lived with her in different houses and different towns, all places my mother didn't live. I had an older sister who had a completely separate governess and a completely separate life. For most of my childhood, Mamie and I lived in a tiny little dark house with a garden in Aiken, South Carolina.

When we occasionally went to the plantation near Charleston to visit Mummy for weekends or Christmas, I lived on the top floor with Mamie, my dog Timmy, and Mummy's private maid. That shows you why I had so little self-esteem; no one even wanted me around.

My father was alive until I was seven, but he didn't affect my life. I hardly knew him, but I idolized him. He was terribly good-looking,

had a sense of humor, and seemed kinder than Mummy. This weird childhood, the experience of no support and loneliness, made me strong in a way that perhaps someone who had a happy childhood isn't. But Mamie made me sane. She gave me enough love and support, so I didn't become a crazy person.

When I was fourteen, I went to Foxcroft School for Girls. Foxcroft was pure torture. I cried every day for four years. During that time, Mummy gave Timmy away. I was so alone. I wanted Mamie. I didn't know how to relate to girls my age. I felt different. I used to hide in the supply closet at mealtime and eat saltines.

Happiness exists all the time, just as sadness and disappointment do. The wisdom of getting older is riding the roller coaster with less attachment.

When I got out of Foxcroft, Miss Charlotte the headmistress and Mummy agreed that I was stupid. "Big head, small brains," they said, and it was decided that I would not go to college. Instead of going to college, I went to Europe and lived with a French family for a year. Then I returned to Charleston and acted in a play. I'd always wanted to be an actress. As a result of that play, I knew a scene by heart and used it to audition for the American Theatre Wing in New York City. They accepted me, so I moved to New York to study acting.

Mummy was horrified by this decision, so she sent Mamie with me, and rented Philip Barry's apartment for me, and I began acting in off-Broadway plays. Looking back, I'm amazed by how much chutzpah I had. I did all kinds of things that you can't imagine. I raised money myself and took one of my productions to Spoletto, demanding that I play the lead role. I gave incredible parties in New York. Arthur Kopit came after the opening of his play; Bobby Short, who became one of my best friends, played the piano until the neighbors downstairs complained. I found a whole world of crazy theater people who loved me.

My life changed 100 percent when I got in charge!

After acting school, I worked off Broadway for ten years until I was twenty-eight. Mamie was a saint, my saving grace for all these years, but she left me when I was twenty-two and went back to England.

Mummy and I traveled around Europe, and I decided I wanted to be a writer. Some friends introduced me to Tex McCreary, who had a radio show, and I began to work with him.

I was offered a job in Palm Beach interviewing people on a show that was called *Bobo in the Celebrity Room*. All the stores on Worth Avenue lent me dresses, and Cartier lent me jewels to wear. Bea Lillie, Bing Crosby, George Abbott—they were all on my show.

Then I got a job with North American News Alliance, a small news service. By now, I was in my late twenties. This job gave me credentials, and friends at *Newsweek* and the *New York Times* asked me to accompany them while they covered the campaign. A friend asked me to go with her to Bobby Kennedy's suite when he was in Los Angeles. He went downstairs to give a speech, and I had stayed upstairs with his family when he was shot. No other reporter was there. I wrote the story and it was published in the *Washington Post*, and then I was hired by the Style section of the *New York Times*.

I wrote an article on modern art and sold it to Bob West at *Show* magazine, and when I went out to San Francisco to collect the slides, I stayed with a friend of Mummy's, Richard, in Carmel. We got married two months later. It was a terrible mistake. I spent five years with him in California. It was the beginning of my karma with California.

I decided to divorce Richard after I went to the coronation of the king of Nepal. I went to all these parties in Kathmandu, and it was very glamorous. Then I had an amazing, transformative experience. A friend of a friend was a Tibetan Buddhist. She invited me to come visit a monastery. When I was there, I felt a tremendous calm, as if

everything was in balance. I had an amazing feeling, as though I was out of my body. I've been connected in a deep way to Tibetan Buddhism ever since.

After I divorced Richard, I wasted a year in Los Angeles before I came to my senses and moved back to the East Coast, ending up finally in Washington. I started to produce a daily talk show on WTOP, the local CBS station in Washington. It was called *Nine in the Morning*. While I was there, I met Arthur on Fishers Island, where Mummy had bought a summer house. The next spring, he invited me to go to France. We drove around and he asked me to marry him. We got married that summer, and in about 1982, we went out to California and lived in San Francisco.

My time in Big Sur changed my life. I got to know all these spiritual teachers at Esalen. Amazing people came into my life. I learned about another reality involving science, religion, and shamanism. A friend of mine said to me, "You came here and changed from a debutante to a shamonette."

Arthur adored Big Sur, but he was being a venture capitalist while I was becoming a shaman. A good friend of mine asked, "Why would a Harvard WASP embrace this stuff?" He was willing to let me love it. We got divorced, but we remained good friends.

It was at this time that I began to get ankylosing spondylitis. I didn't like the doctors. They told me that I had premature aging disease, so I would age very quickly. I thought, "This is unacceptable." I went to Tibet with Bob Thurman and Sam Keen, thinking that Buddhism would cure me. It did not cure me, pray as I might.

In Big Sur once again, I started painting all the time. It was a period of great productivity and creativity until I got desperately sick. From 1995, for a couple of years, I could not roll over in bed without holding onto the side of the bed—I was in terrible pain. Ram Dass, a Hindu teacher, came to see me and talked to me about spiritual

change and how you have to suffer. If one looks for the meaning of what happens to you, it's a completely different experience.

In 2000, Mummy died, exactly fifty years to the day after Daddy died. The day after the funeral, everybody left, and I was suddenly alone. Mummy's dog was walking up and down howling. I felt it was the loneliest thing that had ever happened to me.

Part of the second half has been incredibly exciting and fun. In my fifties, I went from being as alive and vibrant as I've ever been to being sicker than I've ever been. One constant is nature, and I discovered that if I am alone in nature, I can be completely happy and calm. Happiness exists all the time, just as sadness and disappointment do. The wisdom of getting older is riding the roller coaster with less attachment. One transforms through creativity and suffering, but mostly through suffering.

I have learned over time that one should think about the future. In work and love, you have to think about where you want to end up.

My advice to younger women would be: Think ahead. That doesn't mean that you shouldn't seize the moment, but you should also think of the results of what you do. And then seize the moment.

SALAMA BA SUNBOL

Born ca. 1957, interviewed at age 53 • Embroidery specialist and trainer
Riyadh, Saudi Arabia

I grew up in Riyadh. We were eight girls and three boys, and my mother and father, of course. I was the eldest. My father was a car dealer. My brothers and sisters all graduated from college; some of them are teachers, some are nurses, and some work in the pharmacy at the hospital. I started school at eight years old. At that time, that was normal; these days, it's age five or six. I studied until I was eighteen years old, then I took a course in embroidery for three years. I was very young, fourteen, when I got married. I completed my studies after I was married.

My husband's father and my father were friends. My father told my mother that he had found a husband for me, and my mother told me. I was crying because I didn't understand. When my mother told me about the marriage, I hid myself in the cabinet.

I did not know what married life was, but I was happy with the gifts, the dishes, the things that I started to receive. But the

marriage, I didn't understand anything about this. My mother told me nothing about sex. I was the oldest, so I didn't have a sister to ask.

The night of my marriage, I was watching the TV, the cartoons, with the children. My family prepared everything for me. My husband's family provided the apartment, but my family provided the bedroom furniture, the kitchen stuff, and the living room furniture.

On the first wedding day, a lady from the salon came to the house and fixed my hair and my fingernails and toenails. On the second day was what we call the "night of henna." A lady came to put henna designs on my arms and legs. All the women in both families came to watch, and neighbors who are friends came with the traditional food. All the women had henna designs put on, but the bride was given special and unique designs. It started at lunchtime, at three o'clock, and went through dinner, until ten or eleven o'clock at night.

The third day was the wedding night. A lady came and did my makeup and hair in my house, and I put on a dress and veil. The dress was white with silver embroidery. A lot of women came to eat and dance. After dinner, my husband arrived. I hadn't seen him before. I wanted to run away. My mom said, "No, please. You have to stay here. This is your wedding." I was afraid then.

My husband lifted my veil. He put a necklace, a ring, and earrings on me. When he had finished, he went around to another room with the men. The ladies stayed and danced and finished our party.

My husband was twenty-five years older than I. He was handsome. When my family told me, "You must go with your husband and live together alone," I started crying, and my mother spoke to me a lot about this. She said, "Now you are married. This is your husband and your family. You will start a new life, and you have to get used to life like this." It was a big shock because I was so young. My husband had been married three times before, so he had experience. I had no experience, but he was very nice to me. Even so, I was in a state of shock for

a few months. After that, everything was alright. My husband talked to me a lot about married life. He was trying to let me get used to it gently. Sometimes he cooked, sometimes I went to my mom's and she taught me, sometimes he taught me, and I also learned from the books.

Together we had four boys and one girl. The oldest, Mohammed, is now thirty-six years old. He's married with one girl and one boy. The youngest son is nineteen years old and at university. When my oldest son was two years old and my girl was one, I completed my studies. I had more children, but my mother took care of them. My husband was very happy that I was studying. He kept saying, "You have to complete your studies."

After my last son was born, when I was around thirty-six I started working at the university as an assistant. Before I was able to come and work here, I just took the work home and did embroidery at home, and then brought it back. I lived this way for five years. Now I come into work every day and I supervise the others.

For me, in the second half, life is better because I've learned a lot of things through my life, and I've become stronger than before. I'm very, very happy that all of my children studied at university, got married, and then had their own children. I like my job. Now, after fifty, I'm completely focused on what I love, on my work here. I am free now. I like to teach, to help people learn what I know.

My husband died nine years ago of heart disease. He smoked before he got married to me, but I made him stop. Since he died, I have focused on my children. I live with my daughter and two sons. My daughter is thirty-four. If my daughter comes to me and says, "I've picked a man," and we find out about him and he's good, that's fine— no problem. The man's family comes to the women's family about marriage. My sons ask me to find good girls for them, so I am looking. I'm watching a few.

Before my husband died, I was completely dependent on him.

He did everything. He helped me raise the children. After he died, I depended on myself for everything. I made mistakes sometimes, but I learned from them.

When I was younger, learning was very important for me, and now it's less important. All my sisters went to university, but I did not. That's why learning was so important to me. Now all my children have gone to university, so I can relax.

Most important for me now is to complete goals I started; to learn from my experience, my life, and my work; and to now give my knowledge of embroidery to others.

Patience is something I learned in the first half, and it's been very important in the second half. A lot of things in my life were very tough and complicated, and I learned to be patient. I've tried to learn what the good things are that I should keep, and what the bad things are that I should get rid of.

The worst time of my life was when I got married because I had to leave what I knew and go into something that I was scared of. But now I feel very happy. I think a lot about my youngest son because he was only eight years old when my husband died.

My advice for young girls is to be patient with your husbands, and with life. Love your life. Learn how to deal with your husband; this is very important for a successful marriage. Don't let anyone else raise your children for you. Raise your own children. If you say something, and the father says another thing, and the grandmother says something else, the children will be confused. You need to be constant with them. Don't leave your children with the maid. These days, the mothers go to work and leave their children with someone else. It is important to be the parent to your own children, to teach them how to live.

I don't think about the future. All the children are around me, all the people that I love. I'm not afraid of the future. I'm happy living in the moment.

TAMASIN DAY-LEWIS

Born 1953, interviewed at age 55 • Documentary filmmaker, food critic, chef, and author
Somerset, England

I was born in Kensington. My father was the poet C. Day Lewis, my mother the actress Jill Balcon. My brother Dan was born three years later.

My father had been married before and had two sons. My mother was twenty years younger. We moved to Greenwich so my father could write and walk near the river. We had a nanny who lived with us, and I was brought up by the nanny.

Dan and I would go on separate holidays to my parents. We often went to my grandparents' house in Sussex. My grandfather, Sir Michael Balcon, was the founding father of the British film industry. He owned Ealing Studios and produced all the Ealing Comedies. He gave many writers, directors, and actors their first breaks, from Alfred Hitchcock to Alec Guinness. That's where Dan and I spent our holidays until we went to Ireland when I was nine or ten. From then on, we went with my father and mother every summer and stayed in the amazing Old Head Hotel in County Mayo in the west of Ireland. A completely eccentric

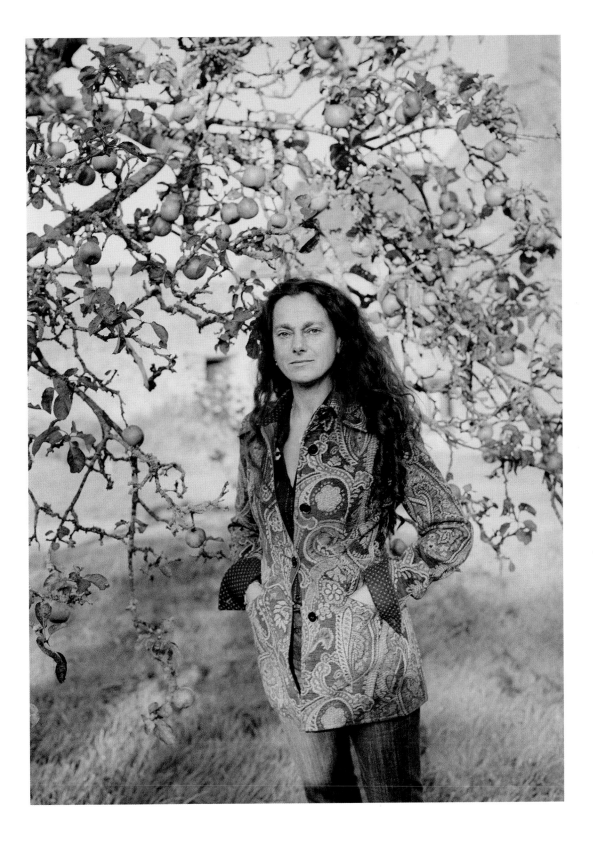

mixture of Anglo-Irish and British society. I worked in the bar on a summer job for Alec Wallace, who owned the hotel, and we would discuss the poets of the 1890s, the Elizabethan School of Night, and why he believed Christopher Marlowe was really Shakespeare.

I went to boarding school in Hampshire—to Bedales, the first coeducational boarding school in England—when I was thirteen. There were a lot of poets, writers, and artists' children there.

When I left school, I was determined to be one of the first women at King's College Cambridge. I took the Oxbridge entrance and I got in. My father was dying, so I postponed my entrance for a year. I was modeling at the time.

My father always wanted a girl. He always read to us. We would knock on the door of his study after lunch, and we'd sit on each knee and he'd read to us. He gave me the key to literature. Because he was older and because he was a writer, he was quite distant, but he had great warmth. He had Aegean blue eyes and an Anglo-Irish sense of fun and wit.

He was part of the establishment, but he was at the same time a poet. In our family, you followed your passion. We were brought up to believe there was such a thing as an artistic bent—or temperament— and to take it seriously, be it the craft of writing, acting, or filmmaking. Nothing was forced on us. Papa never put us in straitjackets. He could be highly moralistic. He had a kindness and amazing curiosity. He had natural grace and manners. He died when I was eighteen.

I loathed my first year at Cambridge. I had been in London, I'd been a model, I'd been leading a very racy life, and suddenly I was writing essays about Sir Gawain and the Green Knight. I modeled during term. I'd go up to London for castings once or twice a week.

I started cooking there, as the food was so bad. Everybody used to come to dinner. I'd have formal dinners for the King's librarian, burn turf I'd brought back from Mayo in the fireplace, and cook

chestnuts over the fire in my bedroom. I went to the market in the afternoon and got all the fresh fruit and veg cheap as the guy was closing. I got the college butler to decant wines from the King's famous cellars and bring up linen tablecloths and napkins.

I'd been brought up with amazing food at my grandparents' house. They had a wonderful cook, and the head gardener brought in fresh vegetables and fruit from the kitchen garden every morning. The eggs and beef came from their farm, and they kept sheep.

Even though I was getting my degree in English, I knew at that stage that I wanted to be a documentary filmmaker. After I left Cambridge, I wrote 150 letters to television companies. I cooked directors' lunches in The City so I could make money. By November, I was offered two jobs: Granada in Manchester and Anglia TV in Norwich. I picked Anglia, where I started off as a promotions script-writer before becoming a researcher. After I'd been at Anglia for two and a half years, I applied to the documentary department at BBC Bristol. I was a documentary film director and producer there for eleven years, but then I married a man who ran the department, so I lost my job.

The older I've become, the more I've been paring away. It's like cooking. When you are young, you make incredibly complicated dinners. Nowadays I prepare meals that are incredibly simple, but the ingredients are better.

I set up my own documentary filmmaking company, Day-Lewis Productions. I made twenty-eight films for BBC, ITV, and C4, which included a series about gifted young musicians, one about Ireland's first self-professed hermit, and *Last Letters Home*, about the letters people wrote home in the Second World War, to celebrate fifty years since VE Day with an accompanying book. It was tough with three young children, and tougher still after my divorce.

I began writing full time for a living. I wrote a book called *West*

of Ireland Summers: A Cookbook. Somebody from the *Daily Telegraph* called up to see if I'd write a food column once a week. I didn't want to write recipes—I wanted to write essays. I had to produce forty-six columns a year. It was quite a lot of research each week. All in all, I have written fourteen books about food with recipes and culinary memoirs.

I had a huge career shift in the middle of my life. You don't make decisions—they happen. What I'm trying to do now is write a novel. Perhaps I can't do it. I started it last year at a difficult time in my life, and it got me through that difficult time. I put it down, then this summer, I started writing it again. We write in order to understand, not to be understood. To my mind, good writing feels like it has to be read out loud.

This novel is the only writing I've really, really enjoyed. I don't know if I can sustain it. It's easier to start than continue. It's not that I'm expecting it to be published. I've already had two careers.

My children are my fiercest critics, and I'm lucky to have children who are perceptive, sensitive, creative, literate, and understand words. Their comments are about the movement of the book in the best possible way.

You've got your children, but then your children have gone. It's the harvest of your life, but what are you going to do next? I'm not going to be some boring middle-aged person. I didn't expect to be alone at fifty. This book is what happens when you find yourself a woman alone at fifty, expecting to have a new chance. A woman at fifty who is both reflecting on the past and what she's going to do next.

I'm fascinated by the process of art, particularly by the process of writing. I've been writing for about ten years, but in the past, obviously about a specific subject. Writing a novel is very different.

The older I've become, the more I've been paring away. It's like cooking. When you are young, you make incredibly complicated dinners. Nowadays I prepare meals that are incredibly simple, but the

ingredients are better. How I approach what I'm doing now is different because I'm more mature. The gradual process of refinement leads one to be more direct, search for the essence of something, learn to adapt and discard one's early preconceptions, and treat "hope" for what it is. It can be dashed, smashed, but should remain a constant; one's optimism may be tempered by caution as one grows older, but there is only and always hope. The best is yet to come.

My friends have always been tremendously important, and as one gets older, one realizes that the value of friendship is inestimable,

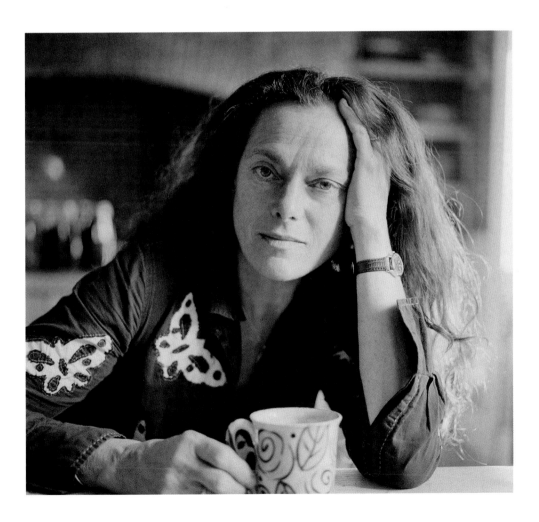

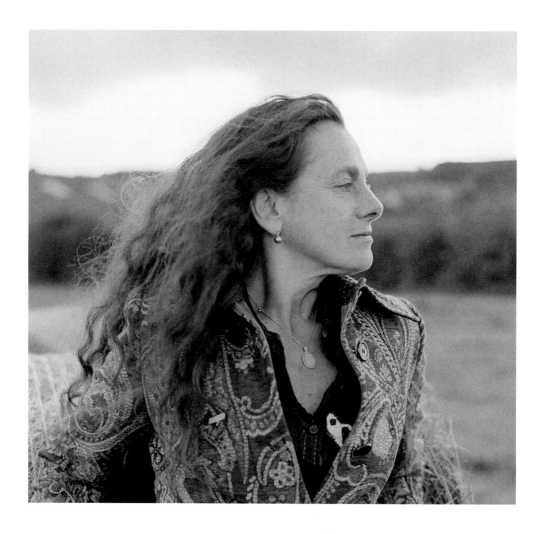

as is keeping good relations with one's children. I would rather go skiing with my children or go to Ireland with them than with anyone else. I have the best fun in the world with my children. One has to keep in touch with younger people, the new pulse of the world, new ideas, remaining open and receptive, curious and fascinated by them—never just presuming it was better in "our day."

I am still thrilled and excited by the simple pleasures of discovering a new novelist or walking the same headland on the wild Atlantic Mayo coast that I've walked since I was nine.

What I'm proud of is bringing up three exceptional human beings. This other stuff is insignificant. They are good at what they do and they are modest about themselves. I just love them as human beings.

I hope I've learned to be a good friend. I've got tremendous energy, and it's something I don't want to lose.

It's incredibly important to be a good wife and a good mother and a good friend, but it's very, very, very important to do what fulfills you. I don't think I was a good wife. I didn't give time and attention to my marriage. I was too tired to do it. I look at people who are still married and I wish that had happened to me. It would be extremely nice to have harvested the rewards of bringing up children and to share in the pride and rewards with the person you brought them up with. But I don't sit around dwelling on what's not to be. I know how lucky I am to be a part of my children's adult lives now that they're fledged, and to see their burgeoning and beginning to fulfill their talents.

GEORGIA NIKITARA

Born ca. 1932, interviewed at age 74 • Farmer

Patmos, Greece

I was born in the house just underneath this one. I had five brothers and five sisters. I was the youngest. My father was a farmer—he grew vegetables. I didn't go to school because when I was young, it was the time of the Italian occupation, and I would have had to study in both Italian and Greek. Besides, my father needed me to work on the farm. I had a wonderful father and mother.

My father used to go to Chora on his donkey to sell his vegetables. In a dream one day, a woman gave him a sitar and told him, "Take it. I will tell you what to do with it." The next day, he met a woman near the monastery in Chora who was selling icons. The woman had no money, so she gave him an icon in exchange for vegetables. A short while later, he dreamt that a neighbor came to his door and said, "I had a dream. You should build a small chapel for the Virgin." He did and put the icon in it. Later, we had a lamb who was sick. They took the icon and touched it to the lamb, and it was instantly cured and had a long and good life.

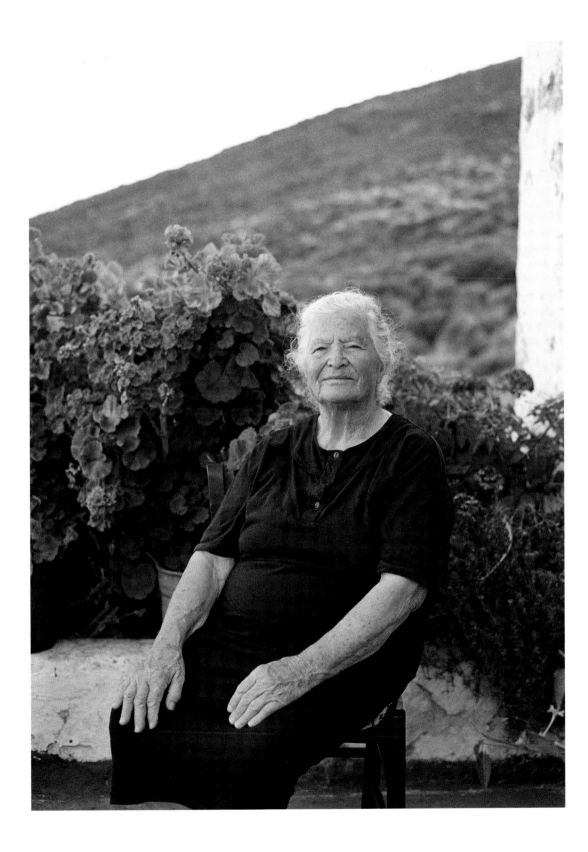

My husband was from the neighboring village of Kampos. He was a farmer, but he also knew carpentry—he was a builder. My father-in-law was rather rich, so my husband took care of some of his land. My parents gave me this house when I got married.

I'd describe the second half as the transition phase of my life. For me, it was the transition from the farm to the house. It is that period of my life during which I am able to rest a little bit, because all the previous years I had to work really hard on the farm with my family to make ends meet. On the other hand, this period of my life was marred by two events that influenced me a lot: the loss of my mother and that of my husband.

The only thing that has changed as I've gotten older is my health. From my sixties on, I have faced problems with my hips on a daily basis. This pain prevents me from doing things that I really enjoy—watering my flowers, going to the beach during summertime, attending services at church. What has become really important to me is the family happiness. I constantly pray for their health and happiness. What's become less important is social life. My life is now centered around my house and my family.

The period of my life when I was experiencing the ultimate happiness was the first three months of my marriage. The times of deepest sorrow were when I lost my mother, who supported me in difficult times. Also when I lost my husband—since then, I've experienced absolute loneliness.

The collaboration that was fostered on the farm by my family was the element that really helped me in my relationships with the people around me. Patience was the other trait that helped me stay calm in the difficult times of the second half.

I believe I have come to terms with my age. What bothers me are the health problems that prevent me from doing things I like. Despite these problems, I feel like a young girl, full of energy. I live with the

hope that sometime I'll get better and I'll be able to work again without feeling pain.

I'd say that I look to the future with optimism. My only fear is that I don't want to get too sick and oblige my children to look after me for a long time. I don't want to become a burden.

My advice would be only two words: Good words. Speak well of people. Be kind and love them.

I don't feel like an old woman. Getting old doesn't make me afraid, and neither does death. This is the circle of life, isn't it?

GIULIANA CAMERINO

Born 1920, interviewed at age 86 • Founder of the design firm Roberta di Camerino
Venice, Italy

I was born in Venice in 1920. I escaped
to Switzerland during World War II and started to work there. The
Germans came in 1943. My husband, my baby son, and I hid in the
house of a friend of ours and afterwards hid in a clinic. You are afraid
for yourself, but you can imagine if you have a little son! The man
who hid us was a very important Fascist. Then in November 1943, we
escaped on the underground railroad. It was a big organization and
cost a lot of money. At the end of the war, we came back quickly the
same way because we were worried about our friend who had hidden
us. When we returned, he was in prison. We were able to save him.

One day, after we escaped to Switzerland, I was in the square
of Lugano with my husband and an Italian lawyer. A woman came
up to me and wanted to buy my handbag. I sold it to her and went to
buy another, but they were so expensive. So I went and cut a handbag
exactly the same as the one I had owned, and found a saddler shop to
stitch it. That was the beginning of my design career. I began to work

with an elegant shop in Lugano designing handbags. Two workers from Vienna taught me how to make them.

We returned to Venice in July 1945. I had to work. My first factory was in an institute for the reeducation of young delinquent girls. I taught girls that came from poor families to begin a regular life. I was lucky because *Bellezza*, the biggest magazine in Italy, discovered me. I opened my first shop in Venice in San Marco in 1948, then in Cortina. Then shops all over Italy. Neiman Marcus and Saks Fifth Avenue asked for exclusivity. In 1956, I received the Neiman Marcus Award. In 1975, I opened my own shop in New York in the Olympic Tower.

Life teaches you many things, and you can have better judgment about people you are meeting and better judgment about everything.

My first show was of accessories. When I was younger, I had wanted to be an art director in the theater. For my first exhibition in 1946–47, I had all the dancers of the Fenice showing my handbags and scarves.

Every time I begin a collection, I am very worried—I think I have no ideas. Then suddenly you think of something—perhaps you see a painting or hear some music that gives you inspiration, and from that, you develop a whole collection. For this coming autumn/winter, I was influenced by many events of students in universities. For each collection I give a name. This one will be Campus.

These days, I do double collections—one for Italians and one for foreigners. Naturally, the designs made for Italy are more complicated and more sophisticated because we are working with art craft at a high level.

Nothing has changed since I was fifty. I am still leading the same life, working very hard every day, happy to design, and I am also traveling. I work all over the world. I have people who have been with me for thirty years.

My husband died of cancer when I was forty-two years old. He was thirteen years older. During the last year of his life, he managed my work. In 1980, when I was sixty, I met another wonderful man. He was an engineer. He came to work with me and develop my business. I lived with him for twenty-five years. He died two years ago. So you see, at sixty, you can have a new life. I was with each man for about twenty-five years. They were two love stories, completely different.

My family—my son, my daughter, my grandchildren, my great grandchildren—is the most important thing to me. Social life is less important. I do what I need to do for public relations, but for me, it's like work. I prefer to enjoy my friends one by one.

Naturally, persecution changed my character and taught me many things. To give importance only to the big things and forget the little things. It taught me how important it is to live life, how important the family and real friends are. It also taught me to fight.

My greatest happiness was when I was very young. I was spoiled by my family. When I was fifteen, there was a law against Jewish people, and I lost my youth. But I met my husband when I was nineteen, so I was very lucky. Even in that terrible period, I had this wonderful joy. I try to forget that terrible time. No, one must never forget, but it is necessary to live in the future. I never wanted to see any films about it.

When my husband was very ill and when the companion of my later years was very ill, those were the tragedies of my life. I've had wonderful times, but I've also had big tragedies. It is very sad when you lose someone you love from a terrible illness. I believe that the people we love—my mother, my father, my family—they are always with me. I had wonderful satisfaction and joy with my work, and when my children were born. That was one of the happiest times.

I love my work, and today I work with the same enthusiasm as when I began. When my companion died, I found reason for my life in

my work—and God helped me, because two days after I lost my companion, my two wonderful grandchildren arrived.

My family has lived in Venice for generations. Now I live in Lugano because Lugano became my second home, but naturally I come to Venice for my children and because the creative part of our work is in Venice. To find refuge in Lugano was amazing. The Italian Swiss were very kind. We made new friends and they are still very close. In Venice, we feel Venetian, not Italian. I am equally at home in both. Love of Venice is the first, but life in Lugano is beautiful.

Nothing changes inside. Life teaches you many things, and you can have better judgment about people you are meeting and better judgment about everything.

I have many projects for the future, and I never think that perhaps my life can finish.

ADA GATES

Born 1943, interviewed at age 67 • Farrier, first woman in North America licensed to shoe thoroughbred horses • Pasadena, California, U.S.A.

I was born in New York City. I was one of eight children. Both of my parents had been married before. I have all these half brothers and sisters, and we're very, very close. We lived in a beautiful, big brick house in Long Island. In the summers, we went to upstate New York. I had a pony, and one of my brothers had a pony, so we two horsey children were inseparable. I rode incessantly.

I went to Briarcliff College, and I started a dance department. I choreographed and we performed modern dance. Certainly, there's a theme, between the riding and the dancing—there was this physical life that I loved. It all had to do with the legs—pliés, forward seat in the saddle.

I got myself a little apartment in New York and I plunged into New York theater. I was dancing, acting, and did summer stock. It became discouraging, and maybe I didn't have enough real drive to sacrifice everything, and so I filled in with modeling.

A girlfriend asked me to take a trip out west in the car. We got to

Vail, Colorado, and the car broke down. It was July or August. Everyone was hiking or working in restaurants; it was the summer season, and it was beautiful. And my girlfriend said, "Well, this is nice, but I'm going back to New York to be a stockbroker." And I said, "You know, I just think I'll stay out here."

I'm in Colorado, I have this little cottage, I'd been there for six months or so, and I buy a horse. And I couldn't find a blacksmith, so I read in a magazine that there was a school in Oklahoma that taught horseshoeing. I thought, "I could go to that school and I could learn how to shoe my own horse." So off I went to the school in 1971. I got there and it was me and forty-nine guys. And the first thing the teacher said to me was, "This is no job for a woman. I don't want no woman in my school. I have to take you, or I'll lose my accreditation, but I don't want you here." Right to my face, he said that—a big redneck from Oklahoma. Brilliant, brilliant horseshoer. So, during the next two months, he did everything he could to make me quit. He made me do all my work over again. He made me shoe the horses over again. When we had exams, we would show the shoes that we had been making, and he would take my shoes and throw them all away. "This is no good." "This is a piece of junk." The guys would go in the trash and take my shoes and give them in the next time we had a test, and they passed. He harassed me.

Finally, one day he threw a snake at me, a little garden snake. I am absolutely terrified of snakes. He threw this snake at me and it touched me, and I absolutely flipped. That was it. And I turned on him. I started screaming at him. I said, "If you don't leave me alone, I'm going to punch you right in the nose." And I had my fist cocked. And he finally got the picture; he had pushed me too far. And the guys were over there laughing because they felt the same way. I graduated. I realized toward the end that this extraordinary man, who had lots of issues himself, had created a successful life against all odds. I realized

that this man's innate wisdom was knowing he had to push me to cull me out, and if I didn't cull out, I needed to be tough enough to survive. I realized this, and I was very grateful to this man.

So I started shoeing in Montrose, Colorado, and I'll tell you, it was the most extraordinary experience of my whole life. I was twenty-seven years old, I was alone, it was me and the world, and every day was this fabulous new challenge. And it was beautiful country. I went out and I started making friends, and I was working on ranches. It satisfied all the needs that I felt I had, which was to have a physical life. It was healthy and it had me with horses. It was very finite, and you could measure your worth. I hadn't felt I had much worth. I had dropped out of college, I had failed as an actress, I never kept a job—there were a lot of demons inside that I didn't know how to assuage.

But shoeing was mine and it was real, it made perfect sense to me, and I had the physical strength in my legs to do it. And I grew a business in Colorado for seven years. I started to get a lot of publicity—from *Time* magazine, *Sports Illustrated*, *People* magazine, "What's My Line"—because in 1972, there were no women shoeing horses in the United States.

Then I got to the point where I thought, "I'm going to quit, or I'm going to become the best farrier I can be. I want to be the best in the country."

I contacted a girlfriend in Pasadena. I said, "Wendy, I need a new place to live, and I'd like to work on the big racetracks." And she said, "Well, my godmother owns racehorses at Santa Anita. Come out here, and I'll introduce you to her trainer and her horseshoer." So I have to go meet the head of the union because I have to apply to take the test to get into San Anita. I'm absolutely shaking in my boots. I've had seven or eight years shoeing cowboy horses. How could I ever dream I could be good enough to shoe a million-dollar racehorse? And I apply to the head of the union, a man called Harry Patton, who is very famous. And

I said, "Harry, could you teach me what I need to know to take my test at Santa Anita?" He shot back without batting an eyelash, "Sure."

So Harry started training me, but he *really* trained me. He took me into his blacksmith shop, and he put me in front of the forge and said, "You're going to have to learn how to do this, this, this, and this."

The test was six hours—five hours in the fire, one hour under the horse. You had to be prepared to do any one of six major black-smithing accomplishments to pass that test. It took tremendous skill and tremendous accuracy, and there was no margin for error. The day I took my test, instead of six men there, there were twenty men there. The entire union had come down to watch a *girl* take this test. I was told that I had failed the test because my toe grab was not in the center of my left hind shoe. It was off-center a tiny bit, but it wasn't accurate. I said, "What? I didn't pass?" I burst into tears. That's when the guys sat around and said, "Hey, we've never had anybody cry in an exam before."

Being older, you have enough experience to deal with just about anything. I don't feel as though I'm tumbling around in a dryer anymore.

I took the test again and I passed. It was February 1977, and I became the first woman in the U.S.A. and Canada ever to be licensed to shoe thoroughbred race horses, and I became a member of the second oldest union in the United States.

Harry became my mentor. Yes, we were attracted to each other, but I didn't want any complications. I kept Harry at arm's length for a year, two years. Finally, he was so persistent. He got divorced because he wanted to marry me. I said, "I'm terrified to get married. You are a poor boy from Long Beach. What will my mother think?" There I was in California, and I was still controlled and ruled by my mother, who was horrified that I was a blacksmith in the first place. My father was actually very proud of me. But my mother had a hard time. What

could she say at a cocktail party when people asked her, "What's your daughter Ada doing?"? She finally came around. She heard people saying, "You have one of the most famous people in the United States. What an accomplishment, Evie—aren't you proud of her?"

Harry and I went out together for eleven years because I was too terrified to marry him. What would people think? I wasn't marrying the banker with the pinstripe suit and the Mercedes. Finally, my girlfriend Wendy said, "Ada, what's the matter with you? Harry is the most divine man in the world. What do you want?"

Harry and I got married on October 29, 1988, at All Saints Church, Pasadena. We had another eleven or twelve years together, shoeing, having our life, and traveling. And then he got cancer and lived three more years, and then he died. I was his caregiver 24/7 for three years. I gained sixty-five pounds. My whole life came to a complete stop. I didn't do any work at all. I fought like a lioness for Harry.

Harry died when I was fifty-five. The first three years without Harry—you wake up sobbing, and you go to sleep sobbing. What has become of your life?

It's been ten years, and I think I'm really kind of going around a corner now. It's as if you're so battered and so hammered, and there is so much fire burning inside of you, that when you come out on the other side, you are like hardened steel. I have a different kind of center than I'd ever had before.

I love my church. And I have girlfriends of a lifetime. They are the strengths of my life, and they are the strengths that I go to now more and more, because as we go into our sixties and seventies, we can sit on a lawn and overlook the water and really talk. It's women who get you through life.

I learned in the first half of my life that I could do anything I wanted to do. When I was young, and all through those early years, I embraced my enthusiasms and lived them. I never had the breaks

on. Underneath, though, was fear from start to finish—complete, abject fear.

In the second half of life, I don't feel fear anymore. I'm no longer a jack of all trades, master of none. I am a master farrier.

Without question, the most important thing to me now is not work—it's person-to-person connection. And it's important for me to calm down and stay quiet enough to receive those connections.

Spiritual life has always been important to me. I've had numerous epiphanies along the way. I pray every day, and if I don't, the day seems to go south. And my prayers are always thankfulness.

Less important is being in the media—being on David Letterman's show or in *Time* magazine. Those were all things that came out of wanting to be an actress. I wanted fame. That's less important.

I think the difference between then and now is that when something approaches that looks like a barrier, I know I can deal with it. I have a huge wealth of experiences to draw upon, and now I can apply that response to this. Being older, you have enough experience to deal with just about anything. I don't feel as though I'm tumbling around in a dryer anymore.

I learned in the first half not to be afraid, because although I went into unknowns over and over again, I survived and actually had some successes.

During the first half, there was always this underlying layer of anxiety, and even though I'm going into a whole new realm now of writing and memoirs and talk shows and television, I feel very relaxed about accepting what's going to come. I have a real vision, but I'm going to allow it to unfold by itself.

How do I look to the future? I'm not done yet. Period. I think this is going to be the best time ever. This is going to be the real me, full out.

121 ADA GATES

MA THANEGI

Born 1946, interviewed at age 65 • Journalist, author, and Ang San Suu Kyi's former personal assistant • Yangon, Myanmar

I was born in Shwebo, a small up-country town. My father was a township officer under the British. When I was eight months old, we all moved to Yangon.

My mother was a faculty member of the philosophy department of Rangoon University and my father was a political advisor at the American Embassy. I have a brother, three years older.

My parents were very Westernized, and they had a busy social life with friends they had known in college. They pretty much left things at home in the hands of a cousin who lived with us, and the cook and driver couple and their family, who had living quarters in the back. When at home, both parents were great readers—Father with his collection of Somerset Maugham and P. G. Wodehouse, and Mum with her pile of the latest best sellers she'd borrow from a shop in town.

As a child, Rangoon (the name given by the British) was fun, both of us attending a coed missionary school. After school and

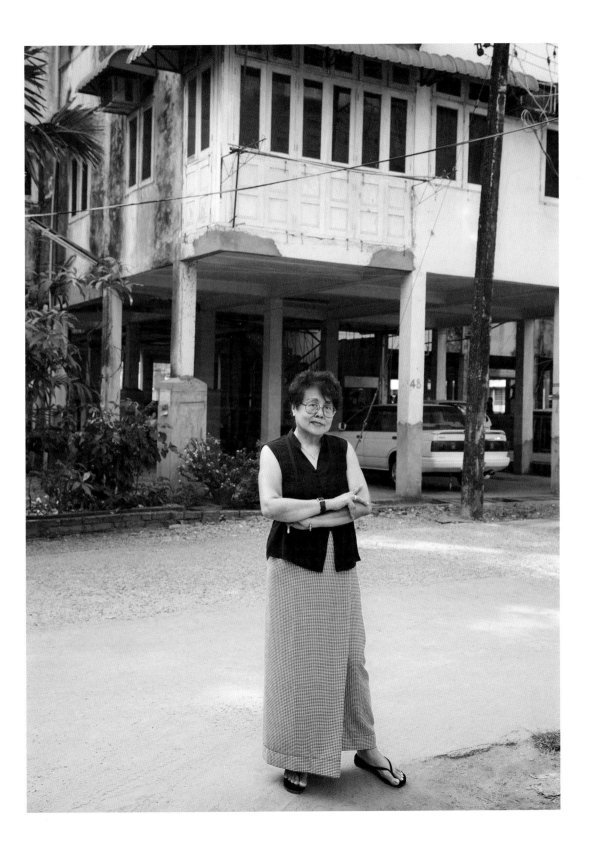

during vacations, there was a whole gang of us playing at one house or another. Within walking distance was the university swimming pool, and my best friend Pat and I would go there when she came over to my house.

My school had a good library, and after discovering children's literature, I was hooked; at home, I always had a book or a cat in my hands. When I ran out of reading material, I would raid Father's bookshelf or Mum's pile. Under her mattress she hid racier fiction, which I would steal and replace. My favorites were crime novels, especially the Perry Mason books.

I always liked to draw, and when I was fifteen, after seeing my first art exhibition, I decided I would become a painter.

After finishing high school, my mother expected—in fact, demanded—that I get a university degree, but I wanted to study art. I was only allowed to go for three months of evening classes before college started. I went to the State School of Fine Arts in Yangon, established by the British. It was the happiest three months of my life.

The teachers were all famous masters and taught with enthusiasm and love. Classes ended at 8 P.M., but we stayed on for an hour at least to talk with the masters. I met day students who were so talented, but after they graduated they'd have to go back and work on the family farm.

For university, I chose the Institute of Economics, only to get a degree to appease Mum and to do so in the shortest time possible, four years. I had absolutely no interest in economics, then or now.

In my second year, I took part in my first group show, the first modern art exhibit in 1967. I was the only woman painting in modern art at that time and I knew most of the modern artists. After I graduated, I received German and French diplomas and continued to paint and exhibit every year in private and state art shows.

I married in 1971 and, as demanded by my mother, we lived with my parents. My husband was first a tutor in the German department and then a junior diplomat at the Ministry of Foreign Affairs. We were posted to Singapore for four years, from 1978 to 1982.

We didn't have children. He was very conservative, a typical Burmese man. It was only after my divorce when I was forty that I was able to do what I wanted, which meant more freedom with friends and to begin writing. For the first time, I was earning regular money for myself by giving lessons in art and English language.

The military took over in 1962 in a coup d'état. There was some freedom of the press in the early years, but around 1970, it got worse. No private enterprise was allowed and there was no freedom of the press. People who had money hid it. For young people growing up, there was nothing to do. Everything was under government control. Think of combining the military with socialism—both are restrictive.

Our art shows had to apply for permission, and a censorship group would check our show the day before it opened to disallow any art they felt was political. I never painted political stuff because if I had anything political to say, I preferred to speak out instead of using my art. I never made statements with my art; I kept the two separate.

The 1988 rebellion happened because we were protesting against socialism. I was demonstrating with my large group of writers, artists, and editors. All we wanted was freedom of expression and publication.

When Daw Aung San Suu Kyi emerged as a leader, we decided to go help her. I asked a mutual friend to take me to her house, while, in that time, others with similar intentions were just turning up at her front door.

She had been in my high school for two or three years, and when we were chatting in English, she knew I could be of use in her dealings with diplomats and the media. I was already known to diplomats, as

many had bought my paintings, and artists were always invited to their homes for private functions.

I became a personal assistant/secretary to her from the beginning of September 1988 up to July of the following year, when she was put under house arrest. I made appointments for her and made sure she took her vitamin pills and her meals. I did errands for her. I would go with her on campaign trips.

On the day of her arrest, July 20, those of us who were helping her personally, not as her party members, and were in her compound were sent to Insein jail. A close coworker had phoned me early that morning and told me that there were armed men surrounding the compound and not to come to work, but I said, "In that case, I am coming right now." In my haste, I forgot to take the bag I had ready with clothing, toothbrush, toothpaste, soap, and medicine. Luckily I had another smaller bag at my work in case of sudden trips. We all knew it would happen one day, so none of us were fazed, even the youngest students among us.

I've become less rigid in my principles. When I was young, I was very judgmental. If I saw someone cheating, I was just judgmental. Now I ask why. I am more understanding of the weakness of human nature.

Conditions were primitive, but the cells were not dirty. There was no torture, no rape. At that time, the guards were ordinary women, uneducated but kind people. Later they hired only university graduates who were more disciplinarian, but that was after I left.

We weren't allowed to have any writing or reading material, but the guards would smuggle in books and tell us stories about movies they'd seen. The guards did nothing political.

Girl students were in prison also, and they were always up to mischief, playing pranks on each other. They refused to be made miserable.

I was inside for a mere three years. Many of my friends had far longer times in jail.

After Daw Aung San Suu Kyi was released in 1995, I went to see her and help for a few days. I reminded her of agreeing to my request to no longer officially work for her after 1990, and she said, "Yes, yes, I know."

In 1998, I publicly came out against her call for sanctions, writing an article called "The Burmese Fairy Tale" in the *Far Eastern Economic Review*. Daw Aung San Suu Kyi thought I was being a traitor, speaking on behalf of the junta. She thought that economic hardship would make the country poor and therefore the military would give up power.

I came out of prison when I was forty-six, in 1993. I've had a few art shows since then, but I've had many commissions to write in English. I've also written books on my own or in collections. My first book, about Burmese marionettes, was published the year before I was fifty. My second book, a travelogue of Buddhist pilgrimages, was published five years later. I've published about twenty books by now. For several years, I was contributing editor at the *Myanmar Times* where I wrote features. It was censored by the military intelligence.

My second half has been very productive. The first half was preparing me for this. In prison, I met murderers and pickpockets. It gave me such a rich knowledge of the people here—my people.

I never thought I'd be a writer, but I've always loved reading. I've read a book a day since I was about ten, sometimes more. I love working. I'm a workaholic. I can't travel for fun. Once, I was visiting a friend for eight days and I thought I would die of boredom!

I've become less rigid in my principles. When I was young, I was very judgmental. If I saw someone cheating, I was just judgmental. Now I ask why. I am more understanding of the weakness of human nature.

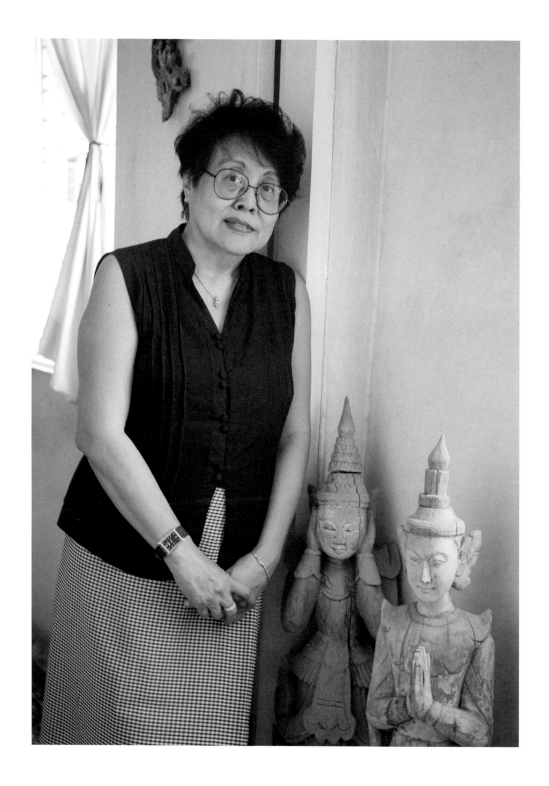

I'm very happy with my life. I live alone. I don't have any responsibilities toward anyone. I am a very private person, and there are only about twenty people I would really trust—not because others are not good people, they are extremely good and kind, but because no Burmese has any idea of keeping secrets for other people's sakes.

The most important things I've learned are about human nature. I learned in prison that what makes you happy is the warmth that people have for each other.

Be strong. Be able to stand on your own feet. Work, and take pride in being independent. Burmese women are tough. They look so delicate and so fragile, but they are so tough.

I'd like to be remembered as an artist and writer who really loved the people of her country. And that I really, really hated those who did harm, both intentionally and not.

FLORA BIDDLE

Born 1928, interviewed at age 80 • Writer, former board president for the Whitney
Museum of American Art • New York City, U.S.A.

I grew up in Aiken, South Carolina. I went to school in a one-room school house that used to be my great grandfather's squash court.

During World War II, I moved to New York City and entered ninth grade at Brearley where I was quite miserable. I knew how to ride, shoot, and fish, but I wasn't socially adept. I didn't know boys. I had pigtails and was generally not "with it." Mrs. MacIntosh told my parents that I'd be happier somewhere else.

I went to boarding school with one friend, Clare Chanler, who remained my best friend all my life. I still wasn't adept socially and was awkward.

I went to Barnard for a semester, then got married when I was eighteen.

I was married thirty some years to Mike Irving, an architect. I lived in New Canaan and Norwalk, Connecticut, near where my husband was working. I didn't feel at home in those places, but I loved my

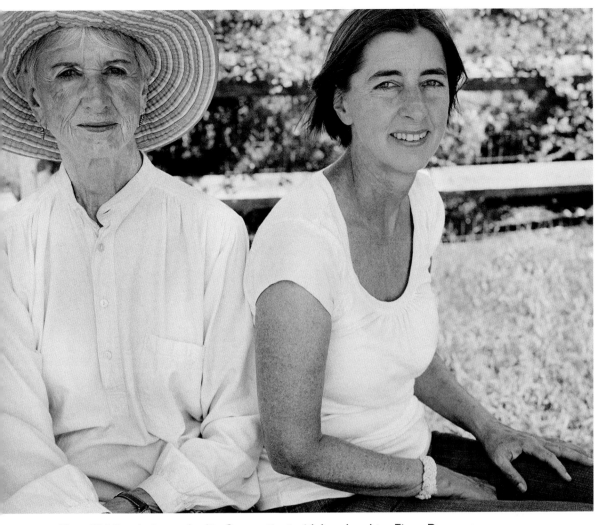

Flora Biddle, photographed in Connecticut with her daughter Fiona Donovan

family. I was really busy with my children. During this time, I became much more involved with the Whitney Museum. In 1958, I joined the board.

When I was about forty, I wanted to have an education, so I went to Manhattanville. It took me about eight years to graduate. One of the classes was a seminar where you had to write about someone you admired, so I wrote about my grandmother. She was a sculptor and founded the Whitney Museum of American Art. She was also the mother of three children and the wife of a sports hero.

> Artists and writers—people who create—bring me much happiness. They can be enchanting—the stories they tell, the complications of mind and life, the sublime art that is produced from that complexity.

I was living in New York during the week and going out to Connecticut on weekends. My husband was a wonderful person. I don't think I tried hard enough to maintain our relationship. I was probably very selfish. This new life was so exciting. I was suddenly able to be in touch with anyone I wanted to be in touch with. I was full of energy.

In the year 1978 I graduated from college, became the president of the Whitney, and fell in love with Sydney. It all happened when I was fifty.

I separated from my husband. I loved being involved in the Whitney and meeting artists. My mother had been the president, and it had always been part of my life. I didn't think I could raise the money the museum needed in order to survive, but I wanted to try. Tom Armstrong, the director, was very ambitious for it and was full of energy. We became a real team.

My younger daughter, Fiona, was at Barnard College. We lived in the garage of my great grandparents' house on Sixty-Sixth Street.

Sydney and I got married in 1981. Sydney was an artist. He was

a very attractive person and had a fascinating mind. He'd won the MacDowell Prize at the Art Students League and used the prize money to study art in Italy and France for a year. When he returned, he found it hard to make a living as a painter, so he worked at an insurance company. We met at a party and got to know each other by running around the reservoir in Central Park.

We lived in New York City for ten years, then moved to New Mexico. When Tom Armstrong was fired as director of the Whitney, I was so upset that I had to get out of New York and away from the Whitney for a while. We bought an old adobe house in Taos, and we made a life there. Sydney was painting and I was writing my book about the Whitney. We had a small group of wonderful friends—Agnes Martin; Richard Tuttle and his wife, the poet Mei-mei Berssenbrugge; and Kenny Price. That was between the time I was sixty and seventy; Sydney was seventy to eighty. We lived there half the year and in New York in the winter. We were very lucky to have that time and to be healthy.

By 1999, my grandchildren were growing up, and summer was the time when I could see them, so we decided that it was time to return. There was a place that we liked in Connecticut where Sydney could have a studio and I could write. But Sydney got ill, and needed more care than I could give him.

We sold our house and were going to move into a retirement home. Then he died quite suddenly. I didn't move into that retirement home.

There have been lots of times that have been very happy. Being in love is quite unique for the extremes, and I've been lucky to have had that more than once. Artists and writers—people who create—bring me much happiness. They can be enchanting—the stories they tell, the complications of mind and life, the sublime art that is produced from that complexity.

I was very sad when Sydney was ill and died, and when my friend

Clare died—that separation is forever. It's sad when friends whom you love are in pain. I'm sad about what's happened to our country. I'm sad about the planet. Those are really things that can make one cry.

I regret having had, when younger, so many expectations. My self-esteem as a child was determined by my parents' and teachers' high expectations, as it surely is for most of us. In my case, there was also a consciousness of some larger distinguished family out there somewhere that I must live up to. I was definitely a perfectionist. If I couldn't live up to what I expected from myself, I felt unworthy. And I came to look at others in the same way. All this was destructive to some of my relationships with my family and my work. I often expected people to be other than they were, to change.

As time went on, I've learned to be more accepting, thanks to my children and others, and to Buddhist teachings—but for a long time, smidgeons of that earlier me remained deeply embedded. Sometimes they emerged as criticism, or as feelings of being offended or disappointed in someone. Eventually I realized that I'd hurt a person I cared for deeply. My advice would be to have fewer expectations.

Also: Love! But that's not just for women. Be aware of every moment, but don't try to do everything. Make time for music, reading, and art. Play. Dance. Meditate.

ELIZABETH JANE HOWARD

Born 1923, interviewed at age 84 • Author
Bungay Bay, Suffolk, England

I was born in London. I had two brothers whom I was devoted to and lots of cousins.

I was educated at home by governesses until I was sixteen, though I don't think "educated" would be an accurate way to describe what went on. I grew up knowing different things from my contemporaries—a wide and varied range of subjects and knowledge was proposed to us, and our studies were very personal and independent. While other people were taught piano, French, and drawing, I was always writing. I ran out of books to read, so I wrote one when I was eight. By that time, I had already been writing very sophisticated short stories.

Miss Millerant was our teacher and governess. She was an amazing old lady—hideously ugly, but extremely gentle and very wise. She managed even the most difficult of us, like the painter John Craxton, with one hand tied behind her back. She adored pictures and took us all to a huge exhibition of Chinese art in 1926.

She lived a life of extreme loneliness, and I'm sure she must have been very badly paid. But we were all fond of her. She let John draw, and she let me write plays; everyone was allowed to develop their own interests.

My parents were a terribly ill-matched pair. My mother was a dancer in the Russian ballet with Diaghilev. My father was a timber merchant. He was very attractive to women, and my mother was no good at sex. He was serially unfaithful to her. He finally went off with someone else. He died of cancer very young, and my mother lived with me for the last six years of her life. She had no friends, but her family was very important to her. She was frustrated all her life. She had been neglected and marginalized by her own family and took out her pain on me. She didn't love me. She loved my brothers.

I was so frightened of people my own age that I didn't want friends for a long time. I was sixteen when World War II started. I dabbled in cooking and acting, as I had decided I wanted to be an actress. I was quite good. I did all kinds of odd jobs. I was a model for *Vogue*, I was a secretary, I was an air raid warden, I was a broadcaster. I scraped a living that way. I lived with another girl. We lived on people taking us out to dinner.

By then I'd met my first husband, Peter Scott, the son of the famous explorer, and we were married for five years. Our marriage fell apart because he was held in thrall by his domineering mother. I was very young, only nineteen at the time. He was a brilliant naturalist, and very talented, but was obsessive and had to be the best at everything. His mother had raised him to believe that everything he said was of the utmost interest. That was difficult. He wasn't interested in people—he was interested in every other species on earth, but not people. One day I just got up and left with a suitcase, leaving my daughter with him since I knew he could afford to bring her up.

I was always writing. I wrote plays a lot. Even though I had been

hell-bent upon acting, after the first year of the war, it seemed irrelevant. I began writing my first serious novel.

I went to New York in 1946. I took my manuscript with me. I was twenty-three. We'd flown from Halifax. I hadn't been in an airplane before. I found myself sitting at dinner next to John Marquand. I behaved badly. I went on a spending spree. You can't imagine what it was like coming to the lights of New York after the darkness of England. I met Robert Linscott—he was at Random House and read my manuscript, and he said they would be interested. Maxwell Perkins at Scribner's also wanted it, but I published with Random House in 1950.

In 1958, I married again—to a con man. It was disastrous. I had a very low opinion of myself. I was exhausted by everyone taking me out to dinner and wanting to go to bed with me.

I met Kingsley Amis at the Cheltenham Literary Festival in 1963, married him a year later, and was with him for eighteen years. Kingsley was very funny, which was one of the things about him that was irresistible to me. When I met him, he was going to live in Majorca. He was in a very bad marriage. I didn't feel as though I had broken anything up, although he did leave her for me. He said he would only be able to come to London two or three times a year, and I said, "I'll settle for that." I thought that a little time with someone you love was better than the rest. We wrote a bit of each other's novels.

My first two years with Kingsley were very happy. He was irascible, tremendously entertaining—he could mimic any kind of noise—and he had a wonderful vocabulary. Kingsley was never pompous with anybody. He had a very romantic side. Poetry or music could easily make him cry. He took his work very seriously without any pretentions. No matter how bad his hangover, he would work the next morning. He was very much in love with me then.

I don't think middle-age marriage can survive without a certain

amount of time alone. Kingsley went off sex, and he blamed me for that. But the truth is that when you drink that much, you can't do it. I don't think I've had a very satisfactory sex life. It was very painful. I thought it was my fault for ages. I lost my balance. I didn't have friends. I was tired all the time. He didn't drive. I drove him everywhere. I did all the cooking and all the shopping. I lied and said I didn't know how to iron. He absolutely accepted it and hired someone to iron.

I descended into a very deep depression about a year after I left my first husband. And then when I left Kingsley, I felt pretty down. An extremely kind friend took me in, and I lived with her for about eighteen months.

You can forgive yourself when you learn to live with yourself. I've gotten less judgmental, more patient.

I think I only earned one hundred pounds for the first six months. I've always been a bolter, and I've never taken money.

I started psychotherapy when I was fifty-three. I had an awful year when Victor Stiebel, the dress designer, died, my mother died, and my marriage to Kingsley was awful. Kingsley was seeing someone about his lack of libido, and she asked to see me. She sent me to see someone else; in one session, the therapist asked me a question and I began to cry uncontrollably. It was that moment that started the process of growing up for me. Most of my regrets are hopeless ones, like my misspent youth. I've not much use for guilt—it isn't productive.

I had colonic cancer about ten years ago. I had a very good surgeon. The hospital was dirty, and the nurses were atrocious. I had about six operations. It's quite nasty waiting for results when you live alone. I had a lot of radiology. It was torture. It shakes you up a bit. It makes you realize what you've missed. I realize that I'm attached to my life.

In many ways, the second half is much better than the first. I often think to myself, "If I'd only known the things I know now." My sense of who I am has changed very much, due in part because I've

done thirty years of therapy. You can forgive yourself when you learn to live with yourself. I've gotten less judgmental, more patient. I'm much clearer about what I'm trying to write.

Reading is an enormous pleasure to me. My husbands preferred me to lead a solitary life without friends. But since then, I've made many new friends of all ages.

I think the greatest pleasure is evidence of affection from my friends. I can store that up. I've gotten used to living alone. I sometimes have ten days when I'm on my own. There are very few people who I actually like talking to on the phone. Otherwise, I find it a torture. I used to like having a proper correspondence.

Life is so interesting. The state of the world is so awful that one can hardly bear to contemplate it, but all the same it's still profoundly interesting to me.

Lovers and the excitement of being in love used to give me the greatest pleasure. I now get a great deal of pleasure out of making things, in cooking and tapestry. I very much appreciate good writing and good music.

I feel very up and down at the moment. My mental health is much influenced by my physical state. I have a low threshold of pain. I think, "How much worse is this going to get, and will I lose my mind as well?"

Two world wars quartered women's prospects for finding a man. Then homosexuality became legal, and this released a lot of men from having to go through the charade of marriage. Now the chance of finding the perfect mate is really decreased.

I would like to be remembered for being a good novelist. I usually write novels once. I don't go over them. Occasionally, I add a comma. I'd like my family and friends to remember me with love. I'd like to be missed.

I look to the future with a certain amount of apprehension. My

mother said that senility and incontinence were the things she most dreaded, and I think she was right. My daughter will take care of me and support me. Homes for old people are Dickensian, and I'm not rich enough to have a career. I don't want to die. I'm afraid of death. I'm also afraid of being a frightful nuisance in what seems like an unnecessary way. I haven't got a nice, neat view of the future at all. I pray I'll get knocked off by pneumonia quickly—but there's no guarantee and there's no justice. It's very worrying. For this reason, I try to live day by day and not look ahead much. It doesn't seem wise. I wish I could say I feel like I'm coming into a safe harbor, but I can't.

Aging makes you think about philosophy and religion, and whether they have value. It is a framework for morality. I have no faith. I don't believe there's an afterlife. The only way we live on at all is through the works we leave behind, but more through example. Example is a seed that can be propagated through generations.

Discriminate. That's a very important thing to do. When you are young, it doesn't come easily. Impulse seems a natural way of getting about. A lot of grief could be avoided through a bit of discrimination. It doesn't mean calculation. It's recognizing what something really is, whether it's a picture, a person, or a feeling.

And it's important to look after your body, because it's your machinery of life and it will respond to how you treat it either way. It's important to find out what you need. I need a lot of sleep, and I sleep as much as I need to. When you're young, people think that caring for your body is to be alluring, but that isn't the point.

Exercise in any way you enjoy. That will make your old age infinitely more pleasurable. We didn't recognize it was important when we were young, but now we know that it is. In the second half, it's not about facelifts. It's about having the energy to do what you enjoy.

143 ELIZABETH JANE HOWARD

MODESTINE BROWNE

Born 1930, interviewed at age 76 • Retired cook
Antigua, West Indies

I worked for the Mill Reef Club for about fifteen years as a cook. I have four children. I was married. My husband died eleven years ago. He was a gardener at Mill Reef.

Life was up and down, but the second half has been easier. When we were growing up, our parents had it very hard. They worked in the garden selling fruits, and my father used to cut cane. When the rain comes, everyone plants, and everyone has the same crops, so there is nothing to sell. Our mom told us that our father worked for five shillings a week. My mom had ten children and I would see my mom cry because there was not enough food to go around.

I started working for thirteen dollars a week. We then had electricity and running water. I was married in 1968. I had two children before I was married, then two with my husband. Together we built this house.

My husband was a good man, but he'd go off. He said he was going with his friends to play dominoes, but that wasn't true. He was

with other women. But he was a good man in his way. He was very fair. Talking didn't make things any better—it made it worse.

Now I'm home and the children take care of me.

I work in my garden. I like flowers. I read books. My hobby is collecting stuffed animals. I like being at home. Reading is important. I read storybooks, books on gardening, and the Bible. I watch TV—*Judge Judy*, and detective stories. I would like to be computer literate. I used to go and watch cricket and football with my husband. Now that's not important. I used to be interested in soaps—no longer. I like to listen to music on the radio—country, Western, and sentimental music.

My greatest happiness was when my children went to school and got good grades, and Christmastime when we sit and laugh together. My greatest sadness was when I was disappointed in something or someone, when someone connected to me did something I didn't like. The times when my husband would go out and I'd feel unhappy.

I got the greatest pleasure from my children. Now Saleem, my granddaughter, makes me very proud. She graduated from primary school at the age of ten and went to high school. She went to Antigua Girls High School for five years and Antigua State College for two years. Now she is studying to be a doctor. I have two other granddaughters who are the same. My children make me very proud.

I feel great now, and when I sit and look at my garden, I thank God. I've been blessed.

I'm looking to a bright old age. When my husband died, we still owed the bank for money we borrowed to build this house. Mill Reef gave me money when he died, and I paid off the bank.

Be yourself. Don't try to be somebody else. Be honest with yourself. Those are the things to learn. Sometimes you feel ashamed and embarrassed. Do not hide from people you owe. Be upfront. Say, "I don't have it. I'm sorry." Be respectful of your elders. Never let your children believe you are the perfect mom. Don't let your children

believe you know everything. Show love and tell them they can talk to their mom about everything.

I want to be remembered as someone who was a good person. I want to live a life in this community and be remembered as someone who was respectful and respected.

People get married today and soon they are divorced. Have good self-esteem. Live good, respectable lives and love God, and when you get married, make certain you can stay together, because that's a good example. Live a life that will count in the community.

I would admonish the youth to let Christ be their example, to think highly of themselves, and to just be themselves. Get an education so you can take care of yourself. Love your children. Teach them to be loving, kind, and respectful. Teach them to be industrious.

CRISTINA LORING DE SAAVEDRA

Born 1947, interviewed at age 61
Madrid, Spain

I was born in Seville. I am the third of a very big family. We are thirteen brothers and sisters. We have one thousand hectares of olive trees, and our family has sold olives since the seventeenth century. With eighteen years between the eldest and the youngest, we had a very active family life and there was no room for selfishness. We had to share the space, the clothes, and the friends. Today, a family gathering means over one hundred close cousins.

I went to a boarding school run by Irish nuns at Loreto Convent, just outside of Seville. My grandmother and my mother went to schools run by the same nuns. I remember they were especially open-minded compared to other schools, which I like to believe is the main reason that I have good memories of those years.

I did many things after I graduated. One thing was being a hostess on boats. I was with a line cruiser company that took passengers around the Mediterranean, the Baltic Sea, and South America. As a hostess, I was in charge of a large group of tourists, and for several

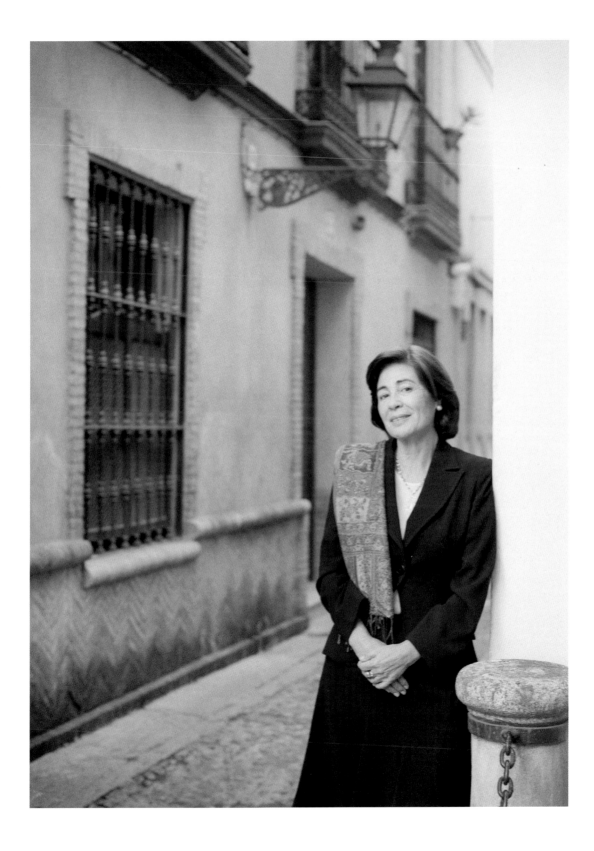

years I had a wonderful time traveling. I traveled to Russia and South America and saw the world.

I dance flamenco. I did ballet when I was very small, but I started flamenco when I was nine with an excellent teacher called "Enrique el Cojo," which means "the lame." To dance flamenco, you have to have good rhythm. When you dance, your sentiment comes out. It's very popular to dance flamenco at parties all year round, but especially at the Feria de Sevilla in the month of April. My husband doesn't know how to dance, so I dance it at home for exercise.

The second half of life is calmer. In the first half, I was not sure of myself, and now, as I age, I am more comfortable with myself.

I met my husband on a weekend house party given by mutual friends in the country. We were hunting wild pigs on horseback with lances. I was on horseback, and he was taking pictures with a Hasselblad. Later he became an art book publisher, which he remains today. He called me when he arrived in Madrid and said he had some photos of me. He decided he was going to marry me almost right away. He called me every night. He was in Madrid; I was in Seville. I was twenty when I met him; he was twenty-three. We were married four years later. I had to decide whether I wanted to live in Madrid. It was difficult for me to decide because it is a very different life. I'm not especially a lady of society. In Seville, we were always in the countryside. I was always on horseback. I had all my brothers there. But many of my friends moved to Madrid after they married, so I started to feel at home there.

My husband and I had three children—a girl and two boys—and have lived in Madrid ever since we were married, though we come back to Seville every month and for holidays.

My family still has a country house an hour from Seville that we all share. We go with the children for weekends and holidays. We have

a big family and no fights. We have one of the best farms in Andalusia. We produce olive oil, cantaloupe, onions, and wheat—but mostly olive oil. We have a meeting every two months with the thirteen brothers and sisters. Three of the brothers manage the farm.

My father-in-law died when he was ninety-four. After I was married, he lived with us for thirteen years. He'd have lunch and dinner with us every day. He was a very nice person. My children loved being with their grandfather, and it was a good education for them. They grew up in touch with an open-minded person that had lived an active life.

Now we have rearranged the apartment, and my son lives in the other half. They all come to lunch at my house. At nighttime, we have separate dinners. My daughter lives two apartment buildings away. My other son works with his father. On Sunday, everyone comes to us for lunch.

The second half of life is calmer. In the first half, I was not sure of myself, and now, as I age, I am more comfortable with myself. I've learned to be happy with myself, not looking to be another person. When you are younger, you want to be always perfect-looking. Now you put something on, you go out, and you don't mind.

Small things are more important when you are younger. When you are older, it's only the important things that you care about.

In the first half, I learned to speak multiple languages—English, French, and a little bit of German—which has been helpful to me throughout my life.

When I was young, I learned to help people by following the example of my mother and my grandmother. My grandmother lived with us, so I learned to be with older people. That's why I didn't mind having my father-in-law living with us. My parents were very liberal. When we were seventeen or eighteen, they were not hovering. They had confidence in us.

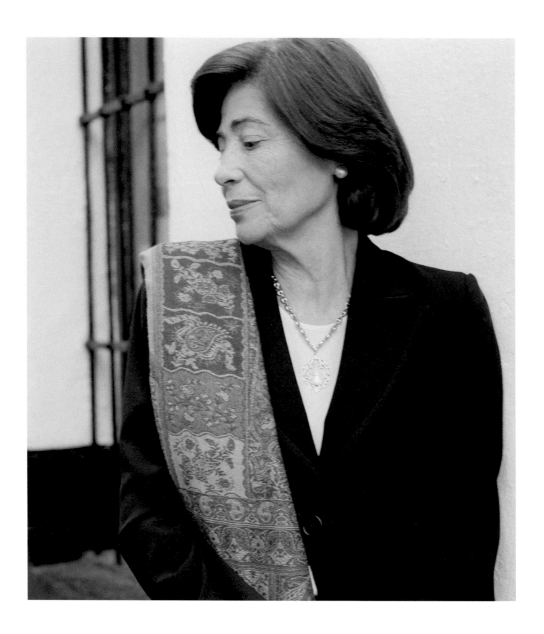

My mother was a very good person. She was always at home and knew each child well, but she was not nervous. She was very relaxed. I was thirty or thirty-one when she died of a brain aneurysm.

My happiest time was when I was young with all my brothers and sisters. Playing in a big family, I was carefree. You don't have to be

responsible when you are very young. My saddest time was when my mother died—she died very young, at sixty-two, twenty-five years ago.

Now I am tired of traveling. I like to travel, but not so much. I like to be with my grandchildren. When I see that everyone is happy and healthy, it gives me pleasure.

I like to look ahead—I want to help people be happy, looking forward, not saying that things were better before.

My advice would be to do what you like to do. Don't be dependent on anyone else for your happiness.

CHRISTINE OCKRENT

Born 1944, interviewed at age 62 • First French woman TV anchor

Paris, France

I was born in Brussels to Belgian parents. We moved to Paris when my father became OECD ambassador. I was raised in Paris.

I spent a gorgeous year in Cambridge, England, pretending to be learning things. I got a Harkness Fellowship to go to the Kennedy School.

I was hired by NBC News here in Paris, then by CBS, and then I worked for Mike Wallace in London for *60 Minutes*. I was at first a researcher, then assistant producer, then associate producer. Then, for family reasons, I decided to go back to Paris in my late twenties, early thirties.

In Paris, I did a lot of documentaries and eventually became an anchor. I was the first woman to anchor a morning news program. Then I was hired to anchor the evening news. I got tired of that job and the star system that goes with it, so I went back to reporting. For two years, I was the editor of *L'Express*. I started an internet company,

but I was wiped out after the bubble burst. I never quit doing TV news until I was appointed as the number two to a newly established corporation at the time, the French TV and Radio World Service.

I am the partner of Bernard Kouchner [founder of Médecins Sans Frontières, past minister of health and minister of foreign affairs in France], and we have one son, Alexander. We've been together for twenty-six years. Neither of us felt that it was compulsory to get married. I think we met during a TV program. He was a guest and I had been asked to take part.

First of all, in my head, I'm always thirty-six. I was very young until I was forty, when I became a mother.

We are lucky to live in an age where we are in much better shape, physically and psychologically. When I look at myself in the mirror, I am quite aghast, but I don't feel that the pace of my life and the sports that I practice have been altered. I probably tire more easily, but I have very long working days, I travel a lot, and I have a lot of jet lag. I don't relate to age except when I am very tired or in a bad mood.

When I was younger, I was lucky enough to be raised by wonderful parents who instilled a kind of personal balance, which is the most extraordinary gift you can give a child—to have priorities. Those may change depending on the cycles of life.

I've always worked very hard, and I've always enjoyed work, and that keeps you young. I remember Mike Wallace calling me up when he was over eighty, and saying, "Do you have a scoop for me?"

My sense of who I am has not changed enough. I still make the same mistakes. One does acquire a more mature approach to people— taking people with more of a grain of salt, and being less demanding than one can be at a younger age. But it is very important to be as demanding with oneself as one is with others.

What comes with age is a way to savor very simple moments, such as looking at the sky. Time becomes more of the essence.

What's certainly become more important is sleep. My son has been important since he was born. I am extremely involved in my job and will be as long as I can breathe, but I love watching my son become a man and make his own choices. Bernard has three other children, so there are lots of grandchildren. I used to work on weekends, but now I have real weekends, which is new to me. Whenever I can, I go to the country and breathe.

Family, then and now, gives me the greatest pleasure, but I am still extremely interested in what I do. I've never been bored. When I became bored with anchoring the evening news—which nobody at the time understood, as it's supposed to be the most coveted job—I said, "What the hell!" I quit and went back to reporting. I was happy to be in some god-awful place with my crew, and I found that it rejuvenated me. That's the issue: to not become bored.

That's the way to chase away age—to do something you've never done before, and all that you've done before pays off.

I would like to be remembered as a journalist. I look to the future with appetite.

I feel great because my new job is fascinating. It's totally different from what I used to do. That's the way to chase away age—to do something you've never done before, and all that you've done before pays off.

Tomorrow is the time of greatest happiness. My father died very young—he was sixty—and when my mother died, those were the times of greatest sorrow.

My advice is to keep at it; never complain, never explain.

PEGGY ELLIOTT

Born 1942, interviewed at age 64 • Manicurist
Fishers Island, New York, and West Palm Beach, Florida, U.S.A.

I've worked harder in the second half than the first half because I realized that I wasn't going to inherit money from anyone. I really feel that my values have changed as my libido has changed. I used to make foolish choices. I got married four times, had several affairs. Passion ruled my mind. Now I rely more on common sense.

My sense of self has become more confident with age. As long as people still listen, I still have something to say. What's become less important is constant dieting and worrying about putting on a little weight; I care much less about my looks. What's more important to me now is maintaining a healthy lifestyle.

I've learned the importance of being generous. Give of yourself, share your thoughts, your money, and your food. I found in the second half that the more you share, the more you receive, tenfold! I was never generous as a young person, perhaps because I had four

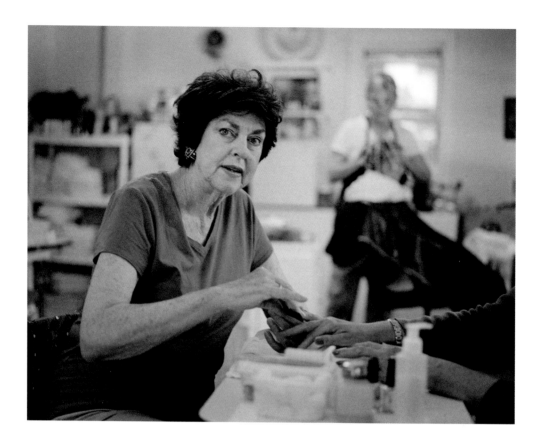

brothers and I was the oldest sibling. The more you give of yourself, though, the more comes back.

My time of greatest happiest was when my daughter-in-law and my son announced that they were pregnant. I threw a spatula into the air. I was cooking dinner. I was crying. It was the most wonderful feeling—I was going to have a grandchild. The next generation is a part of you. You have produced another generation. It's almost a biological thing. It's the most wonderful feeling.

My moment of deepest sadness was the morning they told me that my eldest daughter had been killed in an automobile accident. She was eighteen. I forgot everything. The sad part is that now I can't remember her. It was about twenty-five years ago. She was my friend.

I had her when I was eighteen. She left the house with no regrets. She was a happy person. Some people have guilt. We left each other loving each other. She's always here. Sometimes I feel almost as though someone's brushing by my hair, and I know it's her. It's hard to describe, but I know her presence. She's there.

My work has given me the greatest pleasure; I'm so thankful for the wonderful, interesting clients I've had, and for their loyalty. I'm thankful for the wonderful places I've worked—the Bath and Tennis Clubs in Palm Beach and Fishers Island. That still gives me the greatest pleasure. A manicurist becomes a psychiatrist. You hold in the experiences you've had with people, and you develop a better understanding of people.

I feel more confident, less self-conscious, and much more sympathetic toward people older than me. I live every day and let the future take care of itself. Why worry? What can you do?

I would advise younger women to put joy in their life. Life is meant to be fun. Don't plan every minute. Lighten up. Be yourself, and don't get distracted. Even though you're a little different, let yourself be who you are, and don't be concerned with following the crowd.

LADY ELIZABETH LONGMAN

Born 1924, interviewed at age 82 • Wife of the last head of Longman Publishing Company and bridesmaid to Queen Elizabeth II • London, England

The second half is a bit of a bind. I'm very lucky I've got children and grandchildren. It gives me a feeling of continuity. The first half of my life was much more glamorous, traveling all over the world with my husband, Mark, and meeting interesting people. We always had the best accommodations because he was chairman of Longman's and chairman of the Publishers Association. During the second half, I still travel—probably less glamorously, but no less interestingly. Mark used to take care of everything before he died, but as I had been infected with the lure of travel, I decided not to retire into widow's weeds, but to go on with life. Mark did everything—he had arranged for our life, generally. I had to learn to cope.

I've known the Queen since I was eighteen months old. She was eighteen months younger than I, and we grew up together. My parents were on very good terms with her parents. My father was the Earl of Cavan, and he was an exact contemporary of the Queen's grandfather, George V. My father was asked to look after the Prince of Wales

(before he became Edward VIII) at the front during the First World War. The prince was determined to see action and to be at the front line, which was a great responsibility for my poor Papa, as he had been detailed by George V to keep Edward safe.

The Queen came to our singing class, and I went to her dancing class. Later, in the 1930s when I was about thirteen, they formed a Girl Guide pack at Buckingham Palace, and a Brownie pack also. My sister Joanna and Princess Margaret were the only two Brownies. Patricia Mountbatten was the leader of one of the Girl Guides, and the Queen was her second-in-command. I was second in Winifred Hardinge's pack. We used to go down in one of the royal vans to Windsor Park with the captain of the Guides, who was frightfully hearty. They lived at 145 Piccadilly when her parents were Duke and Duchess of York. We were about twelve when she moved into Buckingham Palace. We never came out [as debutantes] because of the war.

I was one of the bridesmaids when the Queen got married. Most of the bridesmaids are dead now. We went in a car that was sent for us, and we went to Westminster Abbey. Princess Margaret and Princess Alexandra were in front, as they were still children. I was near the front because I was so short. I got terrible giggles with Caroline Gilmour, who was a great giggler. I met Caroline there, and she became a great friend.

My husband, Mark, was my second cousin. There were eight years between us. After the war, I had about a year having a jolly time, then my mother wrote to her cousin Harry Longman and asked if there was any hope of me getting a job at Longman's. That's how I got to know him. One day, he asked me to go back and have tea with his parents, and it went from there.

A housemaster at Eton described Mark as a "very gifted boy." He was very artistic; he won the singing prize and drawing prize at Eton. He was very handsome, very intelligent, and literary. I'd had a very

bad education. I went to Miss Faunce's School, and all I can say is that I made lots of friends there. It wasn't a particularly academic school. It wouldn't be considered great now.

Funnily enough, I'm more tolerant now in the second half than I used to be. I've had more privilege than I deserve. It was sad being widowed so young, at age forty-eight, and having to bring up three daughters alone, but I've led an interesting life. I traveled all over the world visiting publishing houses. I traveled to what had been the British Empire. I wasn't at all confident as a young person, but being widowed young made me realize that I am a survivor.

As long as I can remain independent, I am reasonably happy. I'd like to be remembered as a bad mother and a better grandmother.

Trying to keep one's end up in literary society is no longer important to me. Now I don't mind in the least what people think of me. The way I was brought up, class distinctions were so important. One never socialized with anyone out of one's class because one wouldn't have met them. People were such terrible snobs. Snobbism must have gone during the war. It simply doesn't affect me or worry me a bit now. I don't feel any class barriers. I feel I can get on with anybody.

The time in my life that was the best was being married, traveling, and having children. I felt I was always learning and meeting interesting people. Mark's illness, which went on for five years, was the time of deepest sadness. It was a terrible blow when I found out he had lung cancer. I could have married again, but I didn't feel the options were acceptable. A lot of men seem to want a cook or a housekeeper as a priority in a wife. I was so afraid of being bored. I had many men friends and three very companionable daughters. My daughters are very supportive and concerned for my well-being. I have fun with them and with their children.

Traveling gave me the greatest pleasure when I was younger. Now it's mostly in the mind. I still think of the places that I'd like to go, like riding in the Rockies, or going up the Amazon—although I hate venomous snakes and insects! Reflection on my travels gives me the greatest pleasure now. I feel like a dotty old octogenarian—I don't think there's much of a future for me. I hope I go quickly. As long as I can remain independent, I am reasonably happy. I'd like to be remembered as a bad mother and a better grandmother.

I would advise younger women to never take themselves too seriously. Always be able to laugh at yourself. Don't take offense too easily to what others say and do. One gets lows at times. Vitamin B-12 has a good effect. Never give up, and even if you're in a state of depression, it will lift eventually. If not, get help!

LALI AL BALUSHI

Born ca. 1950, interviewed at age 60 • Housewife
South Mabela, outside of Muscat, Oman

I was born in Muttra. I was born at home, not in the hospital. I don't have any certificates, so I don't know the exact day it was. I was the only child, but my father had another wife aside from my mom, so I had four sisters and three brothers. We all lived together in one house. My mom and the other wife were jealous of each other. My mom was the first wife. My father and mother have died, but the second wife is still alive. I'm not close to her.

I did not go to school. My sisters were all allowed to go to school, but I was made to stay at home and clean. I spent part of every day with my grandmother for ten years when I was little, because she was old and wanted someone to help her with the housework. My father was a good man, but not strong—his second wife was in charge. She was a very powerful woman. My sisters didn't like me, so they never come to see me now. I sometimes go to see them.

I was married when I was fourteen. My mother died the year before and my stepmother decided I should be married. I was playing

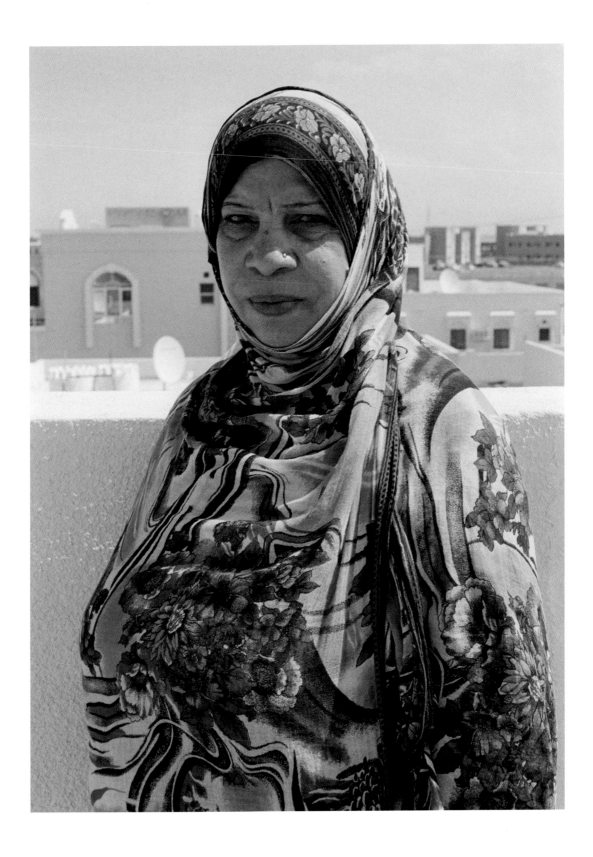

with my friends when my husband's parents came to visit and ask if I could marry him. My cousins were the ones who told me that after a few days, I would be married. My husband was my first cousin. He was a policeman, and he was ten years older than me.

On my wedding day, I was crying. When my husband tried to sleep with me, I was crying because I was so afraid; I didn't know what he was doing. My father took me home to live with my family for two years, and then I went back to live with my husband when I was seventeen. By that time, I knew something about sex. I didn't like my first husband. He wasn't very nice. He drank and he beat me. I didn't say anything. No one supported me. All my sisters were selfish because they were not my real sisters. They said, "Solve your own problems. This is your life. We are busy." I had one girl and two boys with him.

When I had my third child, my husband divorced me, and he took the three children. The youngest baby was only two months old. I was crying, but because I was a woman, no one paid any attention. In those days, women couldn't object.

When I had my third child, my husband divorced me, and he took the three children. The youngest baby was only two months old. I was crying, but because I was a woman, no one paid any attention. In those days, women couldn't object.

After me, he married a Pakistani and took my three children to Pakistan. After seven years, they moved back to Oman, and then I could see my children whenever I wanted. Someone told me, "Lali, your children are back." I ran to see them. I was allowed to see my children for three or four hours each day in their new home, but I couldn't bring them to mine. I was twenty years old when he left with the children.

I had been back in my father's house for two years, and then another man asked my father if he could marry me. My father came

to ask me, and I said yes. My second husband was very nice, and I had three boys and four girls with him. I was married to him for twenty-five to thirty years before he divorced me. We are still friends. The first husband—I don't know anything about him, but the second one I keep in touch with. All my children are now married; I have eighteen grandchildren.

When my second husband left me, I was around forty-five. I went back to my father's second wife's family. I didn't have any choice. I couldn't work at most jobs because I can't read. I worked for a while in a textile company. When it was time to measure, someone had to help me. I took a taxi to and from work each day and fell in love with the taxi man. Now he's my third husband. He's a driver for an electric company. I'm very happy with him, more than with the others. When he gets his salary, he directly gives it right to me. And every Friday, all my children come here and eat with me. I'm very happy with my grandchildren. When I see my grandchildren, I forget all about the past.

In the first half, I was very tired. When I was young, I was not happy inside. Now I'm sixty and in the second half, and I'm very happy because no one orders me around. This is my home. If I like someone, I will open my door. If not, I won't. I'm like a princess in my home.

I feel I am another woman now. Before, I felt I was nothing. I wasn't allowed to talk—to say yes or no—because no one listened to me. Now they do. We women need love at every age. No one gave me love before. Now they do. That's why I feel changed.

My past life is not important. I won't forget it, but it's not important. It is the past. Now I'm proud because I'm a good grandmother. My children and my children's babies are what's important to me. My husband is also very important now. Some people say, "Now that we are fifty, how can we fall in love with a man?" But it can happen at any

age. I am proof that it can happen. We were married ten years ago, and we are still in love. He didn't have any children of his own. He likes all my children, and my children love him. When they are all together, they are very happy.

In the first half, I learned that I can't trust anyone, because even though my second husband and I were happy, he left with another woman. I am now much more careful about trusting people, especially men.

My happiest time was when I delivered my first baby. I was so, so happy when my first baby said, "Mom." My saddest time was when both my husbands divorced me and took my babies away. I felt so alone. My children have always given me the greatest pleasure. Now my husband and children do.

I'm not feeling anything bad about the future. Before, my life was sad. Now I believe everything will be good. Now I'm not scared. If my husband left me now, I know I could live with my children.

My advice to young girls would be: When you marry, be careful. When you care for your children, don't forget to also care for your husband, because it's terrible when he marries another woman. When he's back from work, stay with him and talk to him. Care about your home, your children, and especially your husband. I'm talking about now because life has changed. I'm talking to today's girls.

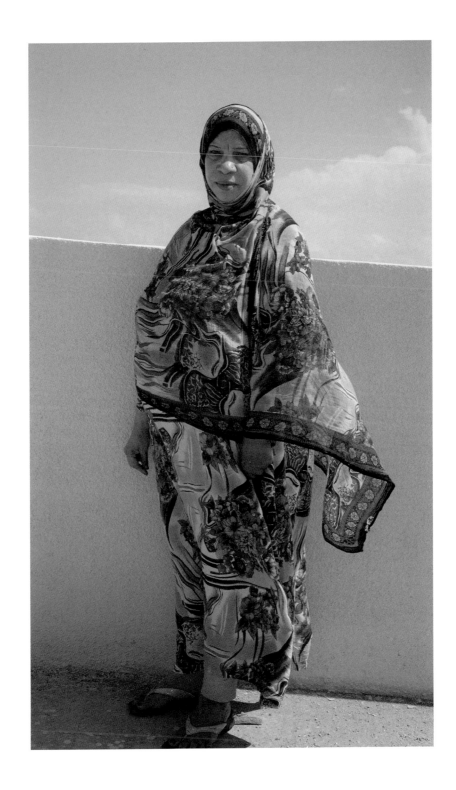

LALI AL BALUSHI

TULLIA ZEVI

Born 1919, interviewed at age 89 • Musician, journalist, president of the Italian Jewish Communities, and vice president of European Jewish Communities • Rome, Italy

I was born in Milan in 1919. When the Fascists issued the racial laws, we escaped to Lugano. My father had been warned by Toscanini, who said, "Look, I've heard rumors that they may arrest you. You'd better leave." The next day, we took the train to Lugano, then we went to Paris. We were in Paris one year, and we went to New York just before the war broke out. I lived there and studied at Radcliffe and Juilliard.

I worked professionally as a harpist. I played with the New York Symphony and the Boston Symphony Orchestra, and also founded the Orpheus Harp Quintet. At the same time, I worked for the Office of War Information and CBS broadcasting into Italy.

Among other things, I worked with Frank Sinatra. We did five shows a day. Once, at the Paramount Theater, I was quietly tuning my harp, and a girl jumped into the pit. She said, "You played for him. Can I touch you?" Girls swooned like anything. The fans' hysterical shouting made it very hard to keep the harp in tune.

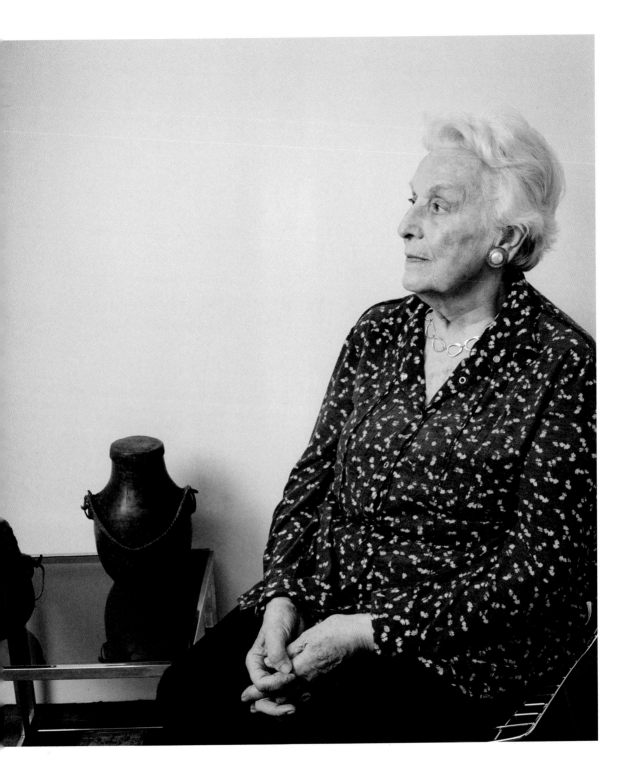

I met my husband in New York. There was a whole group of Italians who had escaped fascism. My husband and I were married on December 26, 1940. I was twenty-one years old. It was a wedding of émigrés—refugees—so there was a lot of pathos. My wedding dress cost $27.95. It was pale blue jersey. I made a turban. A couple of Italians had brought samples of Italian silk underwear—they had been hoping to set up a business. I bought some of the samples. It was my trousseau.

My husband left America in 1943 to do war work from London, broadcasting to Italy. They were operating a short-wave station which kept the American forces in contact with the Resistance. When he left for London, I moved back in with my family. I did graduate work in musicology and philosophy for two or three years. I joined my husband in Italy in 1946. My daughter was born in '47 and my son in '49. I took my master's degree at the Conservatory in Milan.

The most important thing is never to be indifferent to other people's feelings. You are part of a greater thing. You live from others. There is no real life unless you are able to give and receive. It is true with everything.

My husband was Bruno Zevi. He was an architect—a pupil of Frank Lloyd Wright and Walter Gropius. He studied at Harvard with Walter Gropius. Both of my children are graduates in architecture. My daughter teaches history of art. My husband died when I was in my sixties. He was seventy-one.

When I returned to Italy, I started working as a journalist—it was the only way I was allowed to return. I loved it, and have been a journalist ever since. I worked for an English weekly, an American news agency, and an Israeli daily. I wrote the story of my life with my granddaughter. The title is "I Will Tell You My Story." It was published a few months ago.

The second half of life was a return to normalcy, a return home. It was a busy time. I loved being with my family, but I was very unhappy unless I worked.

To change you must, but keep your old interests with new ones. You must keep apace—otherwise you are dead. I enjoyed being both a musician and journalist. I actually find journalism more exciting.

I try to understand how realities change, how the condition of women is changing, and how the man-woman relationship changes.

I realized that financial independence was foremost. To ask money from your husband is not a good thing. This is a lesson I taught myself from the age of nineteen. My husband said that the place of a woman was as a wife and mother. I agreed with that, but it was not enough. I always knew that women have to stand on their own feet. My husband came from a very traditional family, but he realized I would never be happy just as a wife, so he joined the game.

I am a Jew and went into Arab countries. If you don't lie and are natural, you can go anyplace. I've never had any problems. The Arabs were actually interested and curious. When I interviewed King Hussein of Jordan, he was fascinated—so was I. I even interviewed PLF people in Beirut. I never made a secret of who I was, but they were interested. They invited me into their homes.

I feel fulfilled. The most important thing is never to be indifferent to other people's feelings. You are part of a greater thing. You live from others. There is no real life unless you are able to give and receive. It is true with everything.

When my mother was dying of lung cancer, I asked her what the most important thing in life was. She could hardly speak. She said, "Amore." She was right. You have to care about people, things, politics, religion.

My saddest time was when I lost my parents and my husband. As all good girls, I was in love with my father, but when you lose your

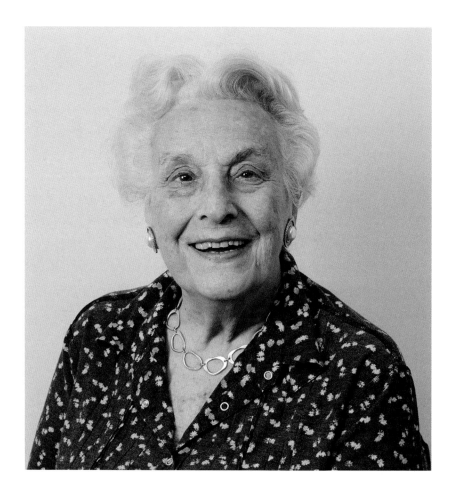

parents, you feel that it's the law of nature. You feel as though you have no person to turn to, but it's natural to be separated from your parents to start a family. When your husband dies, it is a different thing—you feel mutilated. It feels unnatural to be alone.

My greatest pleasure has been to live in a time of peace. Peace gives you all the possibilities in the world—when men don't have to kill each other, hate each other. When you have lived through war and persecution, peace is the most important.

The Latins had a phrase when they wanted to say, "She had been a good woman." It was, "She lived at home and she wove wool." I would

like people to be able to say, "She did her own thing in her own time, praying for peace."

In the Book of Proverbs, there is a phrase about the virtuous woman: "She does good and no harm in all the time of her life." It's as important for men as for women. Hope for peace.

LAMA YESHE DROLMA

Born 1945, interviewed at age 61 • Buddhist teacher in the Bodi Path tradition
Lubeck, Germany • Photographed in New York

The second half gave me a sense of much more freedom and security, looking deeper into more spiritual matters—and also joy, because joy comes from this. So I feel as though I've arrived in the right place.

During the first half, I was in the fashion world as a business-woman, so it was a very interesting life but a superficial life. I was the liaison in a trading company between the producers in Asia and the customers in Europe. I helped people to be beautiful outside, and now I help people to get a sense of inner beauty—the true understanding, the fearlessness, the calm—and a contentment vaster than the world.

I had lived in Hong Kong for three years, and because of a Japa-nese boyfriend, I moved to Osaka for a year and a half with the family of my boyfriend. I had met this boyfriend on a beach in Bali. His father was a lay Buddhist priest. While they were working, I went into the shrine room. I hit the gong and said to the Buddha, "If you really exist, show me the way." I was challenging them. Suddenly I knew I

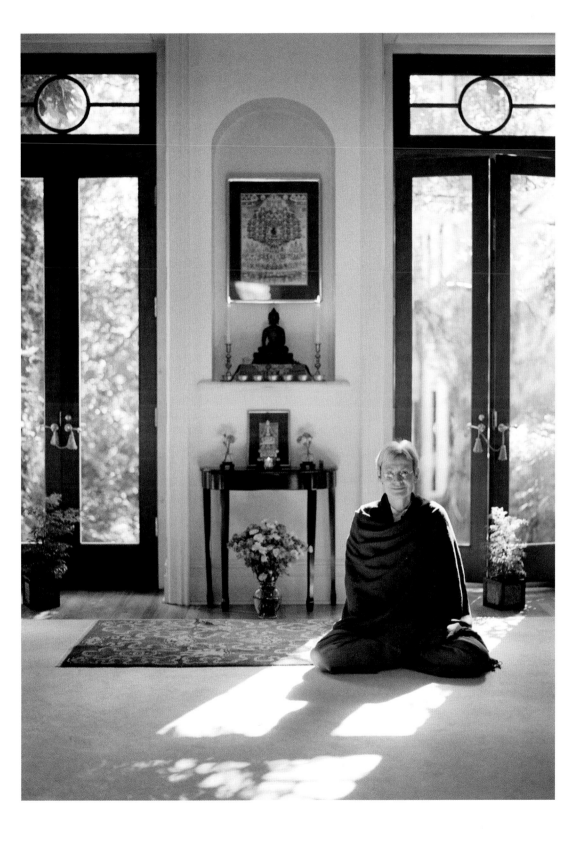

had to leave Osaka and go back to Hamburg. There I met the Buddhism I'm connected to now.

In September 1985, a friend said, "Why don't you come to this teaching by a Lama?" I love walking, and the sun was out, and I really wished to not go, but something made me change my mind. I listened to the information, and from a deep heart, I knew everything was true. I met my master, Sharma Rimpoche, six weeks later and decided to stop working for three months. That was now twenty-two years ago. Step by step, I gave everything up. I did not start out with the intent to stop my worldly career. I was happy with what I was doing. It was just my karma.

Everyone has power. Use your power compassionately and wisely.

Everything I learned in the first half has been helpful in the second. In the first half, I was much more insecure—I had more fear. I started in the fashion world when I was twenty-three. The inner journey gave me so much more security and safety than the material world. I had fear before. Being on the spiritual path, the fear dissolves.

Now is my time of greatest happiness. My deepest sadness was in my young days when I felt alone. There was also a sense of deep sadness when I started my spiritual path because I realized that I had wasted so much time. But now I see that what I did in the first half benefits me, because I understand people and can be more compassionate.

What gave me the greatest pleasure when I was young was exploring something—planning a journey, composing a song, going on a bike ride, making a poem. Now my greatest pleasure is showing what I've received, constantly sharing the dharma and seeing how it benefits others.

I feel very content inside myself—ever growing, with limitless possibilities.

I would say to younger people: Be open, everything is possible. Use positive thoughts; direct your life in positive ways that are inclusive to all beings. Just know that we can become anything if we strive.

Everyone has power. Use your power compassionately and wisely.

LULU BALCOM

Born 1912, interviewed at age 95 • Artist

Fishers Island, New York, and Palm Beach, Florida, U.S.A.

The second half has been as good as the first half. I've been lucky to have friends and a cousin who likes to travel with me so I can do what I want to do, which I might not have been able to do otherwise. I haven't changed much. I'm certainly no wiser. I've always loved adventure and travel. My health is now more important.

I started traveling at eighteen—a Mediterranean cruise with my father. I had been given a choice of going to school in Switzerland or going on a cruise. That whetted my appetite for travel.

When I was nineteen, I talked my mother into a South Sea Oriental Cruise for three months. It was the maiden voyage of the *Lurline*, with five hundred people. We went from New York to Havana and Jamaica, then Los Angeles, Figi, Samoa, New Guinea, China, Hong Kong, Manila, Singapore, and Bangkok. I met my first husband, George Vanderbilt, on shipboard. He got on in Los Angeles and was supposed to get off in New Zealand to meet his

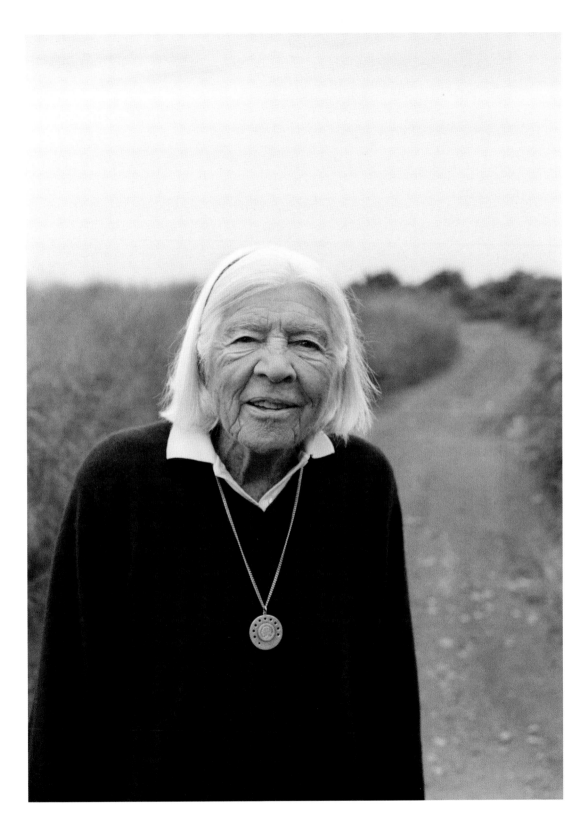

mother, who was arriving there on the *Caronia*, but he asked to stay on till Singapore.

I married him in 1935. He was the father of my daughter Lulu. We took trips on his schooner—the first trip was in 1937. We were married for seven to ten years, but he became an alcoholic during the war, and we divorced.

In 1949, I married Ronnie Balcom. We were married for forty-seven years. The happiest time of my life was when I was married to Ronnie. Love's more wonderful the second time around. We spent only two nights apart. He didn't work, so we did everything together. We skied in the winter. We built a chalet in Cloisters and spent two to three months in the winter there, and went there for a month in the fall also. We also skied in Sun Valley and Vail. In the summers, we came to Fishers Island and played golf all summer. Ronnie had this necklace made for me with all the nine holes in one I'd had. I wear it a lot. We traveled, mostly on cruises. After I married George Vanderbilt, my winter base became Palm Beach. We had a plantation, Arcadia, in South Carolina. After Ronnie died, I traveled with my cousin.

In November, I'll go with a friend on a cruise on one of those horrible 2,000-to-3,000-person boats, because I like to gamble. It's what I call my whoopee cruise.

My hobby is making collages out of balsa wood. I started about thirty years ago. Before that, I used to make ship models. My first husband had a 182-foot schooner called *The Pioneer*—I made a model of that. I like making things with my hands. My stepsister had a collage in her house on Long Island. I thought, "I could do that if instead of carving it out of wood, I cut bands of wood." I cut the wood with a little saw and an X-Acto knife. I painted them with acrylic paints, then glued them on with Elmer's glue. It worked, and everyone said how wonderful it was, so I kept on making them. I make

mostly houses, boats and people. I've done sixty-five of them. I make about two each summer. I've sold about twelve—the others I keep or give away. When I sell them, I give the money to the hospital. I've had about ten people who have commissioned me, but I can't fill the orders. I hate to part with the collages because it takes so long to make them.

I feel just the same as I did when I was younger. I'm not able to do as much, but I'm still having a good time and doing much of what I used to do. I don't play golf or exercise much, but I can still swim. Naturally I'm more lonely because most of my friends have died, and of course Ronnie, but I'm lucky I have a cousin who is my traveling companion. I've made some new friends, but most of the people my age are dead. It's odd to be the sole survivor.

I just plan a year ahead. I'm going to Burma this February if I'm still here. I'll pick up the boat in Thailand, and I am going to the islands off Burma. Apparently, there are beautiful islands there. Then after the trip to Burma, I'll go back to Cloisters for two weeks.

In November, I'll go with a friend on a cruise on one of those horrible 2,000-to-3,000-person boats, because I like to gamble. It's what I call my whoopee cruise. I play roulette and she plays blackjack. I usually come out a little bit ahead—not much, but enough to make it fun. My father used to love to play roulette and I used to watch him— that's where I got the bug.

Last fall, I went with friends on the *Cinderella* from Rome to Portofino in the Mediterranean. In May, I went with six friends around New Guinea. I've been on the *Cinderella* sailboat four times in the last four years.

What I love about cruising is the sea. I think it must be because one of my ancestors was a whaling captain, so the sea is in my blood. I like looking at the water and being on a boat.

This house used to be a boathouse. I saw it one day and I thought,

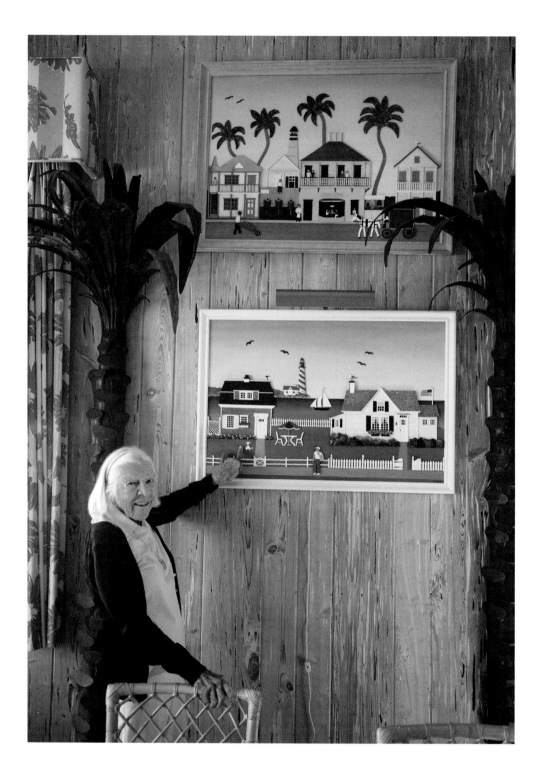

"That might make a nice house!" There was nothing in it. I drew the plans of where the rooms were to go. It feels as though I'm on a boat living here. At high tide, the water goes right under the house. I guess that's why I love it.

Curiosity has been one of the most important things for me.

DODIE ROSEKRANS

Born 1919, interviewed at age 88 • Art collector and patron
San Francisco, U.S.A., Paris, France, and Venice, Italy

I'm not aware of being in the second half of life. I grew up in San Francisco. I was married there, I lived many years in the same neighborhood, and I consider myself lucky to be from such a wonderful city as San Francisco.

However, I am living in Europe now—Paris for part of the year and Venice for part of the year—as well as San Francisco. About four months in each place. It was not planned. It seemed to be the comfortable way for me to live. My mother would not have approved of my life today. She would think I should be living in San Francisco near my family.

I cannot say that I always have done a lot of traveling, because my two husbands worked in San Francisco and loved our city. They were businessmen. Both of them went to Stanford. With my first husband, I had three children and a very happy life, but then he died. Then three years later, I married my second husband.

I was fortunate in experiencing pleasure in my marriages and

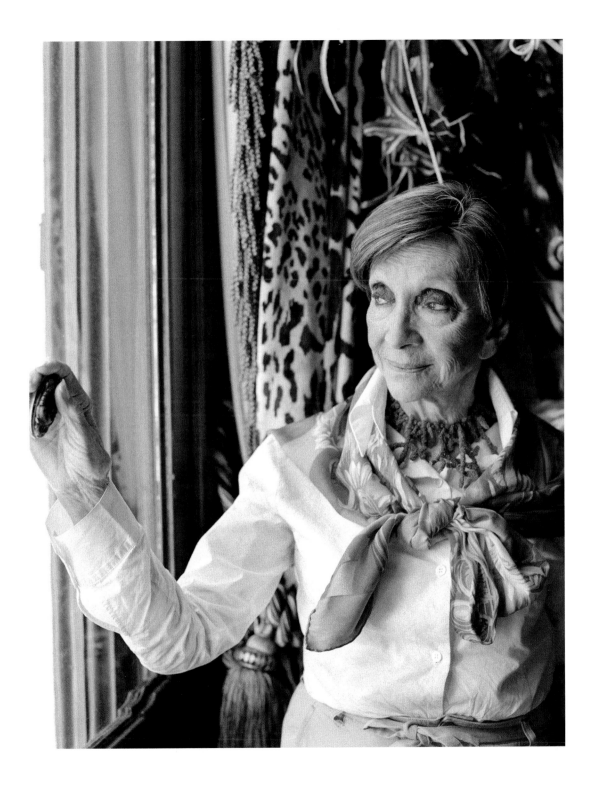

with my family, and I don't mean that I'm a very motherly person. I have a lot of friends, even if only a few close friends. I'm very fortunate in that I never feel lonely. I don't mind being alone. I'm never conscious of being alone.

I suppose I did a fair amount of collecting, but I never thought of myself as a collector. I started collecting as a young married woman. I always had an interest in art. Over the years I have collected everything.

I was very active with the Fine Arts Museums in San Francisco. I loved my experience of being so closely allied with the Fine Arts Museums, and the time and hard work involved was very rewarding and instructive.

I think I got my confidence during a time of psychoanalysis that I successfully experienced in San Francisco, and I feel that all the happiness in my life today is as a result of that analysis. I feel I was very lucky to have it presented to me as a young woman, and I worked with very good people. It was after I was married. Ever since, my life has been wonderful. My sense of who I was developed then.

I think I got my confidence during a time of psychoanalysis that I successfully experienced in San Francisco, and I feel that all the happiness in my life today is as a result of that analysis.

My time of greatest happiness was when my two husbands were alive. Life was more fun because they had a wonderful sense of humor. They were always interested in my life, whatever I was doing.

My greatest sorrows were the deaths of my two husbands and the accidental death of one of my sons. Other than that, I consider myself a very lucky woman. I've always had responsible men in my life looking after me and providing for me. I feel fortunate to have two caring, intelligent sons today.

I feel terrific. I feel comfortable, and my friends mean a great deal to me—and I consider my children my friends. Something I've learned as I've gotten older is that discussing my life is a way of sharing my life with my friends and family.

If you're lucky enough to live a long time, you have time for different experiences. I think that having the courage to experience new things is important and helpful, and even sometimes when there are mistakes, we learn from them.

ELO PAPASIN

Born 1946, interviewed at age 60 • Housekeeper and cook from Manila, the Philippines
Paris, France

The second half is the time when I can look back and see all my achievements. I see that what I wanted to do, I did. The first goal was to give my five children an education, and I did that by working hard and focusing on my goal.

I was born in the Philippines, and I married and had my children there. My husband was a taxi driver. When I was thirty-one, I went to Saudi Arabia and worked there for ten years as a cook, housekeeper, lady's maid, and nanny for four children. The man was very horrible. My madame was very rich and he was not, so he wanted everyone to be afraid of him—my madame, the children, and anyone who worked for them. If you did something wrong, he would slap you. I saw that if I am mentally stronger than him, he would not do it again, so when he slapped me, I turned the other cheek and said, "One more, Sir." He didn't hit me, and never did again. One woman who worked there he beat her several times, and I told her to run away. One time, I put a sleeping tablet in his orange juice, so he slept all day so we could rest.

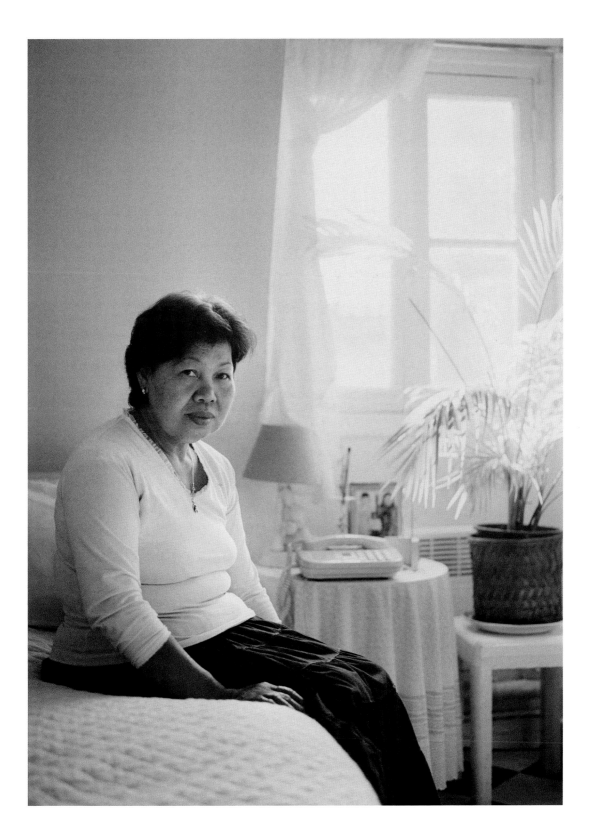

The madame was very ugly, but she was very kind and quiet, and the children were very nice.

After ten years working there, they took me with them on their vacation to the South of France. The man and I got into an argument, and I pushed him down and said, "The law in Saudi Arabia is not the law in France." Then he took my passport away.

The manager of the hotel we were staying in saw how awful he was and helped me escape. He told me the times the trains went to Paris, and I ran away. When I got to Paris, I started walking to the Filipino embassy. When I was almost there, I asked directions of a Filipino couple on the street. They asked me why I wanted to go, and I told them. They invited me to come and live with them until I found a job. I stayed with them for eighteen days and they found me a job.

When I was younger, I thought of others—my extended family—and sent money to them all. Now I'm thinking more of myself and saving. Sometimes when I was young, I was careless. Now I am more choosy, even with friends. I am more solitary now than I was, because I choose my friends more carefully.

When I was younger, I realized that I had an interest in learning, and that has given me enjoyment ever since. If you have knowledge, you have wisdom. I am now very confident in myself because I am reading. I realize I have a good mind. To continue my studies of French is important to me because it is a good exercise for the mind. Less important is going out.

My greatest happiness was when I gave birth to my first child, my daughter. My saddest time was when my husband died and I hadn't seen him in nine years. I was in France and didn't have papers yet, so I couldn't go home.

I feel very comfortable within myself because I know I am following the good example I learned from my church. I know now that when I have problems, I can solve them. I'm not scared of the future

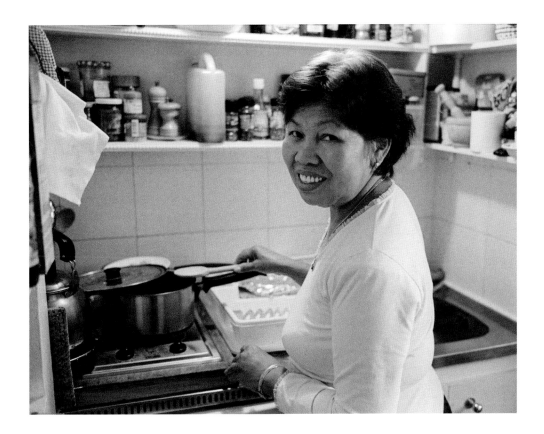

because I realize that after I die, I will return to the Heavenly Father. If you'd like to succeed in life, the first thing you should do is to learn to have faith in God. If you have faith, you can do anything in life.

I now have two houses in the Philippines—one in Manila and one in the country. So when I go back, I can await my end happily.

My four sons are engineers. My daughter is a teacher. I can look back and rejoice in what I accomplished.

MONIKA KOCHS

Born ca. 1946, interviewed at age 61 • Artist
Salzburg, Austria • Photographed in Patmos, Greece

I was born in Wuppertal, Germany, near Cologne, and went to school and university there. I left Wuppertal when I was thirty.

When I was twenty-one, I went to Lausanne to study French for sixteen months. When I returned, I started my studies in German language and art. I wanted to study art, but it was not considered a reasonable profession. My mother wanted me to be financially responsible for myself, to be independent, so I found a good combination—to teach art and German. I always have painted.

My husband finished his studies in engineering near Wuppertal and started working. We met and married quickly—too quickly. I knew him for six months before I married him. After two years, we had a child.

I had my children—boy, girl, boy—when I was twenty-six, thirty, and thirty-seven. It was not so easy to combine a family and a career. There were many times when I wouldn't think of my own interests. It

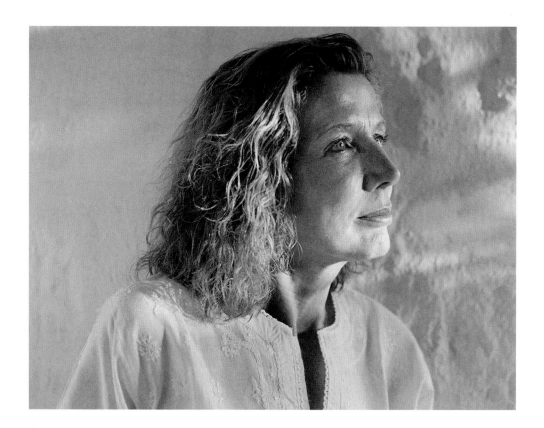

was my profession and my family that took my time. I didn't have a minute for myself. My husband started his career at this time, and he wasn't able to be very present for the family.

I realized after a certain time that I didn't love him anymore. He was a good friend, but I didn't love him. That was lost. I realized that we were very different. I respected him in a certain way, and I stayed for a long time. We were married nearly thirty-five years, but I realized this quite soon.

I wanted to take care of the family. I thought of leaving, but I didn't think it would be good for the children. There were people I was tempted to leave home for, but I didn't act on it.

I met G in the summer academy for painting in Salzburg in 2001. It was a break in my normal life to go to the summer academy, and

I was only interested in painting. As G worked close to me, I saw his work. I liked his work, and he was interested in mine. During the following three years, I returned to the Academy, where I saw him again. Eventually I fell in love with him.

He was the reason I decided to leave my husband. I couldn't stay. I tried to stay with my husband for more than three years after I fell in love with G, but I couldn't stay with him. I couldn't make it work. I tried everything—really, I tried it.

I didn't want that love, really, but I couldn't avoid it once it was there. I was fighting with myself—you can't imagine. I decided to leave my husband. I told him that I'd fallen in love with G, that it was impossible for me to stay. He was furious with G. He's not self-analytical.

The way to live after that was absolutely open. It's still open. When I left, I lived absolutely in the moment because I had no energy to plan.

What is very important is that I had art. "Art is my guarantee of sanity," Louise Bourgeois said. This is up on the wall of my studio in Salzburg. G and I have been together three years. When I came to Salzburg, we didn't live together. After a year, we started to live together, but we still have our own places. I need my room. I must be able to close the door and be by myself.

My youngest child was twenty-three when I left my husband. He knew his way, and this was very important to me. At the beginning, it was very difficult for the eldest. My children supported me, especially my daughter. The children and I discussed it a lot, and I tried to explain it, but I didn't take away their respect for their father.

I definitely decided to be more interested in myself than I had been before. If I want to change something, I have to do it now. So I decided to live for art. I interrupted my work at school in 2004, and the years before, I had reduced my work to see if it was possible for me to paint full time.

When I was younger, I discussed more. Now when I'm convinced about something, I do it. A lot of friends wanted to convince me to not leave my husband. It was my decision, and I will be responsible for it.

When I was younger, I tried to consider what other people said—how does it go with the family, how does it go with social constructs? Now I want to do what I feel I have to do.

I studied philosophy for four semesters—Sartre and Jaspers. All the literature I read stayed with me. I learned to not put anyone in a box when you meet them. Don't label them. I never ask a person what they do.

My greatest pleasure was when I was together with my children, and now it's when I am together with my children and G. And a great pleasure for me is to travel with G, because to travel with him, we have our interest in art, and it's beautiful to observe things together.

I feel independent and this is rather new. I have for so long been responsible for other people, and now I learn again that I can decide today what I want to do. It's a wonderful feeling.

I feel independent and this is rather new. I have for so long been responsible for other people, and now I learn again that I can decide today what I want to do. It's a wonderful feeling.

When I look to the future, I trust myself.

Look closely at the man you are going to marry. I believe in love even though I've had this experience. It is possible to live with a person and be in love your whole life, and to respect the individuality of each other. But if you need to leave, leave. Otherwise, it's the death of the personality. You will not be living or feeling.

The other thing is to live for the utopia of peace. It is a political statement. It is so important for women to do this—they are creative and have other feelings and perceptions than men. They must use these advantages for the common good.

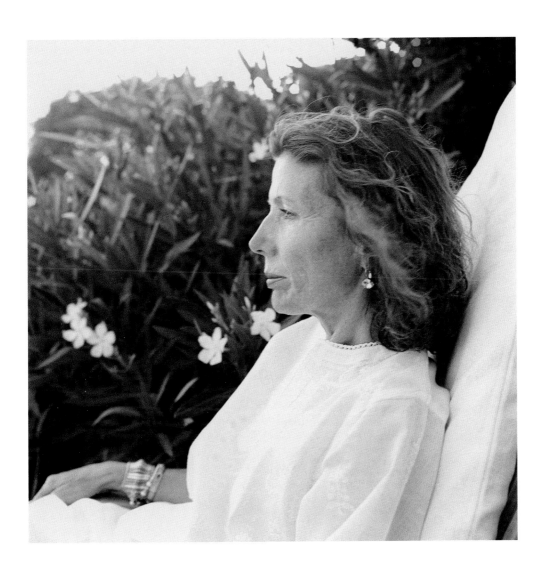

MARINA MA

Born 1923, interviewed at age 85 • Mother of Dr. Yo-Chen Ma and Yo-Yo Ma, cellist
Long Beach, New York, U.S.A.

I was born in Hong Kong in 1923. When I was one and a half, I lost my mother. My Auntie had tuberculosis, and they shared the same bowl of soup and my mother caught it. She was only thirty-three and had six children already. My oldest sister was only sixteen years old when she died.

I had a woman take care of me. After seven years, I had a stepmother, but she didn't do anything. She still was going to school when she got married. Mostly, my older two sisters took care of us, so my sisters and I were very close. We had four servants at home, and after I was married, I didn't even know how to hang a pan on the wall.

I went to a Christian high school where the Americans went. I went to Central University in Nanjing, then I went to college in Chungking. I graduated in 1949 and the communists had come—so I went to Hong Kong. A few years later, I went to Paris to learn singing and opera.

My husband was a professor of music theory at the university

in Chungking for a year. Everyone hated him because he was so strict, but after he left, everyone liked him. When I was in his class, he wouldn't allow us in if we were late. When I moved to Paris, his sister and I traveled together, so we reconnected there. We were married in 1949. He was twelve years older than me. Yo-Cheng was born in '51 and Yo-Yo in '55. In Paris, they didn't allow foreigners to work unless they had a specialty. My husband worked in the Musée Guimet with the Chinese instruments.

In 1962, we moved to New York. My husband was invited to come and start the Children's Orchestra, and he also taught music. Every summer, we returned to Paris. My husband was in New York until he retired in 1965 and then moved to Taiwan and started another Children's Orchestra there. I joined him in the mid-eighties for three years, then came back here. My husband was a fast-tempered person, but he had a wonderful heart and was very nice to people. Children loved him but were also scared of him.

When our children were young, he taught them for three minutes a lesson and then let them go. Yo-Yo realized that when Daddy teaches you, concentration is very important, or you get punished.

From the beginning, we realized that Yo-Yo was going to be good. One day, I was watching him practice, and I looked at the bow. I saw him running the bow. I said, "Oh my God, he can sing on his bow." Even at that time, his music could touch my heart.

I'm Chinese. I have to learn English. Every day in the morning, I have my Chinese newspaper.

Early in the morning, I go to exercise—only when it's windy or icy I dare not go because I'm afraid I'll fall down. I walk on the boardwalk in front of my house for half an hour, and while I walk, I do exercises for the upper part of my body. I go to bed early. Around 7:30 P.M. I'm in my bedroom and I go to sleep around 8 P.M. When I wake in the middle of the night, I get up to read. I get up in the

morning around 5 A.M. and go on the boardwalk around 6:30 or
7 A.M.—a regular schedule.

I prepare vegetable soup with a broth made out of bones. You
have to add vinegar to the broth because the vinegar lets the calcium
come out of the bones into the broth. I cool the vegetables and put
them in the broth. In each bowl of soup, I put two tablespoons of cot-
tage cheese. Cottage cheese has more calcium.

You can say that the second half is a little slower than the first
half. You have more time for reading. Listening to music is my greatest
pleasure.

Sometimes I feel lonely because the children are all gone.

That's why music is so important to me. One day, I felt so angry
about something, and I turned on one of Yo-Yo's CDs. It was Paganini's
"Étude for Violins," and Yo-Yo played it crazily on the cello. He was
playing so fast he scared me, and I completely forgot my anger!

Most important is to focus on happiness. Don't think angry
thoughts to bother the mind. That causes you to collapse, and you
don't want to eat or do anything. Always think on the positive side.

I learned forgiveness in the first half, and it's been the most
helpful in the second. If you do not forgive people, you are not happy
yourself. It's no good for your health.

I learned from my husband. My husband cared so much about
not wasting time. He hated for people to waste time. My husband
worked very hard. Time is not money. He didn't think that way. But
time is knowledge. You can always learn. That's the advice that I'd give
to younger people.

The greatest happiness is when I see the success of the children.
The greatest sorrow is the emptiness I feel because they are gone.
But Yo-Yo is a sweet boy. He calls me every day and asks, "How are
you, Mom?"

CHARLOTTE MOSLEY

Born 1952, interviewed at age 55 • Journalist, publisher, and editor of the letters of the Mitford sisters • Paris, France

I was born in Dorset at home. I am second in a family of six. We fought and we fought and we fought and we fought, but we're very close friends now. I had a mother who had been orphaned young, who married my father when she was twenty. She was raised by her maternal grandparents. She was an only child, so her ambition was to have a large family and repopulate what she'd lost.

I went to the school in the village until I was six, and then I was sent to boarding school in Switzerland. I was there from age six to twelve. I think the separation from her parents had been so traumatic that my mother created the separation paradoxically so we would never know an accidental separation. I had my sister at boarding school, but I quarreled so much with her. Now I admire and adore her, but I took a vow not to speak to her for five years when I was thirteen.

At twelve, I came back to England and went to another boarding school, which seemed like glorious freedom compared to boot camp in Switzerland. I was there until I was eighteen.

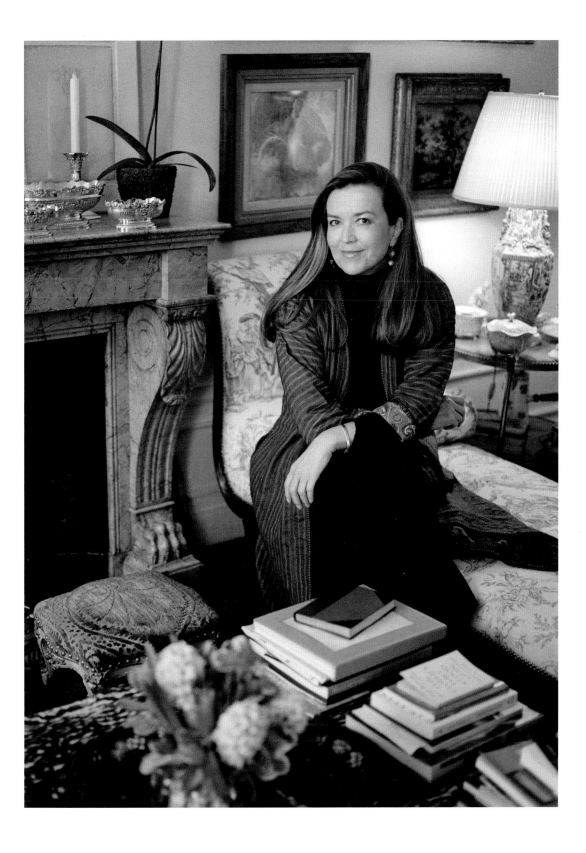

I took a year out and went to Iran, where I worked on an archae-ological dig. I decided I wanted to do anthropology at university. I'd read *The Territorial Imperative* by Robert Ardrey and it was a reve-lation to me. I went to Sussex University, where I did social anthro-pology. It gives you the ability to stand back from your subject and look back.

I'd already met my husband. Alexander was thirty-two; I was twenty. He was working for a publisher in London. We saw each other on weekends. I finished university and went back to Iran to work on a dig for the summer. After I returned, we got engaged. I was twenty-one. He was incredibly good-looking. He came from roughly the same background but had led a very unconventional life. I felt he would give me the freedom to go in any direc-tion I wanted. He had gone to Ohio State University. He went to America to get away from his father, who was very difficult. Alexander was sensitive, intellectual, and vulnerable. His father wanted to make him into an accountant. His older brother Nicholas was very close to him and helped him financially so he could go to university in America.

> As you age, everything you thought was important becomes less important, and the things you took for granted matter very much. . . . Less important is the doing. More important is the being.

While we were engaged, he was offered a job here in Paris, where his parents were living. I'd never been there, but I knew I wanted to spend time in Paris. I spoke French. I loved it from the word go. We had a small publishing house together for about twelve years until I had Louis.

My mother-in-law, Diana Mosley, was one of those people—the lights went on when she entered a room. Beautiful till the day she died. She adored my husband and was thrilled he'd come back. She

was generous and hospitable. She was extraordinarily welcoming, a marvelous conversationalist, and very funny. She came from a background where anti-semitism was normal. She was bowled over with what Hitler was doing in Germany. Her life was completely identified with my father-in-law and his mission. The quest for perfection in her life was very strong. *Perfect* was a common word in her letters. She presented a perfect front.

Prison brought the couple together. After the war, when she was reviled and hated, she was very proud. She'd lost so much and was so invested in her husband. This is trying to reach out to an explanation, but I don't have one. It was something very deep in her, but it didn't spill out on those close to her. It taught me that people are very complicated. She was racially prejudiced. She never denied it. She would have seen it as disloyal to her husband and to Hitler. Being truthful was something she held as a virtue. The quest for purity is a misplaced spiritual quest. My mother-in-law had the kindness and the kind of good manners that come from real sensitivity. The paradox will always be a mystery to me.

Alexander was the most unprejudiced person I ever met. I was completely caught up in my husband and not his parents when I got married.

Alexander got Parkinson's when he was fifty-one, in 1981. His father and maternal grandmother had it. He had a mild form at the beginning. He actually died at age sixty-six of cancer of the kidney.

The beginning of my second half started with being a widow. I had time to prepare for Alexander's death because he was ill for a long time, but nothing prepares you. I was prepared for the grief of loss. I had what I needed to deal with that. But what I hadn't been prepared for was how losing the person who has been part of your life throws everything into question.

I reassessed everything. Who I wanted to see, what I wanted to do with my time. Until then, I'd gone along familiar tracks. I'm not saying they weren't pleasant or enjoyable. It also brings to light that one's life is finite. I was free to choose what I wanted to do.

It's been two years, and they say it takes two years. I've realized that it's fine to be on my own, and that's a very reassuring thing. I don't have to have a man to be contented and enjoy life. If someone comes along, that would be great, but the feeling of not being in need is a good feeling to have. I know that I'm OK.

As you age, everything you thought was important becomes less important, and the things you took for granted matter very much. The knowledge of myself was pretty superficial when I was young, and as you get older, you know yourself better, and the "no go" barriers come down. That exploration of self continues throughout life, and that's comforting to know. Less important is the doing. More important is the being. Who I am is more important than what I do.

I learned that you can't sweep anything under the carpet. The things that you think you can push aside and not deal with always come back, and you have to deal with them.

Life gets better. Sitting here, having lost a husband, I can still say that life gets better. I also think that old age is something that you have to prepare for. You have to be ready for illness and incapacity in yourself and in your friends. You get ready by being ready to let go of things you feel are important and accepting that you are going to die. The knowledge that you are going to die has to be present. It increases the intensity of how you live.

I think I've always had a sense of pleasure in getting things right—the right word or gesture. Finding myself in harmony with what's going on has always given me pleasure, and I think it's easier to find as you get older. Synchronization with whatever is going on is a source of pleasure.

I feel excited about the rest of life in the context of what we've been talking about.

Unless you've done something outstanding in life, you'll be remembered by friends and family. I'd like to be remembered as someone who's at one with my life. The people whom one feels sad about are those who missed being what they could be because of their difficult circumstances or because they were scared. I'd like to be remembered as someone who got the most they could out of life.

You have the right to be who you want to be, and give yourself that right—it's your birthright. Even today, women in the Western world still don't feel they have the right to be happy, to be treated with respect. You have to earn it, but you have the right to get to the point where it's yours. Your work is to find out what you want. Nobody else can tell you what's good for you.

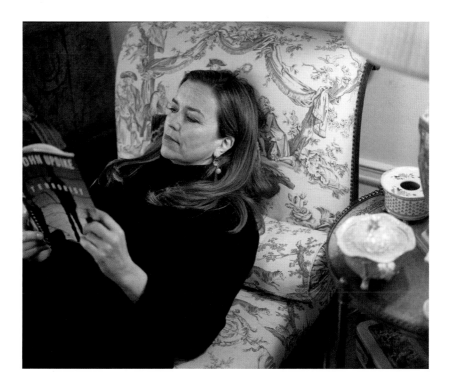

CHARLOTTE MOSLEY

MARILYN NELSON

Born 1946, interviewed at age 74 • Author, translator, and former Poet Laureate of Connecticut • East Haven, Connecticut, U.S.A.

During the war, my father trained as part of the group now known as the Tuskegee Airmen. He was in the air force as a navigator for most of my childhood. We were living in Cleveland, Ohio, when I was born. I was the first child.

We lived all over the country, moving around a lot and living mostly on base. When I started school, we were still in Cleveland, and then we were in Salina, Kansas. My mother taught there. In fact, one of my writing projects is based on a photograph of her in the class she taught in Salina in 1954. She's sitting at the teacher's desk, surrounded by twenty first or second graders who were all white. This was 1954.

We were usually living a year or less in the same place. It's been the curse of my life, something that I think of more and more as I get older—how limited my social life was, and my emotional life. It was just the nuclear family, because we didn't see our extended family either. I think I don't know how to be a friend. I very easily move on. And I have a hard time remembering people's names. I had never put

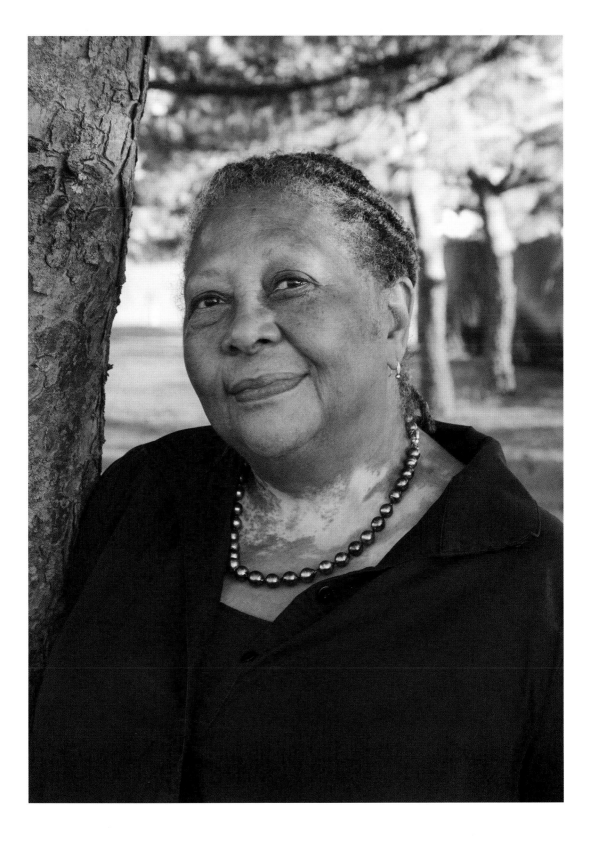

those things together as being cause and effect. On the other hand, it means it's easier to walk into a room full of strangers and start talking with somebody.

I graduated from high school in 1964 and then went to one of the University of California campuses. When I started, it was before Affirmative Action, and there were about fifteen thousand undergraduate students, of whom five of us were African American. That was one place where my air force youth helped. Most of the other African American kids hated being stuck on our almost all-white campus in a little, almost all-white town surrounded by farmland. But I had grown up surrounded by white kids, on predominantly white military installations surrounded by farmland.

Turning fifty was a huge turning point for me because I felt that it was time for me to take control of my life. I gave myself my maiden name again as my birthday present.

I was in Oklahoma for junior high school. We were living on an air force base that was just plunked down in a small country town in the boondocks, and there was no base school. This was about 1958–59, and the civil rights movement was in the news every day. We had to go to the town school. The teachers were all local people who had gone to local schools and had taught local kids, until suddenly these air force outsiders arrived. Among the air force outsiders were me and my sister. I was a smart kid, and in this school, there were the Purdys, a husband and wife who were probably in their fifties. He taught math and she taught English. I was in both of their classes, and I was always the star pupil and I knew it. And I was snobby to them. They were ignorant Okies. They had it out for me, to pull me down. He would never give me the right grade that I had earned on math tests, and I would complain at home, and my father would say, "Marilyn, we're only going to be here a short time. If you can take it, you know you're

going to be leaving. They're going to be in this world for the rest of their lives, but you are going someplace."

Mrs. Purdy noticed that I was the one student in her class who loved poetry, and she brought in this racist poem. It was written in Black dialect, and she said, "Marilyn, I want you to read this to the class." I looked at her and said, "I can't do this. I don't know how to read the dialect." And she said, "You can do it better than anybody else here, so stand up and do it." She had a way of doing mean things and smiling at the same time. She smiled harder and harder until I stood up and did what she had wanted me to do. For me, the saving grace of the experience was my sense that my classmates understood what I was going through and what she had done.

I had grown up with poetry. My parents cared about poetry. We had illustrated poetry books intended for children. I started writing poetry probably in about the fourth or fifth grade, though I had been reading poems from the time I could read for myself. You don't really decide to become a poet, it just happens. I was trying to write poems all the way through school and college, but I'd always thought of myself as just a scribbler. When I was about thirty, I decided to really learn something about writing poetry. To notice, for instance, where and how a poem starts. Sometimes you hear a phrase, an imagined conversation, or you read something that's interesting. Or a story jumps out of historical research. There's a little spark, I guess. Then you just try to breathe on the spark to find out whether it will turn into something. And when is a poem finished? It's finished, I guess, when you don't feel like picking at it anymore.

Turning fifty was a huge turning point for me because I felt that it was time for me to take control of my life. I gave myself my maiden name again as my birthday present. I decided that it was time for me to make choices for myself instead of doing what other people wanted me to do. Connected to that was the decision to retire early,

and to have a big house out in the country where I could invite other writers to come and have quiet writing time. That was something I had dreamed of my whole life, and things fell into place that made that possible.

I had been talked into publishing poems directed to the young adult audience instead of the adult audience. It turns out that the young adult audience is five times larger than the adult audience, and I started getting advances for books, which had never happened before. One of my young adult books won several prizes, so I suddenly had money. I had retired and taken another job, so I paid off all of my debts. I was completely free—for the first time! I traveled on my own and decided what I wanted to write.

I don't know that I've changed as I've gotten older. I'm learning to accept limitations. I had done a lot of traveling on my own when I was younger, and I don't feel like doing that anymore. The trouble with travel is that you want to go back to the places you've been to, and you want to go to so many new places too. There's just so much world.

Seeing landscapes gives me the greatest pleasure, seeing this beautiful planet. And learning new things—that's a great pleasure. And being able to communicate in other languages gives me great pleasure. I can get along in Spanish, German, Danish, and a little bit of French. I've found several people from my past and reconnected with them, and I value that very much.

My happiest time was when I had young children—playing with them, watching them learn, making costumes with them. And times when I've lived abroad. My first husband and I lived in Denmark and Germany, and we traveled. Then my second husband and our children spent a semester in the South of France, and that was great. And I had a very happy time at a rodeo a couple of years ago. The town in Okla-homa that my mother grew up in is an all-Black town, and they've had

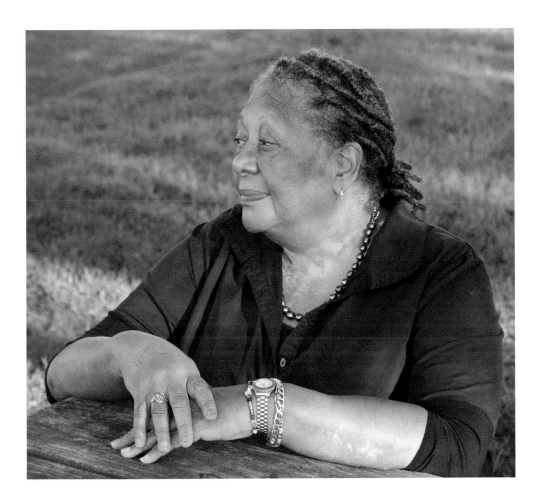

an annual all-Black rodeo there every Memorial Day weekend since
about 1903. My sister and her daughter and I went there together, and
it was just wonderful! It was our mother's hometown, so there was a
family connection. And then on top of that, it was all Black!

My saddest times were losing my parents and my brother,
and being unhappy in two marriages. And the four years of Donald
Trump's presidency. That was so disheartening. All these things that
we thought were gone were just buried. My father was in the mili-
tary—we had taps every evening on the base, and we saluted the flag.
I felt I was going to grow up and join the navy or something. I grew up

with real patriotism. I really believed in the American dream. I grew up believing I could trust the friendships I had. And now I'm not sure I interpreted things correctly. What was the truth about what I was shown? I have no idea. My close friend in middle school was a girl whose father was higher than my father in rank, and we were really good friends. We would have sleepovers back and forth. I felt like a member of her family, and years later, she told me that she had had to fight her parents to be my friend. I was in their house all the time. I thought her parents liked me.

I don't feel too optimistic about the future. I am so afraid for the children who are growing up into a world in which species are being decimated, in which the climate will be so changed that people will either have to die or accept climate refugees, and the future looks very bad. And I feel so angry with these science deniers.

My advice to younger women would be to have the courage of your convictions. We have to listen to the prophets who are telling us what we need to do. We have to listen to them and change our goals, our habits. We have to change so the world as we know it will still be a possibility for future generations.

My advice to younger women would be to have the courage of your convictions. We have to listen to the prophets who are telling us what we need to do. We have to listen to them and change our goals, our habits. We have to change so the world as we know it will still be a possibility for future generations. One of the changes we have to make is to stop believing that our lives will be fulfilled by reproducing ourselves. We keep insisting that we have the right to have two children and a house with four bedrooms and two bathrooms. We need to voluntarily give up that dream. Maybe we have to be more willing to adopt children. There are just too many people, and we have to alter our expectations.

When I was about thirty and was about to give a big poetry reading, an older woman stopped me on the way up to the podium and said, "I can tell you how to be rich." I rushed through my reading in anticipation, and when I finally finished reading and talking with all the well-wishers, I went up to her and said, "Now will you tell me how to be rich?" She said, "Want less."

BLANCHE BLACKWELL

Born 1912, interviewed at age 95 • Ian Fleming's last great love, and mother of Chris Blackwell, who founded Island Records • London, England

I was born in San José, Costa Rica. We were Sephardic Jews. My maiden name was Lindo, but truthfully, Lindo is not a name—it's an adjective. It means "beautiful."

My father and uncle developed bananas for the United Fruit Company. Eventually, they owned a great deal of Costa Rica. In 1916, when I was three, my family returned to Jamaica, where they had previously lived. In Jamaica, they bought several estates and the best brand of rum, J. Wray and Nephew Rum. They were rum merchants, banana merchants, and sugar merchants by 1916.

I grew up with men. I had an older and younger brother, and a father who idolized me. Because my mother loved her sons more than her daughter, my father picked me to take me to the sugar factory to show me the new machinery.

I was tutored at home until age sixteen, when I was sent to a school in Barnstead in Surrey to be finished. I was told to sleep in a dormitory with a whole lot of women. I said, "Me? Sleep with a whole

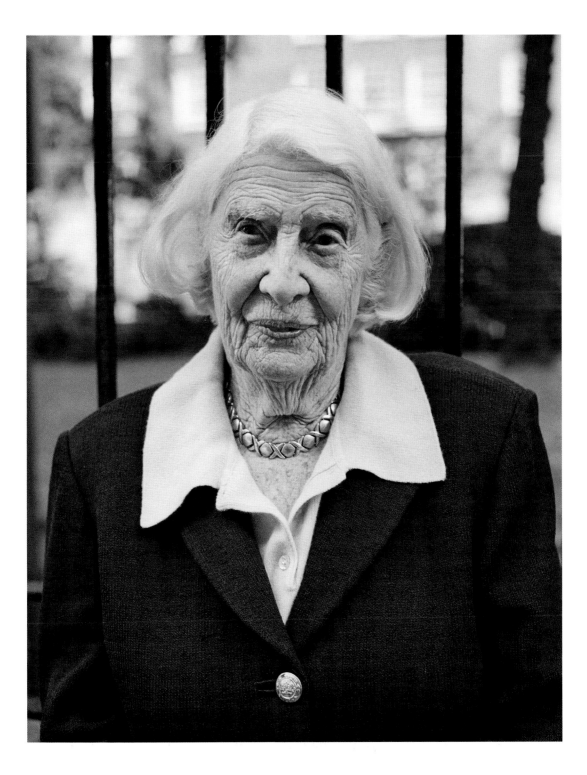

lot of women? Not ever!" so they put me in an attic with no heating. No way was I going to sleep with women, and I never looked back.

We were all sent there to become ladies, which was a great mistake. I've never been a lady. There was a girl there with a different accent, and they were all teasing her. I took the girl who was teasing her and hit her head against the wall. I was there for about a year and a half. I was then sent to Paris at age seventeen to learn French. My mother came too. During that period, I saw Pavlova dance. We were brought up with music. Paris was the first place I heard opera, and I loved it.

My younger brother, who was studying in England, had a nervous breakdown when I was twenty-two. My mother was frightened of illness, so she sent me and my older brother to London to help him. I took my brother out of university and set him up in an apartment in London. I met my husband at my brother's apartment.

My son was born almost immediately in 1937. My husband left me. It started in 1938. He went off with another woman. I was very self-sufficient. Perhaps I wasn't the sort of woman to suit him. I loved him in my own way. There was nothing I wouldn't do for him. How did I fail? I never blamed him. But I could never go back.

In 1945, I came to England with my son to send him to school, but often returned to Jamaica. I was divorced in '49.

Sex doesn't mean anything to men. It's all outside for them. It doesn't mean a thing to them. For a woman, if you love someone, there's no more wonderful thing.

I met Errol Flynn in Jamaica in 1947. When he got out of the car, he took his glasses off, and we felt we'd known each other all our lives, and we became great friends. I was virtually handed on a platter to Errol. He wanted to marry me. I was never attracted to him. He wrote *My Wicked, Wicked Ways* when he was living with me, and he stayed again for about two weeks in 1958 with his ghostwriter and girlfriend.

Funnily, the second half has been great fun. Life has been improving every year. I'm having a whale of a time because I don't care what I say to people. I've done so many things that I've wanted to do, so now that I can't, I don't mind. I thoroughly enjoy my life even though I have disabilities. The other day I was in Selfridges with my maids, and there was music, and I started to dance. The man who was selling me a telephone said to me, "You love to dance." I said, "Come dance with me." My maids were so embarrassed. I told my doctor, and he said, "Blanche, stop those iron pills at once!"

When you're in your twenties, you haven't yet learned how to love. If you have developed, you can love with your heart without asking too much. That's what age is all about.

I'm not one of these people who takes a lot of notice of things. When people told me I was going blind, I didn't mind. I happen to be enjoying my old age. I have my health, I have a certain amount of money. What does it matter if I can't see, if I have all that? My attitude is good because I've been so happy. If I've said that I want to do something, I get up and do it, but then, not an awful lot of people can afford to do that.

I was born a very happy person. I've always been happy. Someone told my future once. They picked up my hand and dropped it. They said, "It's as though you stand in a torrent of water all the time and step out bone dry."

I've always thought of myself as an absolute nobody. What I've done, funnily enough, is gain confidence, perhaps because of my blindness. I'd always been a shy person, and now, because I'm blind, I feel that people can't see me.

My interests have had to change. The first thing that I loved was horses. The second thing was swimming. It was Errol Flynn who got me to scuba dive. I still swim, and now I'm intrigued by the computer. I love reading, but it isn't terribly easy. I use audiobooks. I used to love

to travel, but now I don't particularly want to. As a young person, I learned to get on with myself alone, and that has been very useful.

I've never been afraid of anything. I don't call that courage. I call it foolhardy. I believe that if the Almighty doesn't want you, you're not going, so I've tried everything!

My greatest pleasure used to be jumping over a five-bar gate in the hunting field. Unless you've done it, you can't imagine what a wonderful sensation it is! Seeing my friends gives me the greatest pleasure now. My saddest times were when my father died and when Ian [Fleming] died.

Funnily, the second half has been great fun. Life has been improving every year. I'm having a whale of a time because I don't care what I say to people. I've done so many things that I've wanted to do, so now that I can't, I don't mind. I thoroughly enjoy my life even though I have disabilities.

No one can tell us the future. I have a certainty that if you do what you know has to be done, don't be afraid. Things take care of themselves. I happen to have a lot of time to think. Everything, however awful, happens for a reason. You can learn something from it. Sometimes it takes a bit of time. Sometimes people are asked to suffer a lot.

If you really care for somebody, care for them for their good, not for yours. I learned that lesson from my mother, who loved her sons so much she ruined their lives.

Ian and I were friends, basically—good friends. We loved snorkeling. We never had to say much to each other. He was a man that needed a lot of time to himself. I respected that. He knew that I was there whenever he needed me, and if he preferred to be alone, that was fine with me.

We had an extraordinary companionship. We shared a love of nature. He used to take care of me in such a funny way. He looked

after me without making a fuss, which I would not have wanted. He was thoughtful without being all over you. It's very difficult for some people to love somebody intensely and realize that they don't want to be with you all the time. Human relationships, especially marriage, are not the easiest.

I was forty-five when I met him. When you're in your twenties, you haven't yet learned how to love. If you have developed, you can love with your heart without asking too much. That's what age is all about.

We were together, living or dying. Nobody ever dies, really. They just step out of sight. His last words to me were, "We'll keep in touch," and he does; 007 appears when I least expect it. I've only dreamt of him once. He was standing in the room.

OLIVIA DE HAVILLAND

Born 1916, interviewed at age 92 • Actress
Paris, France

I was born in Tokyo. My parents had two properties. One was up in Karuizawa, in the mountains, the other in Tokyo. One day, a missionary's wife came to call on my mother in Karuizawa, and said, "It is the talk of Tokyo that your husband is having an affair with a maid in the house." So she secretly went back to Tokyo, went into the house, examined the domestic rooms, and, sure enough, in one room, she found my father's gold watch. That did it. She then decided she could never go back to that house in Tokyo.

My father decided that he would buy a property on Vancouver Island, but they decided to go to San Francisco first. When we got there, my tonsils had to be taken out right away, and that meant we could not continue on up the coast. My father left after a week. I was two years and eight months old.

My mother heard that in the Santa Clara valley, there was a lovely Victorian hotel that had recently been built, and the weather there was marvelous, so we went and made life-long friends there. My

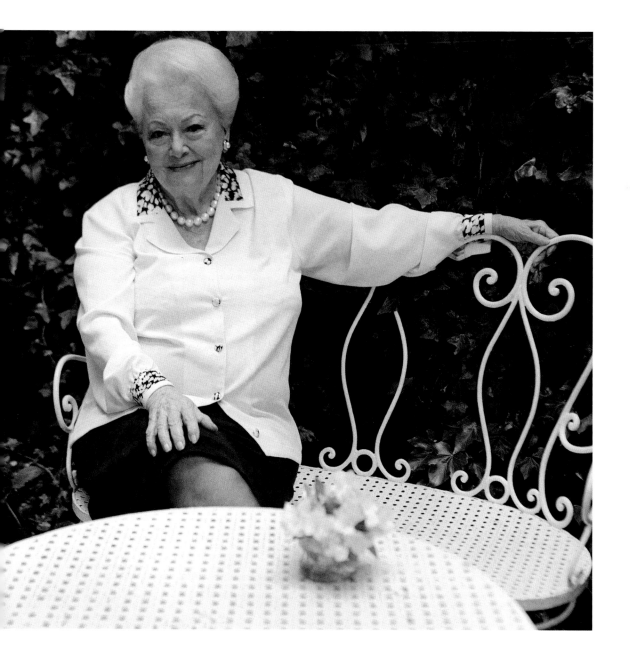

mother finally built a house in Saratoga, and we moved into it in 1924. And that became my home.

In Saratoga, a lady called Dorothea Johnston, who had studied theater abroad, and a friend of hers decided to form an amateur theatrical society. And the first thing they put on was *Alice in Wonderland*, and they cast me as Alice. Well, it was a big success. I was sixteen. The Palo Alto Community Playhouse and several other places invited us to put it on. The best review I ever received in my life was written by George C. Warren in the *San Francisco Chronicle*. I've kept it to this day.

As we were preparing to start a production of *A Midsummer Night's Dream* where I was cast as Puck, I said to Dorothea, "I have written to Max Reinhardt," who was the greatest theatrical director in the world at that time. Reinhardt's casting director, Felix Weissberger, came ahead of time and was on the University of California campus, so I met him on the grounds of the university, and he said, "Well, I would like you to audition." We had dinner together, and he said, "Let's go to the faculty room and you can enact some of Puck." So, into the faculty room we went, and I changed ahead of time into my gym bloomers and leapt all over the chairs and tables playing Puck. He watched and he said, "I would like you to read for Hermia tomorrow morning at 9:30 in my hotel in San Francisco." Well, I didn't know the part of Hermia at all. Dorothea drove me all the way down, and I managed to learn some scenes of Hermia's. He said that if I went down to Hollywood, I could understudy the part. I couldn't believe it! It was *way* beyond what I had aspired to. I would now be an official member of Reinhardt's company for the summer. Down I went to Los Angeles to be the understudy for Hermia, and I ended up getting the part.

Film life is terribly taxing, terribly demanding, and you almost have to live a monastic life when you're in a film. You did in the contract days, because you worked six days a week. You had to be in make up at 6:30 A.M. Then you worked until at least 6 P.M., and on

Saturday night, you would work after dinner. So you had only one day to recover and to study your lines for the next week. It was utterly exhausting, physically and emotionally.

I loved my profession, of course. It's a very great art, cinema—but it is draining and limiting if you live there and if you go from one film to another, which, under the contract system, you had to do.

I was married twice. The first time to an American who was a brilliant writer, Mark Goodrich. It was not the best decision of my life, but in any case, the marriage gave me Benjamin, my son, so it was all worth it. I was just thirty; he was forty-six.

The second time I was married, I was thirty-nine. I came to the Cannes Film Festival and I met a Frenchman, and he pursued me back to Hollywood and persuaded me to return to Paris with my little boy. My divorce wasn't complete yet, but when it was, I was married on April 2, 1955, and I had my adorable daughter, Gisèle. My son was four years old. He learned French in six weeks and forgot English.

When sadnesses come later in life, you can handle them better because you've endured others. The hardest times, I think, are in your teens and twenties. I wouldn't relive my twenties for anything in this world.

The second half is fascinating! In my case, I was enabled to have what I call a real life. The French let you be whatever you are. You get pulled in all directions in Hollywood. Also, you have identity problems all the time. You pick up a newspaper and there's some terrible story, with everything wrong, everything misinterpreted, and you have to go through that every day. I didn't have to go through that here—and there was the joy of learning another language, a beautiful one. I had a personal life in the second half. I think my sense of self changed for the better, very much for the better.

As a Californian, I had to have a house with a little bit of garden. I found this place, and we moved in when my daughter was one year

old. I would commute to Hollywood. I love being in this house and love realizing that I've lived in it over fifty years, and that I've brought up two children in it and they've had the security of a home they could count on. I'm six blocks from the Arc de Triomphe, and I live in one of the most beautiful cities in the world! Isn't that magical? I don't know what more I can ask of life.

In the motion picture business, I learned preparation and organization. I also learned that in school, but it was applied every day in the motion picture industry. Those are very important lessons to learn and apply. They have helped me all my life.

> **I think every age is wonderful. The idea is to do every age well. Don't try to be any other age than what you are—why? You've already had that age. And here's another one before you. How thrilling! Find out about it. Receive all it has to give.**

My happiest time was when I was with my children, and each one would be doing their own thing, including me, and we would be sitting there in perfect harmony—those were moments of bliss, really. I must say that the whole business of giving birth is so extraordinary. It's the most extraordinary experience of life—you can't grasp it.

There were lots of periods of sadness—lots. Many to endure. It was a special sadness when I lost my son from the after effects of Hodgkin's disease. The one thing I had going for me was maturity. When sadnesses come later in life, you can handle them better because you've endured others. The hardest times, I think, are in your teens and twenties. I wouldn't relive my twenties for anything in this world.

I would like to live forever, frankly. I certainly want to make it to one hundred. If the Queen Mother can do it, why can't I? I think every age is wonderful. The idea is to do every age well. Don't try to be any other age than what you are—why? You've already had that age.

And here's another one before you. How thrilling! Find out about it. Receive all it has to give.

Preserve your independence. Make your own decisions so that you go on living a creative life and not a life forced upon you. I have young friends whose mothers are aging, whose fathers are aging, and I say to them, "Don't make the decisions. Let them make the decisions."

It's hard to beat the present as far as greatest happiness. I learned to value equanimity. It's hard to achieve and hard to maintain, but one can learn to do it to a certain degree. It leads you to be more creative in finding solutions to problems with other people, and that's very important. And when a real problem confronts one with shock and big disappointment, I think one should waste as little time as possible in lamenting the catastrophe. Immediately go to finding solutions, or how you can make the best of the situation. Because oddly enough, most catastrophes also hold within themselves the possibility of something quite good—if you search for it and then develop it.

Avoid destructive people. Ask, "Does someone have a destructive or benevolent effect on my life?" If it's destructive, just stay away.

Never assume anything. Double-check anything that comes up and would have a serious effect on what you're doing, or what you want to do. Assuming can be catastrophic.

I think that women should welcome their birthdays. Every birthday is a victory. And it's really very thrilling when you think of a birthday from that point of view. And the more victories you have, the more victorious you are! I love each birthday. The nineties are a decade to enjoy. I do drink champagne. At six o'clock every night, I have two glasses. I used to have three—in my eighties, it was three, and now in my nineties, I'm reducing it to two, and I may get to just one and a half. What do you think of a glass of champagne in the photo, just to get the point across?

AFTERWORD
SARAH LAMB

We've been socialized to think that aging is bad—so bad even that we strive to deny that it happens. A whole industry promotes the idea that "old" is not as good as "young," which motivates the sale of anti-aging products. Dominating gerontology and public health since the 1980s is a "successful," "healthy," and "active" aging model that seems upbeat and positive on the face of it. It suggests that if we eat right, stay fit, choose well, and have a good attitude, we can craft youthful, ageless aging. Such prescriptions for how not to age may at first glance seem appealing and inspirational. But they are also counterproductive and unrealistic. They harbor an internalized ageism at the core—the sense that aging, old age, and being old are so awful that we can "succeed" in life's second half only if we can prevent the real changes of age from occurring. Much of this discourse on successful and healthy aging has been produced by younger people, those who are often approaching the "second half" themselves and are terrified of getting old.

What is remarkable about photojournalist Ellen Warner's extraordinary book *The Second Half* is the way it features the voices and experiences of women who are already in their second half of life, often for many decades, and who look their experiences of aging in the face. The book is not about how to defy the aging process, such as by eating enough kale and doing yoga. Rather, the photographs and narratives highlight aging as a central and meaningful part of life.

The book is ultimately very uplifting, and not in a fake or dishonest way. In selecting women subjects for the book, Warner insisted that the women be open and honest, and that they speak deeply and sincerely about their lives and aging experiences. Readers and viewers come away with a strong sense that women find the latter decades of life, despite important challenges and losses, *better* than the first. Who would have thought? This is not what our North American and European popular cultures tell us!

That the second half can be better than the first is not what my own university students ordinarily assume either. They enroll in my Aging in Cross-Cultural Perspectives class in hopes that the class may help them feel less terrified of their own future aging. Even as young as their teens and twenties, they are bombarded with anti-aging messages, especially the young women who are marketed so many anti-aging beauty products that they internalize an abiding fear of old age. (Is it because aging is so disparaged in North America that no one objects to the term "anti-aging"? What does it mean that anti-aging has become a burgeoning industry when we would never consider promoting an "anti-youth" or "anti-woman" industry?)

North American society is also so generationally segregated that younger people often have little intimate exposure to older people, as peers, friends, and colleagues—people with whom they may share ideas and from whom they may learn. *The Second Half* offers a valuable occasion for intergenerational exchange, as women from their

fifties to one hundred and beyond share their life stories while reply-
ing to Warner's query: "What advice would you give younger women?"

I am a cultural anthropologist, trained to situate personal narra-
tives within particular social-cultural contexts. It has been intriguing
to approach these stories differently. The women in the book come
from diverse socioeconomic backgrounds and from locales ranging
from Europe and the United States, to Algeria, Antigua, Bali, Myanmar,
Oman, and Saudi Arabia. Their stories transcend regions, eras, and
stereotypes.

Enlightening common themes emerge. One of the most prom-
inent is the ways that life's second half is better than the first. Why?
Many women express a sense of increased confidence and freedom
as they enter the second half. They tell of having come to really
know themselves and their priorities, appreciating and accepting
themselves—flaws and all—and tossing aside the kinds of insecuri-
ties and desires to be perfect-looking that plague so many women in
their youth.

Wealth of life experiences also provides a maturity and resilience
that makes the present challenges easier to weather. Life teaches you
many things. "When sadnesses come later in life, you can handle them
better because you've endured others," Olivia de Havilland reflects, at
age ninety-two. Challenging her society's misplaced valorization of
youth, de Havilland adds, "The hardest times, I think, are in your teens
and twenties. I wouldn't relive my twenties for anything in the world."

The theme of mortality runs through the women's narratives
as well. If you live a long time, it's inevitable that people you love are
going to die. But the women's stories challenge the assumption that we
become more fearful about death as we age. The women describe the
searing pain of losing spouses, lovers, friends, children—followed by a
renewed capacity to move on and enjoy again. Through experiencing
such losses, women in the second half also come to realize how time

is finite for us all. Such awareness of the "permanent impermanency" (as Françoise Simon puts it) brings not dread, but an enhanced sense of enjoyment, preciousness, and motivation to concentrate on what is important. Jacqueline Délia Brémond, at age seventy, comments, "I feel at ease most of the time. I try to live every moment as fully as I can, knowing that there are not so many left." Françoise Simon, age seventy-six, states: "I feel engaged with life because there is no time to lose."

The women's stories also give witness to the realities of severe discrimination tied to religion, ethnicity, race, and gender. European Jewish women recall living through the horrors of the Holocaust. Black American women describe the searing racism and overt racial segregation of their youths. Most of the women detail pervasive experiences of gender discrimination, including being told as young girls that they cannot study math or science, rampant sexual harassment, and abusive, philandering husbands. Many of the book's women were first married as young as fourteen, fifteen, eighteen, or twenty-two— often after very brief courtships or in marriages arranged by parents— and we are taken back to a time before birth control was readily available, when marriage was a near universal expectation and demand, and the dangers of pregnancy for women out of wedlock were severe.

By the second half, though, these women give an inspiring sense of having risen beyond many of the challenges of sexual, gender, and racial-ethnic discrimination so difficult in their early years. Later in life, many women were able to pursue sexually and intellectually fulfilling relationships with equitable partners. And they convey having developed a sense of confidence and pride in their body, gender, sexuality, and self. Leslie Caron, age seventy, states: "Experience makes everything easier in that you don't let people walk all over you."

Ultimately, readers and viewers come away with a sense that the second half of life is something to be enjoyed, looked forward to,

and celebrated—and not because one succeeded in staying the same through an ageless aging. These women teach us an alternative to the pernicious message that you lose value as a human being because you're older. Marilynn Preston, at sixty, asks: "Will we go through the same number of changes from sixty to ninety that we've had from thirty to sixty? Life is full of surprises, and I want to be awake and open to all of them—the good and the bad."

As I myself enter into my sixties—after decades of studying and contemplating aging as an anthropologist—I feel hopeful anticipation about the years ahead. As Olivia de Havilland declares: "I think that women should welcome their birthdays. Every birthday is a victory. And it's really very thrilling when you think of a birthday from that point of view. And the more victories you have, the more victorious you are!" I look forward to the possibilities within such victories.

ACKNOWLEDGMENTS

"It takes a village" has never been a more applicable expression than when applied to *The Second Half*. Since its inception fifteen years ago, many people in many countries have helped it come to fruition.

Sheila Rauch has been my go-to phone call for any sort of advice from the very beginning. A few years into the project, Emma Gilbey Keller joined her as a counselor. They have read interviews, listened to any dilemma, and provided good advice. My deepest gratitude goes to them.

I owe so much to those who helped me find good subjects. I'd like to thank Tamasin Day-Lewis, Jacqueline Délia Brémond, Bokara Legendre, and Charlotte Mosley, subjects themselves who recommended others, and Turki al-Faisel, Susan Colgan, Jim Davison, Albina de Boisrouvray, Sybil d'Origny, Lisa Fentress, Natalie Gibson, Peter Paine, Lisa Schubert, Mariette Scott, Ying Sita, and Debbie Stapleton, who made introductions for me. This book could not have happened without them.

I am very indebted to the following people who let me interview them in the early stages of this project or who gave me advice as time went on. I learned so much from each of them. Frances Campbell-Preston, Joe Friedman, Natalie Gibson, Lizzie-Boo Hammond, and Anna Laflin in England; Albina de Boisrouvray and Marie de Hennezel in France; Ludina Barzini, Cristiana Brandolini, Gabriella Codognato, Giulia Cornaggia, Mariapia Fanfani, Marina Giusti, Joan Fitzgerald, Oretta Machivelli, Marina and Vanna Magrini, Dialta Parese, Doris Pignatelli, Gabriella Ruffo, and Fulvia Sesane in Italy; Rita Goldstein in Greece; Isabel de Solis Beaumont and Isabel Leon in Spain; and Lois de Menil, Jason Herrick, Kyra Hickox, Juliana Koo,

Patty Pei, Margaret Sass, Sue Schutz, Tina Sloan, Margot Wilkie, and Millie Yung in the U.S.A.

Working on this book involved travel, and I always stopped en route (usually for rather a long time!) in London and often in Paris. May and Gil Woods have let me be a member of their family in London, and I can't thank them enough. I am also very grateful to Sybil and Henri d'Origny, who welcomed me as their constant lodger during the years I was working in Paris.

Three years ago, Diana Smith, then the arts curator at the Church of the Heavenly Rest, asked if I would have a retrospective in CHR's newly renovated undercroft. One room was devoted to portraits of the women in *The Second Half*. It was their first exposure and made me realize the enthusiasm of the general public for the subject. Diana suggested having a panel discussion on the topic, and I am very grateful to Elaine Pagels, Marilynn Preston, Gayle Robinson, and Gail Sheehy for being part of it, and to Janice Steil, who was the moderator and helped organize it. Many, many thanks to Diana for being a constant cheerleader for the project and to the Church for hosting the exhibit and panel.

I owe special thanks to Bob Morton, who was a champion of this book in its early stages, and to Peter Duchin, who introduced me to Laura Yorke, my wonderful agent who went to bat for it.

The publication of *The Second Half* was serendipitous. My husband and I spent a weekend with friends in Connecticut who took us to a dinner party that Saturday night. There I met Adam van Doren, who, when I described the project, said, "You must get in touch with Sue Ramin," and that was that.

I have never had an editor before, but I can't imagine one better than Sue. She has been endlessly supportive, always has the right instincts, and has a wonderful sense of humor to boot.

The Second Half has been generously supported by Tom Pulling

and the Luce Foundation, Dede Reed and the Thendara Foundation, The Peter S. Reed Foundatoin, Jim Zirin and Marlene Hess, and Ellen and Jim Stirling. I owe them a particular debt of gratitude.

Many thanks to Tina Barney, Liz Buckner, Hilary Cooper, Alexandra Isles, Sage Mehta, Josie Merck, and Pamela Talese, who have helped me in a variety of ways, and to "Margot's Group," who have "kept me steady." Bea Merry and Brian Parmal have been an invaluable help working with me on the negatives and digital files over the years. And a particular shout-out for my good friend Joan Bingham, sadly no longer with us, who provided enthusiasm, criticism, and guidance from the very beginning.

Hearkening back many years, there are two people who gave me the encouragement I needed to forge my career. To them I owe the years of joy I've had traveling, photographing, interviewing, and exploring. My endless thanks to Peregrine, who told me I must keep photographing, and to Jack, who showed me the way.

Finally, but most importantly, I am very grateful for the support of my family. My younger daughter Lily read interviews and gave me the perspective of her generation. My older daughter Alix cheered me on over the phone from Austin. I'm married to an inveterate traveler and lousy cook, but Miner, my husband of fifty years, never complained about being left behind to fend for himself while I was off for a month at a time, and was supportive in every way. I thank him for all of it.

ABOUT THE AUTHORS

Ellen Warner began her career as a photojournalist in 1969. For the following nine years, she photographed in China, Iran, East Africa, India, and Europe. She was published in numerous newspapers and magazines. Over the years, she has developed a specialty of author portraits and has worked for most of the publishing houses in New York and London. She has also written travel articles, which have been published in the *New York Times* and *Travel and Leisure* in the U.S.A., and in *The Traveller* in the U.K.

Erica Jong's first novel, *Fear of Flying*, was published in 1973, and in the four decades since, she has published over twenty-five books, which have been translated into forty-five languages. Her honors include the Fernanda Pivano Award for American Literature and the Sigmund Freud Award in Italy, the Deauville Award for Literary Excellence in France, and the United Nations Award for Excellence in Literature. Her most recent books are the novel *Fear of Dying* and a book of poetry, *The World Begins with Yes*.

Sarah Lamb is the Barbara Mandel Professor of Humanistic Social Sciences at Brandeis University, where she is also a professor of Anthropology and of Women's, Gender, and Sexuality Studies.